FAKING IT

FAKING IT

Art and the
Politics of Forgery

IAN
HAYWOOD

Tutor in English
The Open University

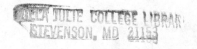
St. Martin's Press

New York

© Ian Haywood, 1987

First published in the United States of America in 1987

Printed in Great Britain

ISBN 0–312–00484–2

Library of Congress Cataloging-in-Publication Data

Haywood, Ian.
 Faking it. 2000

 Bibliography: p.
 Includes index.
 1. Forgery — History. 2. Literary forgeries
and mystifications — History. 3. Art — Forgeries —
History. I. Title.
HV6675.H35 1987 364.1′63 86–27993
ISBN 0–312–00484–2

Contents

1

The Concept of Forgery

In mid-1983 the European public was bemused and fascinated by
the controversy over the newly-discovered and supposedly
genuine Hitler diaries.[1] The furore over their authenticity
occupied the front pages of leading newspapers for several
weeks. The story began in late April when the German
magazine *Stern* announced sensational plans to serialise extracts
from an enormous cache of sixty volumes of diaries by the Nazi
dictator. The existence of such records had never been heard of
before. But they were authenticated by the English historian and
Times director Lord Dacre (formerly Hugh Trevor-Roper). *The
Times'* owner Rupert Murdoch had bought the British and
Commonwealth serialisation rights from *Stern* for $400,000.
Stern began publishing extracts, and the *Sunday Times* put out a
few morsels to whet the reader's appetite. Within a few weeks,
however, West German police were on the trail of a dealer in
Nazi relics, the diaries had become forgeries, reputations had
been sullied, and the press world was reeling. The affair had
become a fiasco. The satirist Auberon Waugh called it 'the most
preposterous cock-and-bull story to be foisted on the British
public since Titus Oates' (*Spectator* 30 April, p. 6) and was
echoed by the *Guardian's* 'one of the world's most audacious
confidence tricks' (8 May). The authenticity of the diaries had
crumbled at the first scientific inspection. Many felt that such
analysis should have been carried out prior to any commitment
to publish. The press was attacked for venality and lack of
integrity. Times Newspapers emerged as foolish and oppor-
tunistic.

The details of this recent case of forgery are worth pursuing

because they introduce many of the issues this book will be dealing with. The consequences of the Hitler fakes ranged wider than the £2m paid by *Stern* to their reporter who 'negotiated' the deal, or the duping of Lord Dacre (rechristened 'Hugh Very-Ropey' by *Private Eye*). The mercenary motives of the forger and the drubbing of the hapless expert are often taken to be the only significant features of forgery. In fact the so-called Hitler diaries opened up larger questions about the acceptability of certain cultural practices. The exposure of such procedures and standards and their questionability is the key theme of this book. Forgeries are subversive artefacts.

Only one week after April Fool's Day Lord Dacre examined some of the Hitler volumes for a few hours in the vault of a Zurich bank. He was the first historian allowed to see the precious relics. He had been chosen apparently because of his scholarly credentials (he had written *The Last Days of Hitler*) and because he was an independent director of *The Times*. After a brief inspection Dacre surfaced from the vault to announce that the diaries were genuine. He had not been able to decipher the handwriting, nor examine more than a few pages of the collection. But he had been overawed by the sheer scale of the find, and accepted the provenance of the diaries at second hand. By the time the revelation was published in *The Times* on 23 April, Lord Dacre was having second thoughts. The story of the rescue of the diaries from a crashed S.S. aeroplane just before Hitler's death had become increasingly untenable in the absence of a named source. Talk of forgotten chests in hay lofts smacked too much of stock-in-trade discoveries of lost manuscripts, classic examples of which will be looked at in this book. By 26 April Lord Dacre had recanted. He called for a fuller examination of the documents, meanwhile giving them 'provisional' authenticity (*Guardian*, 26 April). It is worth pondering on this situation. Lord Dacre's *authority*—his status as an 'authority' or expert—had been the chief agency in giving the diaries even this degree of *authority*. They had not been able to generate their own authenticity and hence authority by mere publication.

The nature of authority in texts is a question that inevitably arises from consideration of forgery. What is highlighted is the fact that the text never stands in isolation. It is part of a cultural

process. Our reaction to it is governed by a mixture of external and internal factors. The fate of the Hitler diaries was decided almost wholly externally.

Before Lord Dacre's demotion of the documents a formidable battery of pundits came out to oppose him. In the fray were Lord Bullock, author of *Hitler, A Study in Tyranny*, Professor Eberhard Jaeckel, a leading German historian, David Irving, the famous ultra right-wing historian (he later changed his mind and argued for the diaries' authenticity), Martin Gilbert, author of *Auschwitz and the Allies*, Simon Wiesenthal, a Nazi war crimes investigator, and George Young, ex-director of Britain's MI6. Such a top-notch parade of experts and authorities will become a familiar sight in this study. Of course anything concerning Hitler is bound to be an emotive issue. But what the controversy revealed was not only strength of feeling but the workings of the corridors and even back stairs of the cultural establishment.

Lord Dacre admitted that fake historical relics were 'going about in a grey market which command high prices' (*Guardian* 26 April). Forgeries, themselves a 'grey' area, have a habit of exposing dubious practices. Dacre regretted that historiographical scrutiny had 'to a certain extent been sacrificed to acquire a journalistic scoop'. As the *Sunday Times* pointed out (1 May), the situation epitomised 'the clash between the demands of journalism and those of historical research'. Lord Dacre's 'staggering U-turn' facilitated analysis of the diaries by the German federal archives department. Paper, glue and bindings were of post-war origin, and the whole was quickly pronounced 'a blatant, grotesque and superficial forgery' (*Observer*, 8 May). Clearly the diaries could not have lasted long without protection. The complicity of the press was attacked vociferously, not least by its own practitioners anxious to whitewash themselves. Auberon Waugh quoted the fake Mussolini diaries of 1967 as an earlier example of 'the *Sunday Times*'s habit of printing completely bogus "scoops" on its front page' (*Spectator* 30 April, 6). In the same journal Timothy Garton Ash asked less outrageously of the diaries: 'Are the journalistic methods used to discover and present them legal, legitimate or desirable?' (p. 7)

These are radical questions, and the *Guardian* answered some of them in its leader of 9 May. The *Sunday Times* was attacked for scapegoating Lord Dacre and 'leaving all the dung on the mat

at Peterhouse, Cambridge'. He had at least had the courage to accept his 'terrible pounding' 'in the full glare of the spotlights' whereas Fleet Street was hiding in its rotten woodwork:

> There is a lesson here, and it it not the lesson that the Sunday Times seeks so unctuously to draw. Hitler's so-called diaries were not a matter of what is loosely called 'investigative reporting.' They were another outcrop of chequebook journalism, in which one large multinational newspaper chain, Mr Murdoch's News International, paid *Stern* magazine fat swathes of cash for a supposed off-the-peg exclusive. One central objection to this kind of operation . . . is that the sheer size and commitment of the investment brings with it a suspension of normal critical faculties. There is such a vested interest in the bought-up tale, that the normal checks and balances of really serious journalism go out of the window. The Hitler farrago wasn't serious or even journalism in any serious defensible way: it was a show-business scrabble from which a few humble lessons might well be learnt when the fluff and nonsense of this (German and Australian) Dutch auction have died away.

So the recriminations of the Hitler diaries affair undermined at least two important if not central institutions: the ivory tower of the scholar and (at the opposite end of the scale) the street-hawker tactics of the capitalist press. The story does not end there. If we turn from the external machinations to the tiny extracts that were printed in the *Sunday Times*, we see again the radical potential of the forgery. *Stern* believed (or claimed) the diaries would necessitate the rewriting of much history of the Nazi period (*Spectator*, 30 April, p. 8). The historical contents of the extracts had been provocative. For instance, one revelation was Hitler's allowing the British Expeditionary Force to escape at Dunkirk. There were immediate accusations that this was an attempt either to whitewash Hitler, to aggrandize his reputation, or even to sow seeds of dissension in NATO. As high an official as the French Interior Minister Gaston Defferre was stung into public utterance:

> A lot of noise has been made of these 'memoires' in far from healthy circumstances. The aim was to elicit an interest in both France and Germany to build up a sort of myth of Hitler the great man. Hitler the conqueror prior to the turning point in the war.
>
> (*Observer*, 8 May)

There was also outcry against the danger of showing Hitler to be

too normal and human. In one entry he supposedly said of Eva Braun: She is a young woman and if she continues to pressure me into letting her spend more time at my side and also to have a family one day, then I shall have to separate myself from her (*Sunday Times*, 1 May). The importance of seeming banalities of social history will be at issue again when we look at the forgeries of the eighteenth century in the next chapter.

The final scholarly insult in the Hitler diaries controversy was that much of the material was copied from a standard reference work on Hitler: the archivist Max Domus's *Reden und Proklamationen 1932–45*. Those bits that were not copied were presumably the new, revelatory material, a method forgery shares with historical fiction. There is a sense in which any forgery is a species of fiction. Though this book deals primarily with forged works of art, Lord Bullock's words are worth contemplating. He warned that even if the diaries were found to be genuine they must not be believed: 'We are dealing here with one of the masters of propaganda, an arch-liar' (*Observer*, 24 April). Authenticity does not mean truth. Hitler is an archetypal unreliable narrator, a fictionaliser. Had the diaries been genuine they would be 'genuine fiction' rather than 'fictional fiction'. The dividing line between the genuine and the spurious, the acceptable and unacceptable, is often thinner than might be thought. These points will be particularly relevant in the next chapter when we look at the early novel, a genre which combined a new-found ability to render experience realistically with authorial disavowal and the passing off of fiction as genuine documents: memoirs, letters, and even diaries.

I have used the Hitler diaries to introduce some of the key issues this book will be discussing. It has been assumed everyone is familiar with the phenomenon 'forgery'. This has largely been for convenience's sake. In the rest of this introductory chapter I want to scrutinise the concept of forgery, particularly in the arts, and to consider the adequacy of standard definitions and categorisations. A perspective will also be sketched of the pre-history of artistic forgery in the modern world, to provide a valuable foil to current assumptions. The notion of art as intellectual property owned by an individual originator is a post-Renaissance development in Europe. Forgeries challenge this

construct. It is instructive then to look back to medieval times when ideas of the artist were quite different.

There is no better way to begin to study the history of the concept of forgery than by looking at the history of its meaning. The definition of forgery in the *Oxford English Dictionary* runs as follows:

1. The action or craft of forging metal
1b. A piece of forged work (rare)
2. Invention, excogitation; fictitious invention, fiction.
 Now only *poet*. Formerly also with a more reproachful sense: (obsolete) Deception, lying; a fraudulent artifice, a deceit
3. The making of a thing in fraudulent imitation of something; also, *esp*. the forging, counterfeiting, or falsifying of a document
3b. The fact of being forged (rare)
3c. Something forged, counterfeited, or fabricated; a spurious production.

The third definition is the one that has gained currency. But the earlier meanings are revealing. Originally the word had a literal meaning: the product of the blacksmith's forge—a meaningful act of creation. Then around the time of the Renaissance in England (the earliest quotation mustered is 1574) the concept was abstracted from the concrete world to apply to the mind's creative faculties. The intellect was assuming its dominance over the natural world. Such power could be used both positively and negatively. Hence the concept of forgery was moralised, and a fissure opened up between permissible 'fiction' and reprehensible 'fraudulent artifice'.

The most interesting transition occurred when the word was then put back into the concrete world. Rather than applying to any fictional artefact—any piece of intellectual property—it carried only its immoral, negative meaning. So what was once a valuable act of creation for society's use had become bastard, 'spurious production'. 'Fiction' was left to carry any positive aspects of artistic invention. Yet fiction and forgery are blood relatives, even if they do not always choose to acknowledge each other. A forgery is still a making: its condemnation is a matter of interpretation and law. Forgery is only a threat when there is the possibility of 'prejudicing another [person's] right', as the falsifying of documents is supposed to do. In terms of art, this right can only be 'prejudiced' if art is regarded as individualised, original creation.

If we turn now to another authority, the fourteenth edition of the *Encyclopaedia Britannica* (1969), we find separate entries for the positive and negative meanings of forgery. The blacksmith's work is in fact entered under 'Forging'. 'Forgery' then refers solely to a 'false writing' or spurious document. The concept is utterly outlawed. There are three qualifications for something to be a forgery: the fabrication must be of an authentic document (which includes the alteration of an original document rather than wholesale reproduction); the authentic document must have legal or commercial significance; the intention must be to defraud. This chemistry is worth bearing in mind when we move on in the next chapter to individual cases of forgery. No single element is enough on its own to make a forgery. A statement intended to defraud is not a forgery unless it hijacks authority: a forgery must be a parody of a rubber-stamped source.

The example is given of a worker who puts on a time sheet that he or she has worked forty hours instead of thirty. This is not forgery because the worker is not sufficiently counterfeiting authority. The time sheet is more the worker's own appurtenance at that point than it is a functioning cog in the bureaucratic machine that will authenticate it. Had the worker penetrated this higher level, presumably he or she could be a forger. On the other hand, no one need actually be defrauded or deceived for forgery to occur. The intention to deceive in general will suffice. Without a forger's confession, however, such intention is very difficult to prove. Forgery is a slippery legal concept, and forged art even more so. Cultural laws are often unwritten. Authority is enshrined more in assumptions and their effects than coded litigation. The *Encyclopaedia Britannica* points out the ambiguity of art in relation to forgery:

> 'Writing' excludes pictures, sculptures and antiques; signing the name 'Rembrandt' at the front of a painting done by someone else is not a forgery. (In some cases, however, the scope of forgery has been expanded by statute to apply to these and other articles which are not considered 'writings' in common law.)
>
> (Vol. IX, p. 621)

Forgery is in fact no longer classed as a common law offence. The 1981 Forgery and Counterfeiting Act made forgery a statutory offence. But though the Act has a clause covering discs,

tapes and soundtracks, there is no mention of art. Art forgery is still not clearly defined in law. The root problem is the legal status of artistic authenticity. Or, put another way: how art derives its authority.

The entry for 'Literary Forgery' in the *Encyclopaedia Britannica* may then offer us some help. But we see immediately that 'literary' is used in its broadest terms to refer to any written document. The definition is merely 'A piece of work created or modified with an intention to deceive' (Vol. XIV, pp. 104–5). Moreover the idea of deception is of little use with regards to art unless it is defined further. Art has always used illusion to great effect. The bird which flies into a realistic painting of a window believing it to be three-dimensional has been deceived. No one would want to call the picture a forgery for those reasons. The *Encyclopaedia Britannica* skirts round aesthetic issues altogether by concentrating on the deceitful *intention* of the forger: the essence of a forgery lies here and not in the work itself. The dismissiveness of this approach is apparent in the easy way four categories of deception are produced: (1) 'works produced to exalt or denigrate some religion, party or race'—the Apocrypha, the donation of Constantine; (2) 'works produced pseudony-mously by an author who despairs of obtaining recognition under his [or her] own name, or who considers that he [or she] has been unjustly neglected and takes vicarious pleasure in hearing his [or her] forgeries lauded by the very critics who rejected his [or her] genuine writings'—Macpherson, Chatterton, W.H. Ireland, Charles Julius Bertram; (3) 'forgeries whose motive is financial'—Major Byron, T.J. Wise; (4) 'forgeries produced as hoaxes'—George Psalmanazer, William Lauder. All these examples will be looked at in due course. The point to note here is how unsatisfactory the categorisation is.

Motives are complex phenomena, often unrecoverable, and nearly always mixed. If a forger's motives were quite different from those given above (for instance the need to become one with a past master, or to provide evidence for a scientific or artistic theory)[2] then the work created would not be a forgery. Category (2) includes all pseudonymous works, which is surely not intended, and categories (3) and (4) are not definitions at all since they use a preconceived notion of forgery. Much art has been produced for money. Nothing said by the *Encyclopaedia*

Britannica would enable us to detect a forgery if we had only the work before us. The question of the intrinsic or aesthetic status of a forgery is wholly eschewed. In the absence of exterior information about the writer's intentions, all works become the same, with no difference apparent between the fake and the genuine. The *Encylopaedia Britannica* would not want us to draw this conclusion. Forgery has undermined *its* authority. This is often the case if serious consideration is given to the confrontation of forgery and cultural authority, as we saw with the Hitler diaries.

The approach in this book then will be to focus on the work itself and how it is regarded by culture, and not on the biography of the forger. Statements by forgers may come in useful, but will not dominate the issue. The external machinery brought into play is the means by which culture imbues a work of art with authority and significance. I am not choosing initially to redefine forgery. The case studies to be examined have all been labelled or 'condemned' already: this is indeed part of their interest. The opinions of critics and contemporaries are more important than the forger's confessions, because in the former we see cultural litigation at work. I try to hold apart art and non-art forgeries, though they are often analogous, and the association between them is at the root of much condemnation of the former.

The Oxford Companion to English Literature (1967) sweeps into one listing 'Forgers and Fabricators, Literary, and Other Impostors'. The examples range from classical times to this century, and include swindlers who never produced works of any kind. One conspicuous inclusion is William Dodd, executed for forging a banknote worth £4200 in 1777. Artistic offences have not yet become punishable by death. Cultural laws and presuppositions are not written down in a statute book. One of the values of forgery is its laying bare of this intangible process for public scrutiny. Exposing prevailing notions is of more importance than merely making a critic look a fool, especially when those notions are found to have defects. Clearly the 'authorities' to which I have turned to give a definition of forgery have had their credibility threatened. This has been the salutary effect of consulting them. The logic they employed has been primarily circular: a forgery is 'false' or 'spurious' because we already know it to be so. There has been no workable separation

between art and non-art forgeries. The prevailing idea has been that forgeries are bastard works, the 'fraudulent imitation' or diabolical double of the meaningful artefact. Forgeries 'counterfeit' authority: they steal or mimic it. The analogy is again to the forged currency. The authentic status of a copy of a work of art is actually problematical, as we shall see. A known copy would not be afforded the praise bestowed on the original, even if the two were identical. That is, unless the copy were by a master of greater prestige than the original painter. All art is imitative, but there comes a point when imitation turns into plagiarism.

The concept of originality will be a central theme in this book, for it is chiefly that notion which keeps alive the idea of artistic theft. Yet most forgeries are not copies. Most of the examples cited so far are 'creative' forgeries: 'new' works either by famous artists or by imaginary creators. These paradoxically 'original' forgeries are the most interesting and the most subversive. The way they create authority is not a simple case of stealth or theft. The consequences for the cult of the original are radical.

The notion of the original work of art evolved in modern Europe in the Renaissance. Before this time we have to go back to the developed culture of classical times to locate an artistic practice acknowledged as forgery.

Andrew Lang has noted that 'if we believe Greek literary tradition, literary forgery was common as soon as the act of writing was used for literary purposes' (Farrer, pp. xiii–xiv). He cites the example of Dares Phrygius's *History of the Trojan War*, supposedly written by an eye-witness, but in Lang's opinion the work of 'a historical novelist, who, by the usual convention, pretended to have found an ancient manuscript' (pp. xiv–xv). 'Convention' is the important word there, for it is not at all certain that in Greek culture the idea of a historical novelist polluting the wells of fact had any meaning. As the Hitler diaries showed, the buried manuscript still has its appeal, but its stock-in-trade status has more to do with the eighteenth century than with classical civilisation. Ancient historiography is notoriously fabulous. Herodotus has long been the butt of much censure: a representative of the lack of scrupulosity in ancient history writing. But again it is not certain that such practices as the invention of speeches for historical characters were necessarily

frowned upon. Once the Romans began collecting works of art and art became capitalised or commercialised we can be sure forgeries began to enter the market, though contemporary views of the situation are lacking. L.D. Reynolds and N.G. Wilson note of the antiquarian book trade in second-century Rome: 'It is tempting to think that the venerability of the books still to be found at this period has been exaggerated by commercial guile or the enthusiasm of the collector, and there seems little doubt that some of the more recherché items were expensive and egregious fakes' (Reynolds and Wilson, p. 28).

Fake documents, seals and artefacts, the distortions of official doublespeak, have probably always been factors in the battle for power in states and nations, and will remain so. When we look at the history of Europe in the last two thousand years, we see it dominated by the Church. If we have so far had to read back forgery into ancient times, it is with the early Church that forgery becomes a more conscious and a more relevant issue.

The Donation of Constantine is probably the most famous Christian forgery. This fake bull, written in the ninth century, was part of the mammoth 'False Decretals' of Isidore, an anthology of sayings and writings of the Emperors.[3] Constantine tells of his conversion by Sylvester and of his reward to the Roman Church of the western Empire. The Donation effectively secured the temporal power of the Church in Europe for hundreds of years. Its authenticity went unchallenged until Protestantism had been founded. J.A. Farrer comments on the Donation: 'one is disposed to wonder whether falsehood rather than truth has not had the more permanent effect on the destinies of mankind' (Farrer, p. 143). As the main transmitter of knowledge in the Dark Ages, the Church has been attacked as much as it has been praised for its practices. Imposition and interference, ideological meddling in the relics of the past: these charges have been levelled at the cloistered monk. The Jesuit Hardouin is reported to have said that 'most of our books are monkish forgeries' (Farrer, pp. 4–5). The medieval chronicle or annal became as hated by scholars as Herodotus's fabulations. (The purity of a received literary text was a huge problem for the eighteenth century, as we shall see in the next chapter. Some of the literary forgeries in that century can be seen to be participating in the debate over the authority of an ancient text.)

For the medieval Church this issue was at its most sensitive when it concerned the Bible. As an 'inspired' text, the relationship between authenticity and authority was at its most powerful. Though most people were denied direct access to the Bible, the authority of the Church was built on the authenticity of the books of the Bible: the sacred canon. The establishing of the canon was therefore the paramount task. It was not a straightforward job. A persistent obstruction were those 'deutero-canonical' books known as the Apocrypha. Their history is worth dwelling on in some detail, not only for its intrinsic interest, but because it forms a compelling paradigm against which to set the later examples of forgery this book will be dealing with.

When Jerome collated the Greek (Septuagint) and Hebrew Old Testaments in the fourth century, he found books in the former that were not in the latter. These he named Apocrypha, meaning 'secret' or 'hidden' texts, because Jerome believed them to be hermetical teachings of the Greek-speaking Jews of the third century B.C.. They were not pure, 'inspired' writings, and therefore could not be used for doctrine, but were still valuable for their moral and historical content. Thus Jerome allowed the Apocrypha to remain in the Old Testament. These books—1 and 2 Esdras, 1 and 2 Maccabees, Tobit, Judith, Additions to Esther, Wisdom of Solomon, Ecclesiasticus, Baruch, Susanna, Song of the Three Children, Bel and the Dragon, Prayer of Manasseh— did not have their 'diminished' status denoted, and hence formed an 'extended canon' (*Catholic Dictionary*, p. 107) in the Latin Vulgate.

Martin Luther first pointed out the ambiguous position of the Apocrypha. 'Not enthusiastic about the religious value of them' (Godspeed, p. 4) Luther rounded them up and placed them in limbo between the Old and New Testaments. The Apocrypha maintained this ambiguous position through all the major early English Bibles, including the Third Authorized (King James) Bible of 1611. Some of the sixteenth-century Bibles contained qualifying prefaces. The Geneva Bible of 1560, for instance, said the Apocrypha should be read only for 'knowledge of the history' and 'instruction of goodly manners'. Even this demotion was not enough for the Puritans, who put pressure on printers to outlaw the Apocrypha altogether. In the eighteenth century those leaves

containing the Apocrypha began to be omitted from Bibles, even though pagination made the absence conspicuous. Eventually, in 1827, the British and Foreign Bible Society banned the Apocryphal books. It is now hard to find a Bible that includes them, and 'reprints' of the King James Bible are in this sense inaccurate.

This brief history of the English fate of the Apocrypha has shown that textual authority is as much to do with the powers that have a vested interest in the text as with the words on the page. In this highly-charged instance the authority we have witnessed in action is the Church. Later we will see the Church of Art wield its power. The story of the Apocrypha is not ended yet, however, because we have not considered the texts themselves. Does their authenticity flounder between Jerome's non-committal scholarship and Luther's subjective rejection? How does a text reveal its authenticity? The *Catholic Dictionary* expressly refutes the objective *and* subjective authentication of the text. Regarding the latter, a 'self-evidencing light' (p. 109), we are told that human feelings are too fallible. Evidence for this is, ironically, disagreement among the Fathers about the canon. As for scholarship, the Bible was given to all, not merely to 'learned men'. There is only one conclusion: 'it is only from this very Church, and on her authority, that Scripture is received'. Authenticity need only be stated. The canon can be left to the 'infallible authority of the Church' and the 'infallible teachings' of the Fathers.

The facts, however, show that the Church hierarchy consists of people often in disagreement. The Council of Trent (1545–64) finally rubber-stamped the secondary or 'provisional' authenticity of the Apocrypha, it being anathema to ignore their 'sacred and canonical' status. But this decree followed centuries of wavering. The Council of Laodicea (343–89) outlawed all Apocryphal books bar Baruch. The Council of Hippo reversed this decision, supported by the decretal of Pope Gelasius (492–96) which gave them authority in Canonical Law; later they were supported by the Council of Florence (1442). So the fate of the Apocrypha was decided at committee meetings. The Council of Trent's endorsement could actually be seen as a counterblast to the Thirty Nine Articles.

The point to note is that forgeries often expose the vested

interests òf those deciding on the status of the text. The text is shown to be part of a cultural process. The *Catholic Dictionary* is forced ultimately to reveal its colours. It counters the authenticity of the Hebrew Old Testament (i.e., the Scriptures that Christ would have known as a fixed canon): 'Nor can any Protestant consistently accept the canon of the Old Testament on Jewish authority, unless he attributes infallibility to the bitterest enemies of the Christian name' (p. 106). 'Only the Church has the right to declare a book canonical' says the *Oxford Dictionary of the Christian Church* (Cross, p. 232). This is to admit the prejudices of such a declaration. Consideration of the Apocrypha enables us to see the Church's power over the text. Otherwise we could not make sense of the fact that a New Testament Apocryphal book (St. Paul to the Laodiceans) 'hovered about the doors of the sacred canon' for nine centuries (*Catholic Dictionary*, p. 39).

The decay in the meaning of the word 'apocryphal' from 'hidden' to 'spurious', is not that dissimilar to the change in the meaning of 'forgery'. But even in their tarnished condition the Apocrypha have a value beyond narrow religious infighting. According to R.H. Charles, for instance, without these texts it is 'absolutely impossible to explain the cause of religious development between 200 B.C. and A.D. 100' (Charles, Vol. I, p. x). The light shed by the Apocrypha on social history is even more evident in the discussion in the *Encyclopaedia Britannica*. A picture is drawn of the rival canonizing authorities of the early Church. Palestine had a 'conservative, not to say reactionary, type of Judaism' which was 'rigidly limited to books that were unimpeachably ancient'. Alexandria had a 'freer atmosphere' which preserved the 'hard core of the Hebrew canon' along with 'greater tolerance' to 'other religiously valuable works, regardless of date and authorship (Vol. II, p. 118). This dichotomy should be kept in mind. It seems obvious to me which of these two regimes would encourage a healthy proliferation of ideas and doubts.

Chambers's Encyclopaedia (1970) is not so benevolent towards New Testament Apocrypha. Unlike the Apocrypha proper (as I have been calling the Old Testament books) the New Testament 'forgeries' have not been afforded even an ambiguous place in the Bible. As *Chambers's* notes, they are

usually 'rejected as without authority or as fabulous' (Vol. I, p. 493). The *Encyclopaedia Britannica* goes even further. Its view is that 'these sayings, whether "authentic" or not, can add nothing to our knowledge of Jesus because the canonical writings provide the only norm by means of which they can be tested' (Vol. II, p. 115). Authority here supersedes authenticity. Matters of belief, opinion, faith, override ostensibly objective data. In the eighteenth century, people began to disbelieve in miracles. Here Viscount Bolingbroke concluded that only the historical passages in the Old Testament could be true and therefore inspired. The supernatural effects were interpolations added by later glamorisers. Bolingbroke had little but conviction to prove his case. His idea of a 'mixed' text of authentic and inauthentic parts is one that will occur again and again in this study. Bolingbroke was wrong to equate realism with authenticity. But he typifies eighteenth-century worries and anxieties about the authority of a text, as we shall see in the next chapter.

In 1947 one of the greatest discoveries of ancient manuscripts occurred. The Dead Sea and Qumran scrolls contained parts of the Apocrypha. This archaeologist's dream-find has still not been enough to promote the Apocrypha to full 'inspired' status. It need not do so automatically, of course, but age tends to be associated with authenticity: older is purer. The ancient manuscript has a cult status. The analogy between canonization in religion and in art extends beyond the scriptures to the cult of the relic. Christianity has always had its own art, but worship of the relic is the direct equivalent of secular worship of the original art object. Relics were originally the remains of the bodies of saints and martyrs sold for high prices. A metonymic 'extended canon' soon developed, however. Objects associated with the martyr, particularly at death, were thought to be permeated with his or her divinity. Shakespeare's laundry list, which W.H. Ireland came close to forging, would have the same importance. At the time of the Crusades, fake relics began to flood the market. The Church felt its authority being undermined and had to litigate. Authentication again became a matter for Canon Law. As the *Oxford Dictionary of the Christian Church* decrees:

> no relics may be venerated without a written authentication by a cardinal or local ordinary; and the sale of genuine relics as well as the fabrication or

distribution of false ones is punished by excommunication. (p. 1170)

We are closer to the issuing of provenances in the art market and the regulation of trade than to any possibility of a 'self-evidencing light'. Even saints do not make themselves.

One of the medieval writers who makes extensive use of the Apocryphal New Testament books is Dante. M.R. James's *The Apocryphal New Testament* (1924) is cited by Dorothy L. Sayers as indispensable source reading for the *Inferno* (Sayers, Vol. I, p. 346). Interestingly enough, the committers of fraud are given a prime place in Dante's Hell (circles 8 and 9). But Dante's notions of fraud have everything to do with morality and nothing to do with art. The defrauders range from 'Hypocrites, flatterers, dealers in sorcery' to the arch-traitors Brutus and Cassius. Now writers and artists may be all these things as well as writers and artists. Dante does not subject his revered authors to such moral scrutiny. The great pagan authors lie, rather like the Apocrypha, in limbo. Yet art may be put to morally unacceptable uses. Dante does not seem to be ruffled by the thought that a poet is a storyteller, a fictionaliser, and hence a kind of 'sorcerer'. Aristotle had established the model of the poet as the inventor of plots. Dante's lack of concern reflects the medieval attitude to fiction. Fictionality was not seen as the primary ingredient of literature. Much literature actually fell into a shadowy world of factual-imaginative writing, a limbo of embellished philosophy. Concomitantly there was no need for an individualistic hold on such work. We think of texts now as the Platonic offspring of the creative artist. The means by which those thoughts and ideas reach us is not an important issue. But in medieval times there was book-making. Saint Bonaventure describes four methods of composition; there is no mystery in any of them:

> Sometimes a man writes other's words, adding nothing and changing nothing; and he is simply called a scribe [*scriptor*]. Sometimes a man writes other's words, putting together passages which are not his own; and he is called a compiler [*compilator*]. Sometimes a man writes both other's words and his own, but with the other's words in prime place and his own added only for purposes of clarification [*commentator*]. Sometimes a man writes both his own words and other's, but with his own in prime place, and other's added only for purposes of clarification; and he should be called an author [*auctor*].
>
> (Burrow, pp. 29–30)

Only the *auctor* comes close to modern ideas of the writer. But clearly what is presented is a 'mixed' text, constantly consulting previous *auctors* or authorities. In fact Chaucer anticipates the early novel by inventing such an authority. His claim to be translating 'Lollius' in *Troilus and Criseyde* is not that dissimilar from Defoe's pretence to be editing Moll Flanders' memoirs, nor from Macpherson's claim to be translating Ossian. But little is gained by calling this fake Lollius text a forgery. The disavowal 'As myn auctor sayde, so saye I' did not seem to offend Chaucer's audience. As A.C. Spearing has noted:

> Surprising as it may seem to us, living after the Romantic movement has transformed older ideas about literature, in the Middle Ages authority was prized more highly than originality. Hence a writer would nearly always refer to an authoritative source for his material. But the particular source he referred to might itself be part of his fiction.
>
> (Spearing, 1982, p. 12)

Chaucer disowns his works in the manner of a worker on a literary production line:

> he useth bokes for to make
> And taketh non hed of what matere he take,
> Therefore he wrot the Rose and ek Crisseyde
> Of innocence, and nyste what he seyde
> (*Legend of Good Woman*, Text ll. G 341–4)

In fact, as J.A. Burrow tells us, even *scriptors* interpolated their texts, including, ironically, the *Canterbury Tales* (Burrow, p. 30).

Chaucer went on to reject his imaginative works in the 'Retraccioun'. His worries about fiction do not seem to have been mirrored in his culture. The reason for this may be precisely because art was not seen as individualised, and the artist and the work as possessing no intimate or mystical affiliation. The writer 'taketh non hed of what matere he take'. In such a situation it is difficult to 'prejudice another's right' by forgery, because that right over the work of art has not been established. But with the growth of capitalism and the Enlightenment (in England in the seventeenth and eighteenth centuries) the individual began to figure much larger in the cultural landscape. The eighteenth century was also an unparalleled age of literary forgery. This

cannot be a random accident of cultural history. We have considered the idea of forgery and its changing conceptualisation. Above all we have established the potential in forgeries for radical revaluation of prevailing values. These notions must now be applied to the great age of literary forgery to see if we can gain a clearer understanding of what is often regarded as a minor aberration in the history of literature.

Notes

1. See Harris 1986, for more details of behind-the-scenes activities.
2. Take for instance the case of the modern reputable psychologist Cyril Burt. He faked results to prove his theories about inherited intelligence. The fraud was exposed in 1976. See Hearnshaw, 1979.
3. The *Historia Augusta* of Ammianus (c. 395) is another parcel of fake imperial biographies. According to Ronald Syme, Ammianus 'comes out before the end as a master in the art of historical fiction' who also 'enters into competition with the historians, modestly adding novel and precise details, the product of scholarly research' (Syme, 1968, p. v, 204).

Four forgers, born in one prolific age,
 Much critical acumen did engage.
 The First was soon by doughty Douglas scar'd,
 Tho' Johnson would have screen'd him, had he dar'd;[1]

 The Next had all the cunning of a Scot;[2]
 The Third, invention, genius—nay, what not?[3]
 FRAUD, now exhausted, only could dispense
 To her Fourth Son, their three-fold impudence.

[1]William Lauder [2]James Macpherson [3]Thomas Chatterton

A mock inscription by William Mason
under a portrait of Samuel Ireland, 1796

there is a spreading evil in telling a false story as true, namely
that you put it into the mouths of others, and it continues a
brooding forgery to the end of time.

Daniel Defoe

The Filiation of a literary performance is difficult of proof;
seldom is there anyone present at its birth
James Boswell, in *Life of Johnson* (1791)

2

The Eighteenth Century:
A Prolific Age of Literary Forgery

It seems a striking paradox that the Age of Reason should have been the most fertile period of literary forgery in British cultural history. A succession of fakes punctuates the century: George Psalmanazar's *An Historical and Geographical Description of Formosa* (1704), Lady Elizabeth Wardlaw's 'Hardyknute', William Lauder's *An Essay on Milton's Use and Imitation of the Moderns* (1750), James Macpherson's Ossianic poetical 'relics' *Fragments of Ancient Poetry* (1760), *Fingal* (1762) and *Temora* (1763), Thomas Chatterton's medieval documents (composed 1768–70, published 1777), and in the last decade William Henry Ireland's fabrications of Shakespeare.

These are only the acknowledged forgeries, of which Macpherson and Chatterton are undoubtedly the most famous. Their remarkable stories will figure prominently in this chapter. But I will also be looking at authors who would never today be thought of as forgers but who produced works which in their time had their authenticity challenged. Pope, Defoe and Bishop Percy all produced texts which in various ways were categorised as 'doubtful'. New methods of publication and higher scholarly standards in editing made the question of the authentic text a central one. The Queen Anne Copyright Act of 1709 stands in ironic contrast to the constant violation of the principles it enshrined. The Act was based on the modern notion of the individualised, inimitable act of literary creation: the birth of the author-owned text. Yet the early eighteenth century lauded imitation, distrusted fictional pretence, and was rife with piracy and misattribution. The 'children of the mind', as Swift termed books, could be fathered on to literary enemies. The scrupulous

theorising of the Enlightenment attempt to rationalise all knowledge was certainly not always carried out in practice. Yet it is wrong to see this disparity as either mere paradox or sheer hypocrisy. The question of truth is never far from the centre of any intellectual debate in the eighteenth century. Likewise the question of falsehood. Rules are most clearly felt when they are broken. In art as in other disciplines eighteenth-century thinkers tried to outlaw the false and unacceptable and establish laws and constructs of the genuine and legitimate. Yet this revaluation often revealed only the productive intimacy of the real and the spurious. The complexion of true art was hotly debated but not brought to a conclusion. Literary forgery is both a symptom of and a participant in this debate. Hence the seminal importance of the period. Many of the questions raised have not yet been resolved.

Formosan Fictions and the Early Novel

In 1704 a book appeared in London which quickly became a sensation. George Psalmanazar's *An Historical and Geographical Description of Formosa* was half-memoir, half-travelogue, and told of exotic rites and customs in the far-off land. The book's author became a celebrity. He spoke a strange tongue but also knew English and was well educated. Soon he was lecturing at Oxford and had entered literary circles. He eventually became a close friend of Dr. Johnson. By that time, however, his *Description of Formosa* had been exposed as a complete sham, a mixture of plagiarized passages and pure invention. In his *Memoirs* Psalmanazar confessed that his 'vile and romantic account' had been a 'shameful imposition on the public' (1764, p. 63). His Formosan language was simple gobbledygook. The modern reader wonders how early eighteenth-century readers could have been so easily duped, especially by the graphic account of the annual sacrifice of 18,000 young males. Psalmanazar's claim to veracity in the preface to *Description of Formosa* appears at first sight risibly and wilfully perverse. He was posing, it must be remembered, as a native of the island who had left after having been converted to Christianity by Jesuits:

when I had met with so many Romantic Stories of all those remote Eastern countries, especially of my own, which had been impos'd upon you as undoubted Truths, and universally believ'd ... I thought myself indispensably oblig'd to give you a more faithful History of the Isle of Formosa.

(p. xxxi)

In other words Psalmanazar is doing a public service by correcting previous forgery. He is replacing the imposition of fiction with his own experience. The claim can be seen as mere rhetoric, of course. An easy way to attempt to authenticate your own work is to accuse your rivals of dishonesty. But the articulation of the pretence is significant. Psalmanazar offers history not story. He offers first-hand experience not material cribbed from other sources. As we shall see, Psalmanazar's preface is a model of its kind, not only in embodying new ideals for authentic knowledge, but in flaunting these ideals in practice. *Description of Formosa* is in this sense a counterfeit. This does not mean it copies exactly the words of another text, but it follows what other writers were doing.

One reason why Formosa's 18,000 sacrifices a year may not have appeared utterly unconvincing was that there were precedents for such mass ritualised slaughter in earlier travel books (Adams, p. 95). The authenticity of those accounts was not guaranteed, nor did it seem to matter. Previous 'authorities' were cited and plundered at the same time. One of the 'Romantic Stories' Psalmanazar vilifies is Candidius's account of Formosa. Yet Candidius was the main source for Psalmanazar's information. Even those travel writers who had genuinely been to the places they were describing could rarely resist deviation. This extraordinary muddling of the empirical and the literary is summed up by Percy Adams: 'It was an age of plagiarism, and travel liars appropriated material from other travelers and, ironically, from other travel liars' (pp. 11–12). So travel literature in the early eighteenth century was a species of embellished fact and dishonestly appropriated material. On both accounts could such literature qualify as forgery. The travelogue was a genre in which fiction could be licensed and disguised. In his *Memoirs* Psalmanazar records how previous accounts of Formosa actually heartened him in his task. Such works were

stuffed with such monstrous absurdities and contradictions ... that I might the more easily make whatever I should say of it, to pass current with the generality of the world.

(p. 216)

So there may be very little difference between Psalmanazar's forgery and the supposedly legitimate travel literature which claimed to be factual reporting. The latter, like the former, was presenting untruths as truth, and another person's work as the author's own. Yet the more pressing question is the relation of *Description of Formosa* and contemporary travel writing to a work such as *Robinson Crusoe*. We class this work as fiction or a 'novel'. Yet *Robinson Crusoe* and other Defoe novels bear striking similarities to Psalmanazar's unacceptable code of artistic practice outlined above. As John Richetti points out: 'many narratives of the period, presented as fact and accepted as such by many, were sheer fabrications' (Richetti, p. 7).

Readers' expectations are virtually impossible to recover. However, by 1718 the magazine *Read's Journal* noted Defoe's particular gift for 'forging a Story', and imposing it on the world for truth' (quoted in McKillop, p. 9). 'Forging' still seems to carry some of its original sense of 'making', but it clearly has the pejorative connotation also. The formula applied perfectly to the appearance in the following year of *The Life and Strange Surprizing Adventures of Robinson Crusoe*. Nowhere do we find any hint that the work is fiction. Crusoe's story, 'written by himself', is presented as an edited document. The anonymous editor claims in the preface that he 'believes the thing to be a just history of fact; neither is there any appearance of fiction in it'. We may want to dismiss the statement as simple sham rhetoric. But as we have seen, such authenticating prefaces were a standard feature of travel literature of the day. Moreover *Robinson Crusoe* was based on the real adventures of the Scots mariner Alexander Selkirk. He had been abandoned on Juan Fernandez island from October 1704 to February 1709 (a much shorter time than Crusoe). He became well known on his return to England, and his story was soon published, though not in his own words. The first account was in Captain Woodes Rogers' *A Cruising Voyage Round the World* (1712) and the second, by Richard Steele, was published in *The Englishman* 26 (December

1713). There is a poignant irony here. Steele claimed his information came from Selkirk himself ('I had frequently conversed with him'). But Steele clearly used Rogers, even to the point of plagiarism. For instance:

> He was at first much pester'd with Cats and Rats ... the Rats gnaw'd his feet and Clothes while asleep.
>
> (Rogers)

> His Habitation was extremely pester'd with Rats, which gnaw'd his Cloaths and Feet when sleeping.
>
> (Steele)
> (*Robinson Crusoe*, 1965, p. 305, p. 309)

I do not propose to show how Defoe both plundered and embellished his sources. Crusoe is to a large extent Defoe's own creation. But as Ian Watt has said:

> *Robinson Crusoe* itself was widely regarded as authentic at the time of publication, and it is still not certain to what extent some of Defoe's works, such as *Memoirs of a Cavalier*, are fictitious or genuine.
>
> (Watt, p. 153)

A distinction must be made here between the 'authentic' and the 'genuine'. By the former Watt means that many contemporaries actually thought they were reading the words of a shipwrecked mariner. Authenticity is a matter of authorship. But 'genuine' I understand to mean 'historical'. That is, no one disputes that the work was composed by Defoe but he may, like a historical novelist, have used verifiable data, documented (though not necessarily true) sources. This distinction between external and internal determination of authenticity is very important. As will be shown in more detail below, authentic historiography had to satisfy both conditions. The most trustworthy account was held to be that of an eye-witness, with actual sensory experience of an event. Ideally such a record would be preserved in a manuscript, which was beginning at this time to acquire a hallowed status. Many of Defoe's novels take this form, which Ian Watt terms 'semi-historical' (Watt, p. 154). *Memoirs of a Cavalier* (1720) is prefaced by an elaborate account of how the manuscript has been transmitted down to the

present. More strikingly perhaps, the 'editor' of *Moll Flanders* (1722) admits that the version of Moll's words we are given is his own interpolated fabrication:

> It is true that the original of this Story is put into new Words, and the Style of the famous Lady we hear speak of is a little alter'd, particularly she is made to tell her own Tale in modester Words than what she told it at first.
> (Defoe, 1971, p. 1)

The extent to which editorial interference in an original text is an act of forgery was hotly debated later in the century, as we shall see. In Defoe's *Roxana* there is another admission of editorial appropriation, this time for 'dressing up the Story in worse Cloaths than the Lady, whose Words the editor speaks' (Defoe, 1976, p. 1).

Nevertheless, *Roxana*

> differs from most of the Modern Performances of this Kind ... in this Great and Essential Article, Namely, That the Foundation of This is laid in Truth of Fact; and so the Work is not a Story, but a History.
> (Defoe, 1976, p. 1)

Not a story but a history. Many forgeries are a brand of historical fiction. This issue will become dominant when we consider Macpherson and Chatterton. It is interesting to compare the different labels given to fiction in the early eighteenth century. Defoe referred to the 'honest cheat' of storytelling (Watt, p. 152) but also revealed his fears that 'telling a false story as true' was a 'brooding forgery' (quoted in Davis, p. 173). Defoe was echoed by Henry St. John, Viscount Bolingbroke, who in 1752 termed fiction an 'innocent fraud'. The fraud is 'innocent' because it is harmless and easily detectable. This dismissive view of the early novel is often wheeled out today. For instance Anthony Burgess remarks about Defoe's *Robinson Crusoe* (1719): 'Defoe keeps a straight face, but everybody knows it is a novel' (Defoe, 1972, p. 13). It is not certain this was the case with contemporary readers, who may not have had a clearly defined notion of a 'novel'.

Samuel Richardson's novels purported to be collections of letters arranged by an editor. The demand for documented empirical reporting was satisfied. *Clarissa* (1747) is even supposed to contain forged letters. That same year Richardson

attests to the ambiguous status of this fiction appearing as fact. He notes 'that kind of Historical Faith which Fiction itself is generally read with, tho' we know it to be Fiction' (quoted in McKillop, p. 54). Though this observation seems to anticipate the one by Anthony Burgess, the tug of history in Richardson's words implies more than the reader's willing suspension of disbelief. By the 1760s the coining of a label for the novel had modulated one stage further. Hugh Blair, Professor of Rhetoric and Belles Lettres at Edinburgh, referred to novels as 'fictitious histories' (Blair, 1783, Vol. II, p. 303; the lectures were delivered in the 1760s). If we allow 'history' to include events which have recently happened, it can be seen that the inconsistencies the early novel shares with *Description of Formosa* and supposed non-fictional writing revolve around this question of inauthentic history. Blair's term is itself an oxymoron: fiction cannot be history and history cannot be fiction. Yet we only have to turn to Defoe's *Journal of the Plague Year* (1722) to discover a superlative Psalmanazarian hoax.

When the plague broke out in London in 1665 Defoe was only five years old. His own memories of the event would hardly furnish a detailed account. So Defoe created 'H.F.', an older eye-witness. There has been considerable speculation about the identity of 'H.F.' A popular theory is that the character is based on Defoe's uncle Henry Foe. This may be the case, but the most important point to note is that Defoe wanted to create history from the inside. *Plague Year* is presented as 'observations or memorials ... written by a Citizen who continued all the while in London'. *Plague Year* is a historical document, fabricated historiography, historical fiction. Defoe used contemporary documents and accounts to gather information about the plague. Hence *Plague Year* is grounded in fact. But on an imaginative level within the story there is an exploration of what constitutes authentic history. 'H.F.' does not rely merely on memory. He enlists the aid of official documents and statistics: bills of mortality, City of London proclamations. Yet 'H.F.' is a wary historian. Neither empirical nor documented information is regarded blindly as the 'sole, true foundation' of history. We are told that the published bills of mortality were deliberately kept low to avoid panic. In other words they were forgeries, an act of 'knavery' (p. 27) and 'fraud' (p. 215). But 'received opinion' (p.

215) is also suspect. Stories passed on by word of mouth have a qualified reliability: 'very certain to be true; or very near the truth; that is to say, true in the general' (p. 71). Some reports, however, are 'more of tale than of truth' (p. 102). Historical fiction within the historical fiction. Defoe applies some checks and balances to contemporary formulas for authentic history. 'H.F.' is not averse to harsh revaluation. He observes wryly that physicians wrangled about the causes of one of the more bizarre features of the epidemic: 'the seeming propensity or a wicked inclination in those that were infected to infect others' (p. 167). 'H.F.' pulls the carpet from under the physicians' feet:

> I choose to give this grave debate a quite different turn, and answer it or resolve it all by saying that I do not grant the fact. On the contrary, I say that the thing is not really so, but that it was a general complaint raised by the people inhabiting the outlying villages against the citizens to justify, or at least excuse, those hardships and severities so much talked of, and in which both sides may be said to have injured one another ... neither of which were really true—that is to say, in the colours they were described in.
>
> (p. 168)

So the deranged acts of infection never really occurred, and such stories were again fraudulent. Defoe is aware that what constitutes a *fact* is as much to do with transmission or authentication as it is with *prima facie* plausibility or implausibility. Put another way, there is always a medium. The centrality of this point will become apparent as we deal with more forgeries. The issue highlighted will be the extent to which a work of art is aesthetically or technically determined. For instance, how does *Plague Year* qualify as a forgery?

The answer depends on the nature of the offence. A forgery has to infringe the rules which govern genuine art. In the early eighteenth century the codification of imaginative literature had not been settled. *Plague Year* is an act of deception: the work is by Defoe and not by 'H.F.'. This question of authorship I would term technical or external, and is to do with the marketing and presentation of the work. If *Plague Year* is a forgery in this external sense, then so are most of Defoe's novels. The other way in which *Plague Year* deceives is in its pretence to be true history, a genuine document. This is an internal matter, and is independent of authorship. The fact that we now know that

Plague Year is by Defoe may make the work genuinely his, but does not make it authentic historiography. I hope to show that forgery is most often externally determined, which means that the authority of a work of art is produced in the same way. The role that internal, aesthetic qualities then have to play becomes extremely interesting. Internal criteria are often forcibly mixed with external.

So the decision as to whether *Plague Year* is a forgery is ultimately one of convention. The value of a forgery is that it forces one to consider the conventions one is judging by. *Plague Year* both is and is not a forgery. It shares characteristics with Psalmanazar's *Description of Formosa*. That work was acknowledged to be a forgery, but it used the corrupt techniques common in other travel writing regarded as acceptable. *Plague Year* also disguised or concealed its true authorship. This was a standard feature of the early novel, and stands in striking contrast to the Copyright Act which had confirmed that a text was the property of the author. The next stage in our exploration of the early eighteenth-century's notions of authentic literary art must be to look at this fascinating legal intervention.

The Morals of Book-Making: Pope and Publishing

The first point to note about the Copyright Act is that it was designed to protect not the author but the publisher. The Act was aimed at curbing piracy. Publishers were losing money because unauthorised editions were swamping the market. According to Pat Rogers, for instance, Defoe's *The True Born Englishman* (1701) was pirated at least twelve times, running to some 80,000 copies (Rogers, p. 41). The Copyright Act protected an author's right for fourteen years (renewable) during his or her lifetime and thereafter for twenty-one years. In practice this meant an author sold a work to a publisher, who then had a monopoly on publication for the specified period. The author received one sum only for this sale. Profits of sale went to the publisher. It was only later in the century that royalties were introduced and an author's earnings could be damaged by piracy. So the Copyright Act was not designed to make the author

financially more independent. But the Act did require the fixing of the idea of intellectual property, of a text being owned by an author. This ownership was not itself a legal transaction. The author did not have to register or patent the creation. Such an act would only have to come after publication, when the text had become a book. Copyright relied on the essentially mystical link between the text and the author: one is parented by the other, and exists as an offspring.[1] This is a one-to-one relationship, not reproducible anywhere else. The text is a unique creation of a single mind. The term which summarises these facets of authentic authorship is originality. The creative act is inimitable; that is why it deserves to be enshrined in the law. The text is yours and yours alone. No one can, or should, copy your format. Only you, as the author, have the initial right to demand or barter for a price for the sale of the text. How this ideal bore up in practice is another matter. To start with, the Act did not even achieve its overt aims, since 'a large body of piratical dealing was left unaffected by this measure' (Rogers, p. 41). We shall be dealing with this contradiction shortly. Piracy attests to the growth of the book trade and literature as a commodity. A literary 'work' was the result of literary labour. But the rights over a product are rarely the worker's. Those rights are usually the employer's.

Defoe was keenly aware that in the new age of the professional author authority was more than ever with the publisher. In *Applebee's Journal* (1725) he presents a hard-headed economic view of the situation:

> The Booksellers are the Master Manufacturers or Employers. The several Writers, Authors, Copyers, Sub-writers, and all other Operators with pen and Ink are the workmen employed by the said Master Manufacturers.
>
> (Watt, p. 153)

This picture might send shivers down many spines. The image of the writer as an 'Operator with pen and Ink' smacks of utilitarianism and G.N.P. But Defoe is surely right to see the book-making process as a composite act. His model is, ironically, closer to medieval collaboration than it is to post-Renaissance worship of the individualised work of art. Though the Copyright Act actually combined the claims of both author and publisher to

a text, the Act did not offer a construct or image for this collaborative work of art. This may be a means of understanding why the early novelists preferred to be published anonymously. As operators on a literary production line, they felt no urgent need to sign a product which was also assembled by others. But collaboration was also an affront to the newly idealised, monolithic status of the single author. These antagonistic demands and the gap between precept and practice can be studied by turning, significantly, to the greatest poet of the early eighteenth century, Alexander Pope. He was both manipulator and victim of the confused and contradictory climate prevailing at the time.[2]

Between 1714 and 1726 Pope published by subscription enormously successful translations of Homer's epics *The Iliad* (1714–21) and *The Odyssey* (1725–26). He amassed around £11,000 in total, a vast amount by the standards of the day. His pre-eminence was established. On both projects Pope used assistants or collaborators. James Broome and William Fenton helped him throughout, and Thomas Parnell on *The Iliad*. These scholars helped gather the awesome bulk of historical and illustrative data that formed the notes to the text, and also to translate the original Greek. On neither score did Pope acknowledge their contribution, and he has been criticised for this shabby conduct ever since. Pope's Homer was popular with readers but attacked by scholars. To begin with doubts were expressed about Pope's knowledge of Greek, and accusations that he was relying heavily on both the text and notes of earlier translations. In other words, these passages were unoriginal and close to being plagiarism or literary theft, something we shall be dealing with later.

In his authoritative edition of Pope's Homer, Maynard Mack concludes that Pope did not always reveal his sources and 'showed off learning he did not have along with learning that was in fact his' (Pope, 1967, p. xli). Nor, it seems, did Pope reveal the precise part Broome and Fenton had to play. It is known that half of *The Odyssey* and portions of *The Iliad* are theirs, but the status of the remaining text is problematical. Broome and Fenton would make their translation and pass it on to Pope, who would then polish and amend it. The result is very much a 'mixed' text. But this is not how Pope chose to present it. In 1723, when he was finding subscribers for *The Odyssey*, Pope

wished to dissemble his collaborators' roles, urging the utmost 'secrecy' about the affair (Sherburn, p. 250). But news leaked out (possibly from Broome and Fenton: they were to receive £800, Pope £5,000). Pope's enemies were quick to launch offensives. They were determined to show that Pope's Homer was an act of literary deception, one of the first criteria of forgery. The *London Journal* for July 1725 accused Pope of having *The Odyssey* 'done by any *Hackney-Hands* for the sake of *Idleness*, and at length publishing it in his own *Name*' (Sherburn, p. 262). *Mist's Journal* in June 1728 levelled the same charge, reckoning Pope 'employed some *underlings* to perform what, according to his proposals, should come from his own hands' (Pope, 1975, p. 331). Pope tried to save face by persuading Broome to write an obsequious disclaimer which was appended to the notes to *The Odyssey*. After staking vague claims to parts of Books 6, 11 and 18 (and for Fenton Books 4 and 20) Broome surrenders all authority and aesthetic merit to Pope:

> If my performance has merit ... it is but just to attribute it to the judgement and care of Mr *Pope*, by whose hand every sheet was corrected ... It was our particular request, that our several parts might not be made known to the world till the end of it: And if they have the good fortune not to be distinguished from his, we ought to be the less vain, since the resemblance proceeds much less from our own diligence and study, to copy his manner, than from his own daily revisal and correction.
>
> (Sherburn, pp. 259–60)

The text is a collaborative document in the way a piece of news copy is, having been rewritten and authorised by a sub-editor. Yet while our view of art is dominated by the single artist the aesthetic merit of a 'mixed' text remains tenuous. Unless, that is, the different contributions are clearly 'distinguished', which is not always the case. George Sherburn puts the problem concisely without answering it:

> Pope's *Odyssey* raises classic problems in the morals of book-making, especially with regard to collaboration. From the point of view of the public the question rises, how explicitly must collaboration be announced?
>
> (p. 248)

Others have coped with this 'moral' dilemma by rejecting the text altogether. Charles Lamb found *The Odyssey* 'a confederate

jumble of Pope, Broome and Fenton which goes under Pope's name, and is far inferior to his ILIAD' (quoted in Pope, 1967, p. cxciv). Aesthetic value crumbles with authenticity. The 'confederate jumble' has still not been sorted out with certainty. Maynard Mack is less dismissive than Lamb. Mack also conflates artistic merit with authenticity, but only piecemeal. Pope is the greater writer, so the good parts of the poem are his, the worst parts are the collaborators'. Mack's assessment is based on extant manuscripts of sections of Fenton's original translation, which can then be compared to the final printed version. I want to borrow one of Mack's comparisons, not to pass judgement but to show the transition from single to mixed text:

> Yet all her blandishments too pow'rless prove,
> To banish from his breast his Country's love.
> Might the dear Isle in distant prospect rise,
> That view vouchsaf'd, let instant death surprize
> With ever-during shade his blissful eyes (Fenton)

> Successless all her soft caresses prove,
> To banish from his breast his Country's love;
> To see the smoke from his lov'd palace rise
> While the dear isle in distant prospect lyes,
> With what contentment could he close his eyes? (Pope)
> (*The Odyssey*, Book I, ll. 73–7; Pope, 1967, p. cxciv)

Should the printed version be called Pope's, or Pope-Fenton's? In the absence of manuscripts, the printed text must be 'self-evidencing' about its authenticity. Faced with this, many prefer to take Mack's way out and associate aesthetic value with originality. The converse must therefore also hold. But if an unacceptable artistic work like a forgery happens to be extremely good the strategy collapses or leads to desperate defensive measures. The confessions of several forgers, as we shall see later in the book, have been rejected because a forger is not thought capable of producing beauty. The most that Mack will concede to Pope's collaborator Broome is to say that 'at some point in Broome's own contributions to the *Odyssey* the combination of his skills with Pope's revisions ensures surprising success' (Pope, 1967, p. cci).

So the fusion of minds in the Pope's Homer broke the artistic code and qualified as a form of literary fabrication. On another

occasion the transgression was more direct, if not detected. To guard against piracy Pope supervised personally the publication of most of his work, including personal correspondence. In the case of his letters to Wycherley and Walsh, this control seems to have been abused. According to George Sherburn, Pope

> 'edited' frequently in such a fashion as really to fabricate letters that were never sent. Usually, to be sure, he fabricated from materials that had been sent, but he rearranged and combined in a fashion that throws doubt on all correspondence edited by him.
>
> (Sherburn, p. 51)

Yet this state of affairs is one of the absurdities implicit in the idea of an author's ownership of a text. At the other extreme is collaborative interference by publishers who bought the text, or other publishers who put economics above literary ethics. One paper called Pope's *Odyssey* 'Quackery and Curllicism in the greatest Perfection' (Sherburn, p. 264). 'Curllicism' refers to the notorious publisher Edmund Curll, with whom Pope had a long-running battle.[3] The details of this battle make picturesque reading, and open up further paradoxes.

Curll's career is in flagrant opposition to the ideals of the Copyright Act. It had defined the *authentic* as the *authorised*. In terms of books, an unauthorised printing is therefore a forgery. Curll thrived in apostasy. His biographer Ralph Straus has described the title pages of Curll's books as 'marvels of optimistic inaccuracy' (Straus, p. 6). (This issue will become particularly important in the next chapter when we look at the forgeries of Thomas James Wise). Iscariot Hackney, the anti-hero of Richard Savage's satire *An Author to be Lett* (1729), confesses that in Curll's service

> I wrote Obscenity and Profaneness, under the Names of Pope and Swift ... I abridged Histories and Travels, translated from the French, what they never wrote, and was expert at finding out new Titles for old Books.
>
> (Savage, 1729, pp. 3–4)

These are different shades of literary crime, but all the offences could be classed as forgery. In 1716 Curll published a volume with the innocuous title *Court Poems*. The provenance of the poems was serendipitously 'a Pocket-Book taken up in

Westminster Hall' (Sherburn, p. 167) and among the contributors was 'the Judicious Translator of Homer'. That could only refer to Pope, who was so outraged at the spurious paternity that he planned a physical rather than literary revenge. With the help of several friends he managed to drop an emetic into Curll's drink at one of London's many coffee-houses. Curll was promptly ill. Pope went home to write up all the lurid details in a colourfully titled pamphlet 'A Full and True Account of a Horrid and Barbarous Revenge by Poison on the Body of Mr Edmund Curll ... Publish'd by an Eye Witness'. In the mock narrative the dying Curll makes a retraction

> for those indirect Methods I have pursued in inventing new Titles to old Books, putting Authors' Names to Things they never saw
>
> (Straus, p. 56)

and various other iniquities. As might have been expected, Curll responded in print. He produced several scurrilous pamphlets, and spread word that the map of Troy in the second volume of Pope's *Iliad* had been stolen from Fuller's *Pisgah Sight* (1650). But Curll's most damaging assault was an aesthetic one. Somehow he obtained Pope's juvenile translation of the first psalm, and published it as *A Roman Catholic Version of the First Psalm; for the Use of a Young Lady*. Pope was so embarrassed by its inferior quality that he publicly disowned it in a statement in the *Evening Post*, 2 August 1716:

> Whereas there have been publish'd in my Name, certain scandalous Libels, which I hope no Person of Candor would have thought me capable of, I am sorry to find myself obliged to declare, that no Genuine Pieces of mine have been printed by any but Mr Tonson and Mr Lintot.
>
> (Sherburn, p. 181)

Pope's 'genuine' is a conflation of the authorised and the authentic. Note that his defensive posture is the one referred to above: what is good is authentic; what is bad is forged. Pope is using his authority to conceal authenticity. A decade later Curll delivered the same blow again. He published some of the young Pope's letters to his friend Mr. Cromwell. Pope's response came this time in the Variorum edition of *The Dunciad* (1729), which is a rich tableau of Pope's literary wars. This time Pope did not

disown the text, but stressed that it had been published without consent and that the letters were insignificant:

> very trivial things, full not only of levities, but of wrong judgements of men and books, and only excusable from the youth and inexperience of the writer.
>
> (Pope, 1975, p. 376)

Pope pilloried Curll as he did many other enemies by giving him a role in *The Dunciad*. In Book 2 Curll participates in the mock-epic games arranged by Queen Dulness to celebrate her coronation. Curll races after a 'phantom' poet, but like Ajax and Nisus before him, slips and falls into the 'plash'. Curll is called a 'Vaticide' (*Dunciad Variorum*, Book 2, l. 74) or poet-killer. Allegorically the episode represents Curll's attempt to seize possession of yet another poet, and possibly kill his reputation. Ironically this 'phantom' (Book 2, l. 46) is James Moore Smyth, who is a 'shapeless shade' (Book 2, l. 103) because he is a plagiarist, taking his identity from others. Pope believed that Smyth's play *The Rival Modes* had stolen five lines which originally appeared in the Pope-Swift *Miscellanies* (1727–28) (Pope, 1975, pp. 332–3, 373–4).

So Curll met his match. But in real life the unauthorised or 'surreptitious Editions' (Pope, 1975, p. 357) went on, and Pope's mock-pedantic editor Martin Scriblerus is at pains to point out their inaccuracies in the notes to the *Dunciad Variorum*. Scriblerus-Pope presents himself in the long preamble to the poem as the victim of a concerted effort by unscrupulous booksellers to discredit him. The tirade stands as a testimony to the vagaries of publishing in the years soon after the Copyright Act, and the difficulties of achieving the ideal of the authentic, untrammelled author-defined text:

> The loftiest heroics, the lowest ballads, treatises against the state or church, satyrs on lords and ladies, raillery on wits and authors, squabbles with booksellers, or even full and true accounts of monsters, poisons, and murders; of any hereof was there nothing so good, nothing so bad, which hath not at one or other season been to him ascribed. If it bore no author's name, then lay he concealed; if it did, he fathered it upon that author to be yet better concealed: If it resembled any of his styles, then was it evident; if it did not, then disguised he it on set purpose.
>
> (Pope, 1975, p. 342)

Pope could find no better way to end the *Dunciad Variorum* than by grandiloquently declaring the true canon of 'All our author's genuine works'. In a formal claim to the authorised version of the poem added in 1732 Pope forbade

> any person or persons whatsoever, to erase, reverse, put between hooks, or by any other means directly or indirectly change or mangle any of them.
>
> (1975, p. 459)

('Put between hooks' is a reference to a notorious edition (1732) of Milton's *Paradise Lost* by Richard Bentley, in which he put in brackets or 'hooks' passages which he believed were fake. This remarkable edition is dealt with below.) But the list of 'genuine' works is not as accurate as the text of the *Dunciad* is set out to be. For instance, Pope claims twelve books of *The Odyssey*, 'with some parts of other Books' and 'some *Spectators* and *Guardians*' (1975, p. 458). Again the authority of the work is being wrested by Pope away from authenticity to aesthetic merit. The list he produces contains those works he wishes to bequeath to posterity.

Pope died in 1744. A few years later an unknown Scot named William Lauder published in the *Gentleman's Magazine* a series of essays claiming that Milton was a plagiarist. It was subsequently revealed that in fact Lauder was the forger. This bizarre affair is our next concern. Pope's chequered relationship with book-making has been largely to do with the 'external' side of authenticity. With Lauder we now plunge back into the treacherous undercurrents of 'internal' or aesthetic matters.

Originality and Imitation: William Lauder and the Milton Controversy

Lauder's essays on Milton were collected and published exactly in mid-century under the title *An Essay on Milton's Use and Imitation of the Moderns, in his Paradise Lost* (1750). Though the title does not reveal it, Lauder's aim was to show that Milton's *use* of certain modern poets was unacceptable. The *Essay* begins only with the claim that Milton was influenced by Grotius, Masenius and other Renaissance poets who wrote in

Latin. Lauder intends his analysis to be iconoclastic, to shatter the bardolatrous idea that Milton was a law unto himself:

> Have not mankind, by giving too implicit a faith to this bold assertion [Milton's claim in *Paradise Lost* that he was engaged in 'things unattempted yet in prose or rhyme'] been deluded into a false opinion of Milton's being more an original author, than any poet ever was before him? And what but this opinion, and this only, has been the cause of that infinite tribute of veneration, that has been paid him these sixty years past?
>
> (Lauder, p. 74)

Samuel Johnson, whose opinion of Milton was certainly not bardolatrous, was persuaded by this salutary objective into writing a preface to Lauder's *Essay*, a cause of much embarrassment subsequently. Lauder's case rested squarely on comparing passages from *Paradise Lost* with translations from their supposed originals. The striking similarities could only be suspicious, raising eyebrows at Milton's procedure. Lauder becomes steadily more venomous as the proximity of the passages becomes more exact and damning. Milton is accused of 'industriously concealing' his sources (Lauder, p. 77), but later of 'rifling the treasures of others' and shining 'with a borrowed lustre, a surreptitious majesty' (pp. 156, 115). Milton like Pope of *The Odyssey* has 'only digested into order the thoughts of others' (p. 155). Compare Johnson's definition of a plagiary in the *Dictionary* (1755): 'A thief in literature; one who steals the thoughts or writings of another.' Actually only the latter strictly constitutes plagiarism and breach of copyright, but the former has run the gauntlet of being either imitation or lack of originality. This issue is opened up by Lauder's *Essay*.

Almost immediately Lauder was exposed as a charlatan. The next year the Reverend William Douglas published *Milton Vindicated from the Charge of Plagiarism*. Douglas applauded the attempt to show Milton's working methods, but regretted that Lauder had to resort to forgery to show Milton a forger. Lauder had not been citing 'Moderns' at all, but simply a Latin translation of *Paradise Lost* made by William Hog in 1690. Even these extracts had been tampered with. Worse still, Lauder had freely invented eight lines credited to Starphorstius, and had even interpolated the 'authentic' text of *Paradise Lost*. Milton was being accused of 'stealing from himself' (Douglas, 1751, p.

36). Lauder publicly confessed his guilt, but later indulged in further chicanery, claiming Milton forged passages in King Charles's *Eikon Basilike* in order to have the king accused of plagiarism (the *Eikon Basilike* is now widely regarded as a forgery, though not by Milton). Douglas countered with *Milton no Plagiary* (1756) and the controversy ended there. But the ramifications of this extraordinary case spread wider than Lauder's forgery. Lauder could attack Milton with the charge of plagiarism only because the idea of originality had achieved precedence. Yet that notion did not exclude imitation. In the mid eighteenth century imitation, with plagiarism at its extreme, was vying with originality to govern the genuine aesthetic product. Lauder's strange assault on Milton can be seen as a pressure point in this conflict.

The late seventeenth and early eighteenth century is often called the Augustan or neo-classical period, implying a great reverence for Greek and Latin authors (usually termed 'Ancients'). All educated people were expected to turn to the Ancients for models. Homer and his classical predecessors had a monopoly over invention and original ideas. As Johnson's fictional sage Imlac puts it in *Rasselas* (1759), the Ancients

> left nothing to those that followed them, but transcription of the same events, and new combinations of the same images. Whatever be the reason, it is commonly observed that the early writers are in possession of nature, and their followers of art.
>
> (*Rasselas*, 1976, p. 60)

'Art' is therefore a combinative or collaborative enterprise not unlike the medieval *auctor*'s work. But the ethics of staying too close to the source was a sore point. In the preface to *Annus Mirabilis* (1666) Dryden has no qualms about copying or uninventively updating Virgil:

> I have followed him everywhere, I know not with what success, but I am sure with diligence enough; my images are many of them copied from him, and the rest are imitations of him.
>
> (quoted in Sutherland, 1963, p. 134)

In fact by the early eighteenth century a peculiar genre known as the Imitation had established itself. Late flourishes of the form

are Johnson's *London* (1738) and *The Vanity of Human Wishes* (1749) which are imitations respectively of Juvenal's third and tenth satires. Johnson described the form in his *Life of Pope* (1778–79) as 'a kind of middle composition between translation and original design' (Johnson, 1975, p. 364). This may have been one compromise, but as James Sutherland observes 'the question of literary borrowing was one to which eighteenth-century poets and critics gave a good deal of thought' (Sutherland, p. 133). To show that you had used the Ancients (and some poets like Pope pointed out the parallels) could be an attempt to aggrandize the text. But it might also lessen its relation to yourself, and hence its authenticity. One Queen Anne poet used drastic bibliographical measures:

> To avoid the imputation of a plagiary, I have printed whatsoever I have taken from any English writer as far as my memory could go back, in a distinct character.
>
> (John Smith, *Poems upon Several Occasions*
> (1713); quoted in Sutherland, p. 135)

That is one way of fixing a collaborative text, but such a rigid binarism or demarcation is cumbersomely unsatisfactory. The young Pope preferred metaphorical musings rather than textual intervention. In a letter to Walsh in 1706 (which I trust we can rely on) he raises the question

> how far the liberty of borrowing may extend? ... writers, in the case of borrowing from others, are like trees, which of themselves would produce only one sort of fruit, but by being grafted upon others may yield variety. A mutual commerce makes poetry flourish; but then poets, like merchants, should repay with something of their own what they take from others; not, like pirates, make prize of all they meet.
>
> (Sutherland, p. 134)

The image of a 'mutual commerce' between living and dead artists is one that will recur. The detrimental idea of either acknowledged copying (imitation) or unacknowledged copying (plagiarism) is kept at bay. But if writers practised this flourishing and fertile co-operation, they were still wary of surrendering independence, or appropriating others'. In the 'Apology' to *Tale of a Tub* (1710) Swift declares ' I know nothing more contemptible in a Writer than the Character of a Plagiary'

(Swift, 1975, p. 7). This is the kind of animus behind Lauder's attack on Milton. It is no coincidence that in the same year Lauder's forgery was exposed Bishop Hurd published *A Discourse on Poetical Imitation*. Hurd strove to show that both Ancients ('miracles of early invention', p. 194) and Moderns drew on the same common stock of images from nature. Hence imitation in this sense is mimesis, an 'original copying' (p. 110) of the real world, which will inevitably lead to similarities of expression. Only when the evidence is overwhelming should one consider direct borrowing. Hurd's argument was summed up by Johnson in *Rambler* 143, written later the same year:

> As not every instance of similitude can be considered as a proof of imitation, so not every imitation ought to be stigmatized as plagiarism.

So this defence of imitation could easily have been inspired by Lauder's forgery. He tried to topple Milton from the pedestal of originality. Only a few years later another death blow was being delivered to imitation. Edward Young's *Conjectures on Original Composition* (1759) urged its readers to 'resemble' rather than 'copy' the Ancients (p. 26). He advises the writer to 'dive deep into thy bosom; learn the depth, extent, bias, and full sort of thy mind' (p. 53). There is no question of 'mutual commerce', only self-expression:

> An *original* may be said to be of *vegetable* nature; it rises spontaneously from the vital root of genius; it *grows*, it is not *made*: imitations are often a sort of manufacture wrought up by those mechanics, art, and labour, out of pre-existent materials not their own.
>
> (p. 12)

Young's words encapsulate the 'internal' complexion of authenticity that has now become current. An original work has a mystery and autonomy that is self-evident. The text is essentially Platonic and intangible. The idea of book-making is given the secondary status of imitation: Young's use of the verb *made* almost has the function of the root meaning of *forged* or *fabricated*. The wheel has turned full circle from Defoe's image of writers as 'Operators with Pen and Ink', which he was putting forward positively. Yet in the same year that Young's

Conjectures were published a countryman of William Lauder's named James Macpherson began to compose the most sensational literary forgery in English literature: Ossian. Ossian introduces radically new features into our discussion, for the forgery did not evolve from literary borrowing of any writer ancient or modern. Ossian confected its own authority, without needing to steal from another. In order to find an angle from which to approach Ossian, we need to return to two related issues: the manuscript and history.

Editorial Interference: Interpolation or Imposture?

It was mentioned in connection with the early novel that in the eighteenth century the manuscript attained a new authority. The literary document in its widest sense became the authentic foundation of knowledge. In terms of imaginative literature, as we shall see, a new scrupulosity to adhere to the original text was demanded of editors. The same standards were also required of historians. The 'voucher' or record became valued more than previous printed sources as being closer to actual experience. The means to check literary sources by archaeological or anthropological evidence was not yet available. The value of the literary source is attested to in 1735 by Pope's friend Viscount Bolingbroke. In his influential *Letters on the Study and Use of History* (published 1752) Bolingbroke complains that Herodotus the Greek historian 'had neither original records, nor any authentic memorials to guide him, and yet these are the sole foundations of true history' (p. 64). 'Original' here means ancient and unaltered. At the end of the seventeenth century the great philosopher John Locke made an ambiguous plea: 'I think nothing more valuable than the records of antiquity; I wish we had more of them, and more uncorrupted' (Locke, 1968, p. 412). At the same time as the manuscript was being revered its intimate involvement with forgery was apparent. The problem was twofold. Most ancient records had been tampered with. Moreover, the oldest records were often poetry, which by definition meant a degree of fiction and embellishment at the very source. The deist John Toland announced that 'truly ancient and unadulterated' records existed in Ireland, but they were

buried among 'greater numbers' of 'interpolated' and 'forg'd' manuscripts:

> the matter is certainly ready; there wants but will or skill for working of it; separating the Dross from the pure Ore, and distinguishing counterfeit from sterling coin.
>
> (Toland, 1740, p. 83)

Neither the skill nor necessarily the will existed.[4] William Warburton believed the new state of affairs was allowing back into culture the meddlings and distortions of the medieval scholars. Historians were using 'every Monkish Tale, and Lye, and Miracle, and Ballad' (Warburton, 1727, p. 64). The new spirit of authentication was achieving contrary results. Regarding very distant periods of national history historians had to confront the figure of the bard, the composer of the first records. Fiction and history coincided. Adam Smith noted 'the poets were the first historians ... the oldest original writings in Latin, Italian, French, English and Scots are all poets' (Smith, 1963, p. 100). Hugh Blair put the point more strongly: 'History appeared in no other form than that of poetical tales' (Blair, 1783, vol. II, p. 317). Historians found different ways of coping with this paradox. The Scot Thomas Innes accused the Irish bards of deliberate falsification. He called them 'forgers' and declared they 'left the spirit of imposture so deeply rooted in their posterity, that even Christianity could not correct it' (Innes, 1729, vol. II, p. 476). William Robertson rejected bardic sources altogether, only beginning his *History of Scotland* (1759) in the thirteenth century. The time before that was an abyss, 'an immense space ... left for invention to occupy' (Robertson, Vol. I, pp. 1–2), which could be a prophecy of Ossian. At the opposite extreme to Robertson was the heavily partisan Irishman, Geoffrey Keating. He authenticated his sources with a fascinating if outrageous indulgence in fantasy. In *The General History of Ireland* (1723) Keating depicts in lavish detail an ancient Irish college at Tara. Every three years the college scrutinised all the archives and purged the records of error. There could thus be no possibility of forged documents. The account is worth quoting at some length for its entertainment value and because it shows how self-conscious writers were about authentication:

> In this Assembly, the ancient Records and Chronicles of the Island were Perused and Examined; and if Falsehoods were detected, they were instantly Erased, that Posterity might not be imposed upon by False History; and the Author, who had the Insolence to abuse the World by his Relation, either by perverting Matters of Fact, and representing them in Improper Colours, or by Fancies and Inventions of his own, was solemnly Degraded from the Honour of sitting in that Assembly, and was dismissed with a Mark of Infamy upon him: His Works were likewise destroyed, as unworthy of Credit, and were not to be admitted into the Archives, or received among the Records of the Kingdom. Nor was this Expulsion the Whole of his Punishment, for he was liable to a Fine, or Imprisonment, or whatever Sentence the Justice of the Parliament thought proper to inflict. By these Methods, either out of Fear of Scandal or Disgrace, or of losing their Estate, their Pensions and Endowments, and of suffering perhaps some Corporal Correction, the Historians of those Ages were induced to be very exact in their Relations, and to transmit nothing to After Times, but what had passed this solemn Test and Examination, and was recommended by the Sanction and Authority of this Learned Assembly.
>
> (Vol. I, p. 67)

The possibility that this is state censorship is not raised. The authenticity of the text is in the hands of the authorities. Keating's Assembly may remind us of the Church's hold over the books of the Bible. Literary forgery is a cardinal offence, breaking more than unwritten cultural laws. Keating's piece of forged history is one imaginative intervention in the debate about the authenticity of historical sources. Macpherson and Chatterton followed suit.

If the purging hand in Keating's Assembly had been that of an individual rather than a state body that person could have himself been accused of subjective, covert or morally unacceptable interpolation. This was a problem for eighteenth-century editors and anthologists, both in what they saw in other editors and in what they did themselves. Authenticity was as pressing an issue for the literary historian as it had been for the historian. In the declaration at the end of the *Dunciad* Pope accused editors of 'clipping, coining, defacing the images, mixing their own base alloy, or otherwise falsifying the same; which they publish, utter, and bend as genuine' (Pope, 1975, p. 459). At this point we can mention Richard Bentley. In the 1690s he had been embroiled in a controversy about the authenticity of epistles of Phalaris and other Greek writers. Bentley argued with a massive display of classical erudition that the extant texts were

not original, but forgeries perpetrated by the Sophists, renowned for their 'Skill in Imitation' (Bentley, 1697, p. 9). Bentley is reported to have said 'it be the chief Province of a Critick to detect Forgeries' (Bentley, 1701, p. 90). He certainly relished this role when he came to edit Milton's *Paradise Lost* in 1732. He claimed the received text was 'vilely' corrupt and offered a specific reason. The fault lay with the amanuensis to whom Milton dictated the poem every day (Milton had become completely blind). This person had been very negligent in 'Overseeing' the text through the press. He 'did so vilely execute that Trust, that *Paradise* under his Ignorance and Audaciousness may be said to be *twice lost*' (Bentley, 1732, A$_1$ verso). It was Bentley's job therefore to regain paradise through his own 'Conjectures, that attempt a Restoration of the Genuine *Milton*.' These emendations were put in the margin so that the reader could choose between the versions. But there was a further level of corruption beyond printer's errors. The amanuensis thought fit 'to foist into the Book several of his own Verses, without the blind Poet's Discovery' (Bentley, 1732, A$_2$ verso). Hence the text contained many spurious passages. In the absence of a manuscript, however, Bentley admits it is only intuition or 'Sagacity' that leads him to identify these flaws. The forger's interpolations are italicised and bracketed, and Bentley adds comments in footnotes. It turns out that many of the anathematised passages are those elaborate and distinctive epic similes that embellish the poem. Bentley is repelled by these, and cannot accept that Milton was responsible. For instance, Bentley comments on one 'spurious' simile (*Paradise Lost*, Book I, ll. 579–87):

> Milton indeed in his Prose works tells us, That in his Youth he was a great Lover and Reader of Romances: but surely he had more Judgement in his old Age, than to clog and sully his Poem with such Romantic Trash, as even than when he wrote was obsolete and forgot. To stuff in here a heap of barbarous Words, without any Ornament or Poetical colouring, serving only to make his own Argument, which he takes from the Scripture, to be suppos'd equally Fabulous, would be such Pedantry, such a silly boast of useless Reading, as I will not charge him with: let his Acquaintance and Editor take it.
>
> (Bentley, 1732, p. 26)

Bentley's bizarre manoeuvre is one of the most striking

examples of the conflation of aesthetic value with authenticity related to a single author. Bentley invents a meretricious forger to excuse those parts of the poem Bentley would clearly like to expel altogether. Bentley's is yet another attempt to separate the 'Dross from the pure Ore', the 'counterfeit from sterling coin' as Toland put it. Bentley, like Keating, has had to resort to fiction. Samuel Johnson believed Bentley's 'supposition' to be 'rash and groundless if he thought it true, and vile and pernicious if, as is said, he in private allowed it to be false' (*Life of Milton* in Johnson, 1975, p. 99). If the latter detail is true, Bentley like Lauder after him used forgery to foist forgery into *Paradise Lost*.

Bentley's vagaries were not as anomalous as might at first be expected. Other highly respected figures got into trouble over textual authenticity. It is important to note that anthologists believed they were restoring history as well as literature. As Thomas Warton said, the best ancient poem contained 'features of the times' it was written in, 'preserving the most picturesque and expressive representations of manners' (Warton, 1774–81, Vol. I. pp. i–ii). Literary history was precisely that: history seen through literature. A poem need not describe historical events to be a record of social history. By osmosis it absorbed the 'manners' of the life around it. This historical authority was made all the stronger if the poem had an author. He or she could be regarded as an eye-witness producing the hallowed empirical date of history. Thomas Blackwell lauded the historical value of *The Iliad* by saying of Homer '*what* he felt and saw, *that* he described' (Blackwell, 1735, pp. 34–5). As we shall see, Macpherson and Chatterton reconstructed that situation for their imaginary authors.

Thomas Percy wished his *Reliques of Ancient English Poetry* (1765) to carry such authority. The foundation of the collection was an old folio manuscript which Percy had discovered at a friend's house. The poems on this manuscript, Percy claimed, were written by medieval minstrels, the successors of the bards. Hence the *Reliques* asserted their authenticity through historical authority. But Percy had to admit that the folio manuscript was damaged and had required restoration in places. Percy's interpolated passages, like Bentley's 'Conjectures', were supposed to be conspicious by being enclosed in inverted commas, but very few were. The ethics of collaboration modulates here into the

ethics of interpolation. Unacknowledged restoration can qualify as forgery. Percy's procedure raised the suspicions of the fiery editor Joseph Ritson. He had already denounced his fellow anthologist John Pinkerton for duplicitously adding to the infamous poem 'Hardyknute'. This ballad appeared in 1719 as a newly discovered ancient poem, though its authors were soon thought to be Lady Elizabeth Wardlaw and Sir John Bruce. The poem was published again in 1740 as a 'Fragment'. In *Scottish Tragic Ballads* (1781) Pinkerton claimed to have restored 'Hardyknute' to its 'original perfection', having obtained new stanzas orally from 'the memory of a lady in Lanarkshire' (p. xxxv). This shabby provenance outraged Ritson, who saw Pinkerton's version as forgery twice over: 'palpable and bungling forgery', 'studied and systematic forgery' (Ritson 1794, vol. I, pp. lxii, lxxvi). Ritson lambasted Scottish culture for being addicted to 'fraud, forgery, and imposture' (p. lxx) and likened Pinkerton to Lauder, Macpherson and David Chalmers (his *History of the Popes*, 1748–66, plagiarized the French historian Tillemont).

But Ritson was not merely concurring with Johnson's maxim that the Scots love Scotland better than truth. In *Ancient Songs* (1792) Ritson looked askance at Percy's *Reliques*. Ritson demanded an inspection of Percy's precious folio manuscript, which 'no other writer has ever pretended to have seen' (p. xix), a charge levelled constantly at Macpherson. Percy responded tentatively. In the fourth edition of the *Reliques* (1794) he published the manuscript version of 'The Marriage of Sir Gawaine', hoping to persuade his critics

how unfit for publication many of the pieces would have been, if all the blunders, corruptions, and nonsense of illiterate Reciters and Transcribers had been superstitiously retained, without some attempt to correct and amend them.

(1794, Vol. III, p. 350)

Ritson did not disagree with this editorial responsibility. But 'The Marriage of Sir Gawaine' only convinced him that Percy should have published all the originals and made his interpolated versions accountable. Without this means of discrimination, Percy's interventions are 'his own fabrications' (Ritson, 1802, Vol. I, p. cix). This was the light in which Macpherson was seen. Once Ritson had undermined the authenticity of the *Reliques*, its

historical authority came crashing down:

> The purchasers and perusers of such a collection are deceiv'd and impos'd upon; the pleasure they receive is deriv'd from the idea of antiquity which, in fact, is perfect illusion.
>
> (Ritson, 1802, Vol. I, p. cxli)

Historical fiction. Ritson's conclusion might be compared with one of Johnson's comments on Ossian:

> Had it really been an ancient work, a true specimen how men thought at the time, it would have been a curiosity of the first rate. As a modern production, it is nothing.
>
> (Boswell, 1924, p. 320–21)

I have ranged freely in this section to show how central an issue forgery was in the search for the authentic text. It is time now to turn to the contributions made to this debate by the two greatest forgers of the eighteenth century: James Macpherson and Thomas Chatterton.

Macpherson's Ossian

On 19 May 1763, after a night of 'high debauchery' at the Shakespeare's Head tavern in London, James Boswell recorded in his diary

> I breakfasted with Macpherson, who read me some of the Highland poems in the original ... I then went to Lord Eglinton's ... after having walked in Hyde Park with Macpherson, who was railing against the human species, and in vast discontent.
>
> (Boswell, 1974, p. 264)

The twenty-six-year-old fellow Scot Boswell refers to was James Macpherson. By then a considerable celebrity, he had come to London as the supposed editor of three very successful anthologies of ancient Gaelic verse: *Fragments of Ancient Poetry* (1760), *Fingal* (1762) and *Temora* (1763). All the poems were claimed to be the oral compositions of a Scottish bard named Ossian. From the beginning doubts were expressed about Ossian's authenticity, but not about his aesthetic merit. Ossian

·was soon to be the rave of Europe, an anodyne for young Werther, a pocketbook for Napoleon. Macpherson could not really lose out. If proved to be a forger he would be a very good poet; if not, an industrious editor. So the pose he presented to Boswell of malcontent and rebel had much bravado in it, as the next meeting of the two men makes clear:

> The Sublime Savage (as I call Macpherson) was very outrageous today, throwing out wild sallies against all established opinions. We were very merry.
>
> (Boswell, 1974, pp. 265–6)

But Ossian did challenge the 'established opinions' about art. The existence of an Homeric poet in fourth-century Scotland was to some a necessary if 'outrageous' fiction, to others a radical cultural discovery.

In early 1760 there appeared on the literary scene a slim anthology of fifteen prose-poems with the title *Fragments of Ancient Poetry, Collected in the Highlands of Scotland, and Translated from the Galic or Erse Language*. The editor-translator remained anonymous, though his identity was soon discovered. The preface to *Fragments* refused to comment on the 'poetical merit' of the pieces. Rather it stressed their authenticity, their composition in pagan Scotland probably by a prince named Ossian—'the last of the heroes'—who had also composed longer extant pieces, the existence of the (undated) manuscript which the editor was using, and finally the poems' historical value in shedding light on the dark ages. Macpherson anticipated the means by which 'legitimate' editors like Bishop Percy sought to give their poems authority. The *Fragments* were also mostly monologues in the present tense; voices from the past; first-hand rendering of historical experience. Macpherson even produced scholarly footnotes.

Two years later the format expanded lavishly with the promised Ossianic epic *Fingal*. The response to *Fragments* by the Edinburgh literati had been so enthusiastic that they financed Macpherson to tour the Highlands and rescue this Ossianic relic from oblivion. The sponsors were not disappointed. *Fingal* was hailed as a great national epic. Macpherson received £1,200 from his publishers. Thomas Gray

confessed Macpherson had 'lighted on a treasure hid for ages' (Gray, Vol. II, p. 680). This time Macpherson's name had appeared on the title page. *Fingal* contained fifteen shorter poems as well as the epic in six books, and an awesome 'external' apparatus of footnotes, dissertations and introductions. As far as anthologists were concerned Macpherson had effected a *coup de théâtre*. Michael Lort noted: 'Macpherson with his Galic poetry has set all the English antiquarians agog after the Welsh, in hopes to find something equal to it' (Lewis, 1957 p. vi). Bishop Percy did not think Ossian was genuine. But while *Fingal* was in the pipeline he remarked

> Macpherson goes on very successfully in picking up subscriptions, for his proposed translations of the antient Epick Poem in the Erse language: Tho' hardly one reader in ten believes the specimens already produced to be genuine—How much greater attention would be due to an editor, who rescues the original itself from oblivion.
>
> (Lewis, pp. 18–19)

So the original, authentic text is brought to the fore. When the second Ossianic epic, *Temora*, appeared in 1763, full-scale literary warfare broke out. At issue was the means of assessing an authentic text. Spurred on anew by Chatterton's forgery, the controversy was not to subside until the end of the century.

Most of the writers involved divided their approach into external and internal questions of authenticity. External matters involved provenance, and historical and biographical scrutiny. Internal matters were style, diction, versification and so on. Macpherson had actually initiated this binarism by authenticating the text with masses of historical information. It is not surprising that many of the responses to Ossian can be found in history books. In order to prove that Ossian was a Scot rather than the traditional Irish bard, Macpherson had to show that the Scots were the more ancient nation. Macpherson participated directly in a nationalist historiographical wrangle that had been going on for some time (we saw earlier Geoffrey Keating's contribution). The array of classical sources and pseudo-historical explication was sufficiently convincing for Edward Gibbon to cite Ossian in Chapter 1 of *Decline and Fall of the Roman Empire* (1776) ('according to every hypothesis' says Gibbon, the poems 'were composed by a native Caledonian'; Vol. I, p.i,

footnote 12). Macpherson knew the Irish Fenian poems. He ingeniously suggested that the setting of *Fingal* and *Temora* in Ireland had inspired the medieval Irish bards to appropriate Ossian's poems. The allusion was of course designed to buttress the authority of Macpherson's Ossian. As for the poems, Macpherson brilliantly if tediously captured the voice of the bard of oral times as it spoke: history in the making. It is as if we could eavesdrop on 'H.F.' at the time of the plague or be witness to his situation in 1722 as he looks back. Macpherson created the post-historian, spontaneously generating history from the inside. Ossian is also the last of his race, perched on the edge of the abyss of Christian time. The eschatology gave added poignancy to the historical drama of the poems:

> Such, Fingal! were thy words; but thy words I hear no more. Sightless I sit by thy tomb. I hear the wind in the wood; but no more I hear my friends. The cry of the hunter is over. The voice of war is ceased.
>
> (Macpherson, 1762, p. 40)

It must also be said that a similar abyss was opening up in Macpherson's day, as the English systematically destroyed Highland culture after 1745. Nowhere does Macpherson refer to the present day, however. Nor did he furnish the Ossianic world with more than the most basic props, exasperating the anachronism-hunting scholar.

For it must be remembered that the controversy was really a dating exercise: the poems were either ancient or modern, or a concealed mixture of both. As the poems were translations and Macpherson sat on the supposed originals there was little grist for the linguist's mill. Scholars floundered in speculation about what should have been included in an authentic ancient poem. Percy, for instance, declared the poems could not be genuine because there was no mention in them of wolves (an 'internal objection' raised on 7 April 1775, and reported by Boswell; 1970, p. 615). Henry Home, Lord Kames, was driven to the opposite conclusion:

> Can it be supposed, that a modern writer could be so constantly on his guard, as never to mention corn, nor cattle? ... a man of such talents inventing a historical fable, and laying the scene of action among savages in a hunter-state, would naturally frame a system of manners the best suited in

his opinion to that state. What then could tempt him to adopt a system of manners so opposite to any notion he could frame of savage manners? The absurdity is so gross, that we are forced, however reluctantly, to believe, that these manners are not fictitious, but in reality the manners of his country, colour perhaps, or a little heightened, according to the privilege of an epic poet.

<div align="right">(Home, 1763, Vol. I, pp. 283–4)</div>

Clearly the idea that the age of a poem could be determined by the period of history it presented was proving inadequate. Put another way, Ossian was pressing the possibility that a modern poet could actually create a meaningful vision of the past. This was an uncomfortable conclusion for many, who preferred to see only the original, ancient work and the modern imitation. T.P. Peardon has suggested that Ossian was an artful piece of historical fiction aimed at a Scottish audience who were 'emotionally predisposed to accept as historic a picture of the ancient Celts which was really manufactured to fit their mood' (Peardon, 1933, p. 111).

Ossian's world was felt by many to be anachronistic in exhibiting behaviour much too polite and refined for a barbarous pagan society. As Malcolm Laing said in his *History of Scotland* (1800):

nothing peculiar to the age is described; but the savage state is gratuit-ously invested with more than the generous gallantry of chivalry, the morals of Christianity, or the sentimental affectation of the present times.

<div align="right">(p. 396)</div>

In fact Macpherson wished Ossian's world to be an enlightened one. The mystery-mongering Druid priests had been banished. The leniency and romantic affections of the Fingalian warriors were responsible for their being placed by some above the heartless heroes of the Homeric epics. As a corrective to the widely-held dismissive view of the dark ages, Ossian anticipated Chatterton's medieval Bristol.

Laing's attack on the text was two-pronged. In his own edition of Macpherson's works (1805) Laing gave an exhaustive list of echoes of other poets in Ossian. He styled the poems 'a wild and wonderful assemblage of imitations' (Laing, 1805, Vol. I, p. 441). But this was shaky evidence. Macpherson (who died a rich man in 1796) could have claimed he brought in the echoes in translation, rather in the manner of an 'Imitation' in the style of

Pope and Johnson. Or he could refer back to Bishop Hurd's thesis that echoes did not mean copying but rather borrowing from the same source: nature. The 'imitations' Laing exults in could not of themselves make Ossian unoriginal. Macpherson had not stolen authority from any other writer. Ossian was a wholly imaginary poet who certainly unsettled the 'established opinions' about literary authenticity. The Highland Society of London commissioned a full-blooded inquiry into Ossian's authenticity which took thirty years to complete. Experts were consulted, interviews conducted with those who knew Macpherson and those who claimed to have heard or seen the original Gallic poems (Macpherson never yielded up the manuscript in his lifetime; a Gallic text with a Latin translation was published in 1807, but it has yet to be determined whether the Gallic is merely a translation of Macpherson's English). The eventual report concurred with what Johnson had said from the beginning. As he put it in *A Journey to the Western Islands* (1775), Macpherson 'may have translated some wandering ballads' but had embellished them (Johnson, 1924, p. 107). So Macpherson was no different to Percy, or indeed to most of the 'embellishers' we have looked at so far in this chapter. Except that the unqualified aesthetic success of Ossian (barring Johnson's remark that 'a man might write such stuff for ever, if he would *abandon* his mind to it' (Boswell, 1970, p. 1207)) seemed to have brought into question the need for authenticity.

The report of the Highland Society was published in 1805. That year Walter Scott summarised the position of Thomas Chatterton as 'the ambiguous reputation of an ingenious imposter' (Scott, 1834–71, Vol. 17, p. 241). Chatterton's forgery was also an aesthetic success (even winning over Dr. Johnson) and its repercussions were even more disturbing than Ossian.

Thomas Chatterton

Thomas Chatterton died of venereal disease in London in the summer of 1770 aged a meagre seventeen. He was a long way from his native Bristol both literally and artistically. Bristol's history was the inspiration for the stream of fake documents Chatterton produced in 1768 and 1769 which constitute his

forgery. Once he turned his back on Bristol to seek literary fame on Grub Street, Chatterton did not survive long. He was quickly immortalised as the archetypal Romantic genius destroyed by an uncaring society, Wordsworth's 'marvellous boy'. My interest in this undoubted prodigy however is to investigate further the challenge made by his forgery to contemporary notions of the authentic work of art.

There is little point in repeating the qualities Chatterton's forgery has in common with Ossian. The differences are many and illuminating. Macpherson published three volumes of Ossianic verse. Chatterton's historical vision comprised over a hundred unpublished items, and many genres and forms of discourse: poetry, prose, letters, diaries, proclamations, drama, treatises, drawings. These were supposedly written by medieval authors, and chiefly two fifteenth-century Bristolians: a poet-priest named Thomas Rowley; and his patron, the mayor William Canynge (both men really existed). Hence Chatterton's forgery has quite erroneously been labelled 'Rowleyan poetry'.

A large portion of the forgery is prose, much of it in a non-imaginative mode. Chatterton's diverse fabricated historical sources interconnect and intermesh to form a living past unmatched even by Defoe's *Plague Year*. Unlike Defoe Chatterton broke with all established conventions of literary form and went much further than Macpherson's prose-poetry. Ironically this convoluted art form was totally *original*, and has not been attempted since. Such a creation resists homogenous publication; it does not easily translate from manuscript to book. The chronological fashion in which Chatterton's forgery is published today may not have been the way he would have organised the material if, like Macpherson, he had been given a free hand. The forgery resists classification. Many early editions had to rely on a convenient 'etc.' in their titles to cope with the diversity of documents. Chatterton never sent off a completed manuscript to a publisher. The radical shape of the forgery would almost certainly have been rejected by 'established opinions' about art. Bits and pieces only found their way into print.

The source Chatterton gave for his precious relics was a lumber-room in Redcliff cathedral, the church at which his father had been sexton and from which genuine old documents

may have found their way into the Chatterton household. Unlikely as the story may seem now, it did not stop Dr. Johnson wheezing his way up flights of steps to view the famous chest in 1776. Unlike Macpherson, Chatterton did use palimpsests to create 'original' manuscripts instead of relying purely on supposed transcripts, though he produced those also. He tested his 'finds' out first on local historians and dignitaries and had a very small measure of success. Then he looked to the metropolis, but was spurned by Percy's publisher James Dodsley and, more famously, by the antiquarian and novelist Horace Walpole. Walpole is the villain of the Chatterton legend, but we shall return to him for more constructive reasons.

To brand the forgery as 'eccentric' will not help us. The forgery is an extreme example of art striving to be non-art. So many of the items of the forgery were built on genuine sources ('authorities') as to make it debatable whether they are historical fiction or historiography. Pieces such as 'The Rolle of Seyncte Bartlemeweis Priorie' or 'Heraldic Account of Bristol Artists and Writers' seem at first sight mere wilful displays of erudition. But they function within the historical vision as a whole, and cannot be dismissed. They challenge our notions of acceptable art. Even Chatterton's present-day editor and champion Donald Taylor cannot decide what authority should be given to many of the items, saying they 'exist in a kind of shadow ground between literature and imaginative history' and hence Chatterton 'must, therefore, be studied both as artist and as some kind of historian' (D.S. Taylor, 1978, p. 46). The categories, it is implied, are exclusive. Looking back to the eighteenth century, Chatterton, like Macpherson, sent shock waves through the literary citadel. This time, however, there was an abundance of linguistic and scholarly material to gnaw at, not merely historical theories.

The gauntlet he threw down to established notions of cultural history can be seen in a footnote to the first forged work 'Bristowe Tragedie' (Chatterton, 1971, Vol. I, p. 6). Chatterton's editorial note says the ballad is 'a Specimen of the Poetry of those Days, being greatly superior to what we have been taught to believe.' When he sent a sample of the major Rowleyan tragedy *Aella* to James Dodsley his cover note emphasised the corrective measures he wished to be applied to received opinion about the middle ages:

> The Motive that actuates me is ... to convince the World that the Monks
> (of whom some have so despicable an Opinion) were not such Blockheads
> as generally thought and that good Poetry might be wrote, in the dark days
> of Superstition as well as in these more inlightened Ages.
>
> (Chatterton, Vol I, p. 172)

It was precisely a 'despicable' view of monkish scholarship that
had fired the drive for the authentic historical artefact.
Chatterton reckoned the balance should now be redressed. His
forgery was a direct challenge to the facile linking of aesthetic
and historical progress. The public had their chance to read *Aella*
in Thomas Tyrwhitt's pioneering 1777 edition of Chatterton's
works. One year later the leading scholar and literary historian
Thomas Warton published the second volume of his *History of
English Poetry*, the first attempt to systematically show the
evolution of English verse from Chaucer.

Warton's approach to the Rowley poems (he ignored the
prose) expresses beautifully the ambiguous status of the forgery.
The poems are slotted into the fifteenth century, though
Warton's text declares itself doubtful of their authenticity. His
opposition stiffened later as criticism was levelled at the
credibility of his stance. He begins Section 8 by declaring that if
the poems prove genuine 'a want of genius will no longer be
imputed to this period of our poetical history' (p.139). Warton's
evidence to the contrary is flimsy. After much biographical detail
he notes

> above all, the cast of thought, the complexion of the sentiments, and the
> structure of the composition, evidently prove these pieces not ancient.
>
> (Warton, 1774–81, Vol. II, p. 156)

That does not mean the verse is bad, of course. Chatterton's
forged verse was aesthetically very successful, and Warton was
an admirer. But the consequences of this were painful in various
ways, not the least of which was that artistic merit was wrenched
free of authenticity. Warton's defensive manoeuvres reveal this
against his will. In order to show that ancient poetry is bad, and
that Chatterton-Rowley's is good and therefore cannot be
ancient, Warton boosts the authority of authenticity so as to
make merit irrelevant:

Antient remains of English poetry, unexpectedly discovered, and fortunately rescued from a long oblivion, are contemplated with a degree of fond enthusiasm: exclusive of any real or intrinsic excellence, they afford those pleasures, arising from the idea of antiquity, which deeply interest the imagination.

(Warton, 1777–81, Vol. II, 164)

This totemic inclination is a point we shall return to later. But the positive side of Warton's logic also had its problems. To attribute the poetry to Chatterton upset current ideas about the nurturing of poetic genius that took many years to complete. As Johnson admitted: 'This is the most extraordinary young man that has encountered my knowledge. It is wonderful how the whelp has written such things' (Boswell, 1970, p. 752). Warton's accolade was even more stirring. Had Chatterton lived he 'would have proved the first of English poets' (Warton, 1774–81, Vol. II, p. 157). The sword cut both ways. The cultural dilemma was summed up in *The Critical Review* for June 1782, the *annus mirabilis* of the Chatterton controversy:

If … we consider these poems as the work of a priest of the fifteenth century, we shall view, with admiration, our language advancing, with unexampled rapidity, to a degree of purity and elegance, which has been usually considered as the work of ages—the effect of repeated attention and continued labour. If they are the production of a charity-boy of the eighteenth century,—of a little learning and few opportunities of acquiring knowledge—we shall be astonished at the genius which could suggest the attempt, and admire the abilities which enabled him to execute it with so much success.

(p. 402)

The same year Warton confessed in his *Enquiry into the Authenticity of the Poems attributed to Thomas Rowley* 'the Bristol Chest has become the box of Pandora to the critical world' (1782, p. 6). Indeed literary authority was stretched to its full in that year. Jacob Bryant and Jeremiah Milles produced massive tomes to authenticate the poems. Their erudition was essentially a *fait accompli*: the 'charity-boy' could not possibly warrant such scholarship. As Bryant said, 'it is repugnant to nature and contrary to all experience' (1781, p. 502). Opposing Bryant were Warton, Edmond Malone and Thomas Tyrwhitt. Warton makes the most far-reaching statements. the threat to

'established opinions' posed by Chatterton's forgery is nothing less than apocalyptic:

> Insignificant as it may seem, the determination of these questions affects the great lines of the history of poetry, and even of general literature. If it should at last be decided, that these poems were really written so early as the reign of king Edward the fourth, the entire system that has hitherto been framed concerning the progression of poetical composition, and every theory that has been established on the gradual improvement of taste, style, and language, will be shaken and disarranged.
>
> (Warton, 1782, pp. 7–8)

The fate of literary studies hung in the balance. They did not collapse, but that does not mean the shock given to the nervous sytem was not salutary. It took in fact well into the nineteenth century before Skeat laid to rest the fiction of Thomas Rowley.

Another fascinating document to appear in 1782 was a long letter to the *Gentleman's Magazine* written by Horace Walpole. The controversy like a vortex sucked in literary doyens against their will. Walpole was famous as a dilettante antiquarian and Gothic novelist: *The Castle of Otranto* (1764) was virtually the first novel of its kind. The second edition of his *Anecdotes of Painting in England* appeared in 1767. Chatterton read it closely, saw there was a gap in Walpole's knowledge of Saxon art, and promptly despatched to him a 'Saxon' manuscript 'The Ryse of Peynceteynge, yn Englande, wroten bie T. Rowlie. 1469 for Mastre Canynge'. This piece of opportunism was initially very successful. Walpole was impressed and grateful. Rashly Chatterton sent off another manuscript. This was stretching things too far. Walpole sought help to verify the pieces, and soon rejected them. For Chatterton supporters in the later part of the century this act secured Walpole's place in the hall of literary infamy. Walpole was effectively credited with Chatterton's death (the idea that Chatterton did not commit suicide but died of venereal disease is a very recent correction to the Chatterton legend). Chatterton himself wrote a bitter poem to Walpole which was never posted. Its most interesting comment is a literary one:

> thou mayst call me Cheat—
> Say, didst thou ne'er indulge in such Deceit?

Who wrote Otranto?

(Chatterton, 1971, Vol. I, p. 341)

The Castle of Otranto had appeared as a supposed translation of an Italian black-letter manuscript dated 1529 and discovered 'in the library of an ancient catholic family in the north of England' (Fairclough, 1972, p. 39).

So it was inevitable that as the controversy raged after Chatterton's death Walpole was called to vindicate his name. His first response was published privately in 1779, and hardly satisfied public demand. So in 1782 he allowed the text to be published in the *Gentleman's Magazine*. The terms in which he defends his actions are very interesting. He makes the issue grave and portentous by linking literary forgery to forgery in general. For much of the time he erodes the boundary between art and non-art, and frames Chatterton's offence as a crime:

> If a banker to whom a forged note should be presented, should refuse to accept it, and the ingenious fabricator should afterwards fall a victim to his own slight of hand, would you accuse the poor banker to the public, and urge that his caution had deprived the world of some suppositious deed of settlement, that would have deceived the whole court of chancery, and deprived some great family of its estate?
>
> (*Gentleman's Magazine* Vol. LII, 1782, pp. 191–2)

Walpole did his public duty and protected property. It is surely no coincidence that literary forgery burgeoned at a time when the commercialisation of art and society was well under way. As Roy Porter says trenchantly:

> The law was being brought increasingly into line with the needs of new forms of property and securities in a sophisticated capitalist economy ... fresh forgery and counterfeiting statutes were brought in to protect currency and credit ... two thirds of those found guilty of forgery were actually executed.
>
> (Porter, 1982, p. 151)

One of those unfortunates, as we shall see in a moment, was a friend of Dr. Johnson. The threat posed by forgery to the capitalist system is summed up by Porter: 'Coiners and forgers were shown no mercy, for they betrayed the system of credit from top to toe' (p. 152). This is the context of copyrighted art:

intellectual property. Walpole's contextualising testifies to this new status of art at the same time as he attempts to tread warily:

> I do not mean to use the term forged in a harsh sense. I speak of Chatterton's mintage, as forgeries of poems in ancient language.
>
> (p. 192)

But as was pointed out in Chapter 1, a forged work of art has little if any legal definition. So when he wishes to speak of litigation, again Walpole has to apply an analogy to coining:

> Yet the cause of Rowley's poems would not last half an hour in a court of law. If Chatterton had pretended to find a hoard of crown-pieces, but stamped with the face and titles of Edward IV, and if it were proved that he coined half of them, would a jury doubt a moment but that he had coined the other half?
>
> (p. 194)

The confrontation between matters of artistic authenticity and social and legal authority is only too apparent. Walpole does not have the vocabulary for artistic jurisprudence, so he refers to the legal process which could not actually be applied. This ambiguity was manifested by Boswell and Johnson with regard to Ossian. While on their Highland tour in 1773 the pair had many skirmishes with pro-Ossian Scots. While at Dunvegan Castle in September the preacher Macqueen recited some verses in Gallic he claimed were the original of Macpherson's text. When pressed by Johnson, however, he back-pedalled considerably. Boswell comments on this 'shuffling': 'I said if Macpherson was capitally tried for forgery, two such witnesses would hang him' (Boswell, 1963, p. 206; these details are lacking in R.W. Chapman's edition). Johnson was delighted: "'I should like to see Mr. Macpherson examined in one of our courts of justice about Ossian'". For published comments such as these Johnson was threatened with violence by Macpherson—an act which, if it had been carried out, could have sent Macpherson to prison. But we have to wait until the nineteenth and twentieth centuries before art forgers are put on trial, the most spectacular case being that of the Dutch painter Hans van Meegeren. Johnson produced another hypothetical court case a few weeks later:

Why is not the original deposited in some public library, instead of exhibiting attestations of its existence? Suppose there were a question in a court of justice whether a man be dead or alive. You aver he is alive, and you bring fifty witnesses to swear it; I answer, 'Why do you not produce the man?'

(Boswell, 1963, p. 380).

Johnson had good reason to be worried by forgery. Four years later his friend Dr. William Dodd was executed for forging a banknote. Johnson tried desperately to secure a pardon, though he could not reduce the 'enormity' of the crime and the 'danger of its example' (Boswell, 1970, p. 831). Recording this painful event, Boswell calls Dodd's offence 'the most dangerous crime in a commercial country' (p. 828). These sentiments are behind Walpole's most strident remarks: to have supported Chatterton

would have encouraged a propensity to forgery, which is not the talent most wanting culture in the present age. All the house of forgery are relations; and though it is just to Chatterton's memory to say, that his poverty never made him claim kindred with the richest, or most enriching branches, yet his ingenuity in counterfeiting styles, and, I believe hands, might easily have led him to those more facile imitations of prose, promissory notes.

(p. 194)

Once again, however, Walpole follows up this denunciation with some 'shuffling'. Despite 'all the house of forgery' being 'relations' the artistic members are less party to 'the most dangerous crime' than others:

Yet it does not appear to my knowledge that his honesty in that respect was ever perverted. He made no scruple of extending the circulation of literary credit, and of bamboozling the misers of Saxon riches; but he never attempted to defraud, cheat, rob, unpoetically ... though I had no doubt of his impositions, such a spirit of poetry breathed in his coinage, as interested me for him: nor was it a grave crime in a young bard to have forged false notes of hand that were to pass current only in the parish of Parnassus.

(p. 248)

The patronising note is just as defensive as the previous imperiousness. An extension of 'literary credit' should not be taken as a serious threat, especially if the author happens to be good.

There is an apt irony with which to end the discussion of Chatterton. In one of his fake antiquarian tracts he cites as a source the Roman-British topography of a fourteenth-century monk, Richard of Cirencester. Documents attributed to him which showed Roman Britain to be far more populated than was previously known had appeared in the 1750s, and had been authenticated by the famous antiquary William Stukeley. In 1866–67 Richard of Circencester was shown to be the fabrication of one Charles Julius Bertram.[5] Whether Chatterton knew this or not cannot be proved. Bertram has often been regarded like Chatterton as a prodigy. Henry Bradley in the *Dictionary of National Biography* (1885), for instance, styles Bertram 'the cleverest and most successful literary impostor of modern times.' Bertram provokes that peculiar mixture of reverence and revulsion afforded to the forger. His 'ingenuity and learning' were 'really extraordinary':

> Bertram's antiquarian information, moreover, was, on the whole, quite on a level with the best knowledge of his time. The spurious treatise, therefore, was eagerly accepted by most of the English antiquaries as an invaluable source on the Roman geography of Britain; and the injury which the forgery has inflicted on this study can scarcely be overestimated.
>
> (*Dictionary of National Biography* (1885), Vol. IV, pp. 412–13)

The opposite conclusion has often been drawn, as we shall see.

W.H. Ireland's Shakespeare Fabrications

At one point in the *Life of Johnson* (1791) Boswell lists several examples of 'literary fraud' (1970, p. 254). All are kinds of literary appropriation, not so much plagiarism as wholesale theft of a text: Richard Rolt claiming the Irish edition of Akenside's *Pleasures of the Imagination*; 'Mr. Innes' Dr. Campbell's *An Enquiry into the original of Moral Virtue*; Mr. Eccles Henry Mackenzie's *The Man of Feeling*. Despite the copyright laws Boswell reckons 'this kind of fraud to be very easily practised with successful effrontery' (p. 255). His reason is seminal:

> The *Filiation* of a literary performance is difficult of proof; seldom is there any witness present at its birth.
>
> (p. 255)

The notion of authorship which is the basis of the 'authentic' text is actually its greatest defect. The witnessing of the birth of a text is a purely external matter, and lacking such evidence there is little currency in the text affiliating itself: there is no 'self-evidencing light', no inimitable hallmarks:

> A man, either in confidence or by improper means, obtains possession of a copy of it in manuscript, and boldly publishes it as his own. The true author, in many cases, may not be able to make his title clear.
>
> (p. 255)

This puts the images of paternity presented early in this chapter in an interesting light. One exception to the rule, needless to say, is Dr. Johnson, who

> from the peculiar features of his literary offspring, might bid defiance to any attempt to appropriate them to others.
>
> (p. 255)

This point is reinforced by a quotation (from the preface to Dryden's version of *The Tempest* (1667)):

> 'But Shakespeare's magick could not copied be,
> Within that circle none durst walk but he!'

The choice of quotation could not have been more ironic. Only four years after writing these words Boswell was to go down on his knees before the forged Shakespeare manuscripts of a young man named William Henry Ireland, claiming them as invaluable relics. Another irony can also be noted. Dr. Johnson has had a contribution to make to most of the examples looked at in this chapter. But he had his own skeletons to hide. Like Chatterton, the young Johnson came to London seeking employment if not literary fame. He secured a post (1737–41) with the newly-formed *Gentleman's Magazine* as one of the first parliamentary reporters. That at least was his professional title. As one of Defoe's 'Operators with Pen and Ink' the demands of professionalism forced him into expediency. Johnson was supposed to receive notes of the parliamentary speeches from others and correct and polish them, producing an 'enriched' text (Boswell, 1970, p. 85) rather like Pope's Homer:

Sometimes, however, as he himself told me, he had nothing more communicated to him than the names of the several speakers, and the part which they had taken in the debate.

(Boswell, 1970, p. 85)

Enrichment has become forgery. Though Boswell does not use the phrase, he records Johnson's retraction:

a short time before his death he expressed a regret for his having been the author of fictions, which had passed for realities.

(Boswell, 1970, p. 110)

The words echo the *Read's Journal* description of Defoe as 'forging a Story, and imposing it on the World for Truth.'

Johnson did not live to witness the W.H. Ireland farrago. The son of a feckless bibliophile father Samuel Ireland, William Henry was a self-styled disciple of Chatterton. He was an attorney's apprentice and a lover of ancient documents, both Chattertonian qualities. Ireland recorded his sense of destiny in his *Confessions* (1805): 'I used to envy his fate, and desire nothing so ardently as the termination of my existence in a similar cause' (p. 11). One would not have thought such adolescent romanticism would come to much, but Ireland did have a meteoric success. He chose to plug the greatest gap in literary studies: Shakespeare manuscripts. He obeyed and undermined the new rigorous standards of literary editing and scholarship for which the original manuscript was acquiring sacred status. Following Chatterton, he produced a stream of diverse documents, some by Shakespeare (including two new plays and many amendments) and others written to him. All were written in antiquated hand on palimpsests. The documents included correspondence both formal and intimate, deeds of employment, deeds of trust and gift—almost, but not quite, Shakespeare's laundry-list.

Ireland's father was so supportive of the authenticity of the find that he was suspected of being in collusion with his son. Ireland the elder published the documents in facsimile in 1796 under the title *Miscellaneous Papers and Legal Instruments under the Hand and Seal of William Shakespeare: Including the Tragedy of King Lear and a small fragment of Hamlet, from the original MSS in the possession of Samuel Ireland of Norfolk*

Street. The literary world, which was still reeling from the Ossian and Chatterton controversies, was knocked off-balance again. The Norfolk Street house became something of a shrine. According to William Henry, Boswell knelt before a batch of manuscripts crying '"I now kiss the invaluable relics of our bard: and thanks to God that I have lived to see them!"' (Ireland, 1805, p. 96).

Scholars rallied round the cause, but Edmond Malone effectively signed Ireland's death-warrant with his *Inquiry into the Authenticity of Certain Miscellaneous Papers and Legal Instruments* (1796). The attack was timed to coincide with the one and only production of one of the 'undiscovered' plays *Vortigern and Rowena* at Drury Lane. The performance turned into a farce when David Garrick, an unwilling member of the cast, overemphasised one of his lines: 'And when this solemn mockery is ended'. *Vortigern* and *Henry II* (the other new play) went the way of Lewis Theobald's *Double Falshood* (1728), an earlier forgotten attempt to produce a convincing Shakespeare pastiche. Ireland's effort was feeble and dull. He came nowhere near Macpherson and Chatterton in aesthetic terms, and that is one reason why his forgery can be easily dismissed. Take for example an extract of the 'original' manuscript text of *King Lear*, very different from any of the received printed versions. Kent's lines near the end of the play, 'I have a journey, sir, shortly to go:/My master calls, and I must not say no' are 'restored' to

> Thanks, sir: but I go to that unknown land
> That chains each pilgrim fast within its soil;
> By living man most shunn'd, most dreaded.
> Still my good master this same journey took:
> He calls me; I am content, and straight obey:
> Then farewell world! the busy scene is done:
> Kent liv'd most true, Kent dies most like a man.
>
> (quoted in Ireland, 1805, pp. 117–18)

Such stuff could hardly pass for Shakespeare. In the documents, however, Ireland seemed more at home. The Chattertonian effect of a living past is produced with some success as one hears Shakespeare's own voice in varying roles. Moreover it should not be declared impossible that Ireland had a satirical purpose in

mind: to expose the bardolatrous obsession of Shakespeare lovers and scholars with banal details of the bard's life. A parody of the documents, published in the *Telegraph*, struck this tone:

> Tooo Misteerree Benjaamminnee Joohnnssonn
> DEEREE SIREE,
> Wille youe doee meee theeee favvouree too dinnee wythee meee onnn Friddaye nexte att twoo off theee clockee too eatee sommee muttonne choppes andd somme poottaattooeesse.
>
> <div align="right">(quoted in Mair, 1938, p. 62)</div>

Not only the orthography is being satirised. Many of the Ireland-Shakespeare documents seem to be deliberately over the top. The most famous example is an account in Shakespeare's own words of how one of Ireland's ancestors saved him from drowning in the Thames. As a reward Shakespeare gave 'William Henrye Irelande' a lifelong friendship and the manuscripts of *Henry IV*, *King John*, *King Lear* and *Henry III*, all of which Ireland's descendant in the eighteenth century could lay claim to. The account is hilarious:

> onne or abowte the thyrde daye of the laste monethe beyng the monethe of Auguste havynge withe mye goode freynde Masterre William Henrye Irelande and otherres taene boate neare untowe myne house afowresayde wee dydd purpose goynge upp Thames butt those thatte were soe toe conducte us beynnge muche toe merrye throughe Lyquorre theye dydd upsette oure afowresayde boate baynge alle butte myeselfe savedde themselves bie swimmyng for thought the Waterre was deepe yette owre beynge close nygh toe shore made itt lyttel diffyculte for themm knowinge the fowresayde Arte Masterre William Henrye Irelande notte seeynge mee dydd aske for mee butte oune of the Companye dydd answerre thatte I was drownynge onn the whyche hee pulled off hys Jerrekyne and jumedd inn afterre mee withe muche paynes he draggedd mee forthe I beynge then nearlye deade and soe he dydd save mye life and for the whyche Service I doe herebye give him as followithe!!! fyrste mye written Playe of Henrye fourthe Henrye fythe King John King Leare as allsoe mye written Playe never yett impryntedd whych I have named Kyng henrye thyrde of England.
>
> <div align="right">(Ireland, 1796, q$_2$ verso)</div>

Ireland had not discovered stream-of-consciousness a century early. The account earned from Edmond Malone the comment 'a very pretty story, and almost as interesting as some of our modern novels' (*Inquiry*, p. 213). Fiction masquerading as fact again.

Ireland confessed his mischief soon after Malone's *Inquiry* was published. In confessing his crime he followed the example of George Psalmanazar. The eighteenth century closed as it had opened with a celebrated literary forgery.

Rather than attempt to summarise the many issues about authentic art that have been raised in this chapter I want to quote two opinions on the period, one modern, one contemporary. The first is René Wellek in *Theory of Literature* (1949):

> In the history of literature, the question of the authenticity of forgeries or pious frauds has played an important role and has given valuable impetus to further investigations. Thus the controversy about Macpherson's *Ossian* stimulated the study of Gaelic folk poetry, the controversy around Chatterton led to an intensified study of English medieval history and literature, and the Ireland forgeries of Shakespeare plays and documents led to debates about Shakespeare and the history of the Elizabethan stage.
> (Wellek and Warren, 1963, p. 67)

A good forgery is like a shot of adrenalin in the bloodstream of culture. The second opinion comes from the *Gentleman's Magazine* for August 1777, the year the first edition of Chatterton's works was published. The writer signs himself 'A Detestor of Literary Imposition, but a Lover of Good Poetry':

> Whatever may be thought of the *author*, I cannot see any reason to depreciate the work. 'If the pieces are modern,' it has been hinted, 'they are of little value.' I must own, I am of a contrary opinion. Whether a poem was written three centuries ago, by a Romish priest, in real old English, or seven years ago, in fictitious old English, by a lawyer's clerk, surely, cannot either enhance or diminish its merit, considered merely as a poem ... the constituents of a poem are, bold images, pathetic sentiment, natural description, and musical language.

This is a radical uncoupling of authenticity from authorship. Similar views will be found in the letters columns of *The Times* almost two hundred years later in relation to the Tom Keating affair. But there is no such thing as 'merely a poem', as the writer in fact shows. Addressing forgery forces the writer to reveal the rules being used.

Notes

1. In *Tom Jones* Book XI. Chapter 1 Fielding refers to books as 'the author's offspring, and indeed ... the child of his brain' (Fielding, p. 506). Swift gives the idea a twist in 'On Poetry: A Rhapsody' (1733), where the newly-born poem is styled 'The Product of your Toil and Sweating;/A bastard of your own begetting' (ll. 115–16; Swift, 1967, p. 572). If we take into account the threat to capitalist economics posed by bastardy (Johnson remarked that the 'chastity of women' was 'of the utmost importance, as all property demands upon it' (Boswell, 1970, p. 702)) an observation by Boswell about Ossian gives further twist to the idea of the poem-child:

 > Antiquaries, and admirers of the work, may complain, that they are in a situation similar to that of the unhappy gentleman whose wife informed him, on her death-bed, that one of their reputed children was not his; and, when he eagerly begged her to declare which of them it was, she answered, '*That* you shall never know;' and expired, leaving him in irremediable doubt as to them all.
 >
 > (Boswell, 1924, p. 423).

2. The year Pope completed *The Odyssey* Swift wrote 'Advice to the Grub-street Verse Writers' (1726) which expresses wittily the vagaries of the new age of the professional author:

 > Ye Poets ragged and forlorn,
 > Down from your Garrets haste,
 > Ye Rhimers, dead as soon as born,
 > Not yet consign'd to Paste;
 >
 > I know a Trick to make you thrive;
 > O, 'tis a quaint Device:
 > Your still-born Poems shall revive,
 > And scorn to wrap up Spice.
 >
 > Get all your Verses printed fair,
 > Then, let them well br dry'd;
 > And, *Curl* must have a special Care
 > To leave the Margin wide.
 >
 > Lend these to Paper-sparing *Pope*;
 > And, when he sits to write,
 > No Letter with an *Envelope*
 > Could give him more Delight.

> When *Pope* has fill'd the Margins round,
> Why, then recall your Loan;
> Sell them to *Curl* for Fifty Pound,
> And swear they are your own.
>
> (Swift, 1967, pp. 309–10)

For Edmund Curll, see later in this chapter.

3. Pope was not the only one. Swift's 'Verses on the Death of Dr Swift' (1731) contains a blistering attack on Curll. One footnote contains the following vignette:

> Curl hath been the most infamous Bookseller of any Age or Country: His Character in Part may be found in Mr. Pope's *Dunciad*. He published three Volumes all charged on the Dean, who never writ three Pages of them: He hath been used many of the Dean's Friends in almost as vile a Manner.... He hath in Custody of the House of Lords for publishing or forging the Letters of many Peers.
>
> (Swift, 1967, p. 503)

4. In his *Dictionary* (1697) Pierre Bayle called for the passing of a Law of Authentication which for historiography would 'serve as a hook to separate one from the other, truth from falshood' (entry for 'Nidhard'; quoted in Lennard J. Davis, *Factual Fictions*, 1983, p. 37). As I show later in the chapter, Geoffrey Keating gave such a law to early Irish culture in his *General History of Ireland* (1723).

5. One accepted taste in fake antiquity in the eighteenth century was the fake ruin, which Spengler has called 'the most astonishing bizarrerie ever perpetrated' (*Decline of the West*, 1926, Vol. I, p. 254). Pope and Lord Bathurst built between 1721 and 1734 'Alfred's Hall', a mock-castle in Oakley Wood, Cirencester. The ruin was mocked in 'On Lord Bathurst's Park and Wood' (1747) by Edward Stephens ('This pile the marks of rolling cen'tries wears,/Sunk to decay,—and built scarce twenty years') and held in disdain by John Byng, Lord Torrington: 'It is called Alfred's Cave (why I know not) and there is an intention of deceit by old dates' (quoted in Brownell, 1978, p. 274).

an even more objectionable procedure which seems to have been much practised in recent times since the cult of collecting first issues of modern authors found so many and such wealthy followers ... has for its purpose the transformation of an ordinary and comparatively useless copy of a book into one belonging to a much rarer issue.

'On Fakes and Facsimiles' in McKerrow (1928)

3

Scholar Forgers:
John Payne Collier, T. J. Wise

If Macpherson, Chatterton and W.H. Ireland were youthful literary revolutionaries bent on undermining the authority of the cultural establishment, the corresponding position of the most famous literary forgers of the nineteenth century could not be more different.

John Payne Collier and Thomas James Wise were revered and respected bibliographers. They did not strike at authority from the cultural fringe. They operated from within. Towering institutions such as the British Museum became forgers' dens. Yet the actual forgeries are in inverse relationship to the position of their creators. Whereas the eighteenth-century forgeries were new artefacts which engaged very central issues about literature, the nineteenth-century equivalents occurred in much more refined and specialised contexts. Collier's forgery occupied literally the margins of the text, being emendations to a Shakespeare folio. T.J. Wise tampered with the book-making process; there was no creative input to the text. So it is imprecise and unhelpful to call Collier and Wise literary forgers if by that is understood forgers of works of art. The specialised and 'expert' nature of their crime matches the growing specialisation in literary studies, particularly in bibliographical and editorial matters. Collier and Wise forged books or parts of books. They did not attempt the fabrication of manuscripts, or even the suggestion of this. Collier's emendations could be thought of as manuscript material grafted on to printed texts (ie. a book personally annotated by someone), and Wise's false dates on books as corruptions in publication. Neither man produced a new text or directly doctored an 'original' one. The way in which

71

their creations are forgeries can only be understood in relation to the processes of literary production: the editing, publication and sale of texts. An investigation of Wise's forgery does not lead us to the mass-marketing of fiction, but to the rare books market. The nineteenth century brought literature under the auctioneer's hammer. Wise may be a successor to Edmund Curll. But Grub Street has become St. James's.

Marginal Alterations: John Payne Collier and the 'Old Corrector'

The first point to note about Collier is that the evidence against him has recently been challenged. Dewey Ganzel's *Fortune and Men's Eyes* (1982), a massive biography, suggests that Collier may have been the victim of a frame-up perpetrated by Sir Frederick Madden and other rivals at the British Museum. The Shakespeare folio emendations are indeed forged, but not by Collier. So in calling Collier a forger I may be guilty of misrepresentation. Until the matter is solved, however, I feel justified in referring to Collier as he is almost unanimously referred to: a forger. I will make it clear where the discrepancies in the received (nineteenth-century) account and Ganzel's version occur, without trying to mediate or judge Collier's guilt myself.

Collier is a nineteenth-century W.H. Ireland: older, less extravagant, more discreet, more refined, more stately. Those who imagine forgers to be cheapjacks, sharpers and hacks producing sub-standard articles for immediate gain will be dismayed by Collier's credentials, and indeed by Thomas James Wise's. Collier's literary career was in many ways monolithic. He began as a journalist, with almost three decades on *The Times* (1809–21) and the *Morning Chronicle* (1821–47). By mid-century, however, he had established himself as one of the leading editors of Elizabethan and Jacobean literature and memorabilia. He was a founder member of the Camden and Percy Societies, who specialised in reprinting early texts. Collier was director of the Shakespeare Society founded in 1840, and vice-president of the Society of Antiquaries (1849). He was secretary to the Royal Commission on the British Museum, whose main job was to decide on a form for a new catalogue

(1848–50). Most of his prodigious energy went into editing. Even Arthur Freeman, a firm believer in Collier's transgression, has recently admitted:

> his industry alone made him legendary in his time, but his output is also remarkable for the quality of its basic intentions and the wealth of new matter and good judgement in its commentary.
>
> (*Times Literary Supplement*, 22 April 1983, p. 391)

Collier was in every sense the literary specialist, producing scores of minor texts and literary-historical documents in newly printed versions. But needless to say, the laurels could not be worn with confidence until editorial expertise had been proven on Shakespeare. Greatest authority would be awarded to the scholar who could produce the most authoritative text. This job was of course made extremely difficult by the absence of manuscripts and documents in Shakespeare's hand. W.H. Ireland tackled the problem head on and plugged the gap. But scholars who preferred not to invent evidence were left with variants and variations in printed texts, and a job of collation and conflation. Eighteenth-century editors were prepared to interpolate if necessary, and use intuition to inform them when a corrupt passage or words were present in a text. Richard Bentley's *Paradise Lost* was an extreme example of this method, a perverse adherence to the 'self-evidencing light' supposedly emanating from the text. But by the mid-nineteenth century standards had risen, and direct interference in the text was not sanctioned. Nevertheless the editor's Eldorado was still a text which was close to Shakespeare, which he had authorised (or might have), and which absorbed his presence like a religious relic. The quartos and folios are the closest we can get to Shakespeare. We can see Collier as desperate to achieve this authentic reading, and striving to give his version relic-like status. He possessed a genuine 1632 Folio of Shakespeare, but needed the extra indications that this folio was special. Collier could not tamper with the text directly, so the new material went on to the margins of the page. It would be going too far to fabricate Shakespeare's handwriting or thumbprints (especially as he had been dead sixteen years when the folio appeared) so Collier settled on the 'old corrector', an anonymous hand of

someone who may well have been a contemporary of Shakespeare, who may have seen the plays acted, and read all the printed, if not manuscript, versions. Collier did not discover new plays or documents, or like Wise 'new', older editions. He came up with hundreds of new readings of words and short passages, a massaging of previous versions of Shakespeare into the most authentic text yet. As we shall see, this act was certainly not to brew a storm in a literary teacup.

Collier first produced an edition of Shakespeare in eight volumes between 1842 and 1844. The edition was well received, especially as Collier published in the surrounding years papers and documents by people such as Alleyn and Henslowe. But Shakespeare editing was an intensely competitive field. The reputable scholars Halliwell, Singer, Knight and Dyce were all preparing editions which they presumed would supersede Collier's. So in 1852 he played his trump card. He announced the discovery of a 1632 folio containing marginal emendations in a seventeenth-century hand. The binding of the folio had the name 'Tho. Perkins' scribbled on it, and hence became known as the 'Perkins folio'.

The provenance of the folio was as phantom-like as the 'old corrector'. Collier claimed he had bought the folio in 1849 from a bookseller named Rodd who had since (conveniently) died. Collier (unlike Bishop Percy) displayed the famous folio but somehow managed to withhold it from Halliwell, who was at the proof stage with his edition. Halliwell's Shakespeare thus appeared without access to the revelatory 'corrections', and Collier could suavely set about transcending it. He selected some 1,100 emendations for *Notes and Emendations to the Plays of Shakespeare* (1852). The book sold 4,000 copies in six months, a measure of the popular interest such an issue could arouse. The first doubts about the 'old corrector' were not so much concerning his authenticity but his authority. There was less than ecstatic support for the scholarly and aesthetic value of the emendations. Undeterred, Collier included a selection of the new readings in a one-volume Shakespeare (1853). If his editorial coup was carefully pre-planned its initial results must have been satisfying. As Dewey Ganzel notes, and as W.H. Ireland had shown, 'any reference to Shakespeare, no matter how minor, immediately acquired an interest disproportionate to its intrinsic

worth' (1982, p. 75). Authenticity outweighs authority. Some of Collier's rivals begrudgingly bowed down and included some of the Collier material in their own editions. Others levelled serious charges about the 'old corrector's' existence, though it was a few years yet before Collier was openly called a forger. Collier managed to have Andrew Brae's vilificatory 'Literary Cookery' (1855) withdrawn on libel charges. But a more lethal assault was just around the corner.

Collier bequeathed the 'Perkins folio' to his patron the Duke of Devonshire. He died soon after and was succeeded by his son. The new Duke made an enormous blunder. The folio was lent to the British Museum for inspection. A request for this had come from Sir Frederick Madden, Keeper of Manuscripts. Madden is the true villain of the controversy if we accept Dewey Ganzel's version of events. Collier had made an enemy of Madden years earlier by exposing a very shady deal in which Madden had procured manuscripts for the British Museum from the library of the Duke of Ellesmere. Collier, who was the librarian there, discovered the manuscripts had been stolen. Nothing was proved, but Madden's reputation was damaged. According to Dewey Ganzel, therefore, Madden was seeking revenge. With the Perkins folio in his possession he had seized his prey. Be this the case or not, Madden appointed two deputies to publicly spearhead the anti-Collier campaign. The first was Nicolas Hamilton, Madden's assistant at the British Museum. In *The Times* on 2 July 1859, he announced the results of an extensive bibliographical examination of the Perkins folio. The age of the handwriting in the margins was questioned. It was certainly not as ancient as the seventeenth century. There were more shocking findings. Under some of the emendations had been detected partially-erased pencil corrections. There was only one conclusion. A modern editor (hinting at Collier) had concocted some of the emendations firstly in pencil and then had inefficiently traced over them in ink. Collier did not put up a spirited defence. He denied authorship of the emendations but did not refute the basic points that the seventeenth-century 'old corrector' was a sham. Hence Madden could announce victoriously 'the authority of the famous Perkins folio is gone' (quoted in Ganzel, p. 241). Madden's other myrmidon was Clement Mansfield Inglesby, Professor of Logic at the Midland

Institute. Though the source of his animus is not clear, he published two swingeing indictments of Collier: *The Shakespeare Fabrications* (1859) and *A Complete View of the Shakespeare Controversy* (1860). The latter has become the standard account of events, and the one Dewey Ganzel strives to refute.

Ganzel claims that the modern emendations are not the work of Collier but Sir Frederick Madden. He forged the corrections while supposedly giving the folio its scientific or 'forensic' examination. Ganzel fashions Madden as a nineteenth-century William Lauder, using forgery to frame the charge of forgery on a literary enemy. This bizarre state of affairs was presented by Collier at the time, who claimed after sufficient provocation that he was the victim of a conspiracy, and that the Perkins folio had been doctored in the British Museum. He was not a lone wolf. There were sympathetic denunciations of the scale of Madden's witch-hunt. He and Hamilton had been grubbing up Collier's literary past. They claimed he had forged insertions in many of his earlier publications, including the Alleyn and Henslowe documents.[1] Hepworth Dixon, editor of the *Athenaeum*, was outraged at the volume of dirty linen the literary establishment was washing in public. He called the British Museum a 'beargarden' and its senior employees 'fierce literary partizans and polemics' (Ganzel, p. 261). The line between judicious cultural litigation and personal vendetta was a thin one. So, regardless of whether Dewey Ganzel is right, there were contemporary misgivings at the way affairs were being conducted. Hepworth Dixon's attitude is of course not one we may wish to support. He was calling for the whole business to be hushed up and dealt with internally behind closed doors in a gentlemanly manner. Such protocol, confidentiality and secrecy surrounds the art market, and may actually sanction dubious procedures.

Collier plodded on with his massive editorial labours despite being branded a forger. He was not outlawed. His edition of Spenser's works (1861–79), for instance, was well received. But the controversy surrounding the 'old corrector' remained the most important event of his career. In his *Autobiography* he seems to come very close to an admission of guilt when he says

if the proposed emendations are not genuine, then I claim them as mine;

and there I intend to leave the question without giving myself further trouble: ... no edition of Shakespeare, while the world stands, can now be published without them.

(quoted by Arthur Freeman, *Times Literary Supplement*, 22 April, 1983, p. 392)

Macpherson adopted a similar position, but Ossian had been an aesthetic success. As either editor or author Macpherson could not lose out. Alterations to the text of Shakespeare are perhaps a more specialised concern. Arthur Freeman quotes a 'celebrated' example from *Coriolanus* III, i, 131–2 ('How shall this bosom multiplied digest/ The senate's courtesy?'): 'bosom multiplied' is revised/'restored' to 'bisson multitude.' The reader may judge the change for him or herself. Arthur Freeman sums up Collier's editorial policy (as an interpolator) thus:

his 'methodology' depended less on the principles which we now generally accept (above all that 'authority' stems from the author, as close as we can get to him, and not from ourselves) than on the simpler notion 'early' is better than 'late'.

(*Times Literary Supplement*, 22 April, 1983, p. 392)

It seems to me that one of the ways we arrive 'as close as we can' to the author is to go back in time to 'early' readings and texts. Freeman actually shares with Collier the subscription to the relic-status of a text, the need to regress to that emanating light-source of original authorial creation. Yet it has by now become apparent that the 'self-evidencing light' is something of an *ignis fatuus*. One motive Freeman assigns to Collier's forged insertions into the *Stationer's Register*, for instance, is that he wished to produce 'small pieces of evidence to support his theories of authorship'. The authentication of a text is a culturally determined process. The totemic worship of the original act of authorial creation is still with us today. Earliest is still in many cases the best. Hence the 'magical value' of the literary manuscript, as Philip Larkin terms it (1983, p. 99). But that 'value' translates into economic value. Once a text becomes intellectual property, once it is individualised as belonging (legally or mystically) to an author, the text enters the market. Which brings us to our next forger, operating at almost exactly

the same time as Collier, and necessary to look at briefly before we move on to T.J. Wise.[2]

False Paternity: Major Byron

Like Collier and Wise, Major George Gordon Byron (also known as 'de Gibler') did not forge works of art *in toto*. His speciality was the literary autograph. An excellent calligraphist, he fabricated scores of letters by the Romantic poets Keats, Shelley and Byron. Many of these were sold in auction rooms and in private sales. The Major claimed to be the poet Byron's illegitimate son by the Countess de Luna. Whether this paternity was any more authentic than that of the forged letters has yet to be proved. What is certain is that his forgeries were very successful for a number of years. A brief look at this episode gives a valuable insight into the trafficking in literary documents at the time.

Major Byron appeared on the literary scene in the 1840s as a dealer in autographs by the younger Romantics. He was selling letters and also collecting them for an edition of his 'father's' works and a biography. These two activities were linked. When he had a genuine letter in his possession he would copy it. The counterfeit would then be kept, the original given back to its owner, and the counterfeit sold on the market. Or both might be sold at different times, the equivalent of false currency and the undermining of credit. The forged letters are another example of the tenuous nature of authorial identity in a text: if it can be harnessed by another, to what extent is it unique? Major Byron sold many letters to Mary Shelley, Shelley's widow. She was anxious to secure all her husband's documents, and paid considerable prices to prevent unauthorised publication.

Major Byron operated through a bookseller named William White, who may or may not have been an accomplice. In 1851 at Sotheby's auction room White sold a large number of Shelley, Keats and Byron documents. This sale was the Major's greatest coup. Most of the Shelley letters were bought by Edward Moxon, who published twenty-five of them in 1852 as *Letters of Percy Bysshe Shelley*. Robert Browning was hired as editor, and prefaced the poems with his famous 'Essay on Shelley'. Thus

Browning became the Dr. Johnson of Lauder's Milton forgery. The hoax did not last long. Sir Francis Palgrave recognised in one of the letters a plagiarism of an article by his own father which had appeared in the *Quarterly Review* (Vol. CXL). The article had been about Florence, and the letter in question was supposedly from Florence. The revelation led to an investigation of the postmarks on the letters, which proved to be false, though the handwriting was more difficult to disprove. Major Byron had ransacked contemporary periodicals, magazines and books for material he believed was Shelleyan or Byronic or Keatsian. If there is an inimitability about an author, the Major understood its complexion better than many of the experts. He even used sources as outrageous as novels: Disraeli's *Venetia* was profitably mined. The Major rarely invented wholly new material; he was more of a compiler and sub-editor. As T.G. Ehrsam notes, the Major's forte 'was not so much in inventing Byronic material as in weaving together sentences or fragments from different sources in a smoothly joined letter' (Ehrsam, 1951, p. 176). Sometimes only a fake signature would be added to an already genuine letter to boost its value. The extent to which these 'mixed' texts are authentic and inauthentic is somewhat dizzying. The *Athenaeum* acknowledged the skills of the Byron letters which were sold at Sotheby's to none other than John Murray, Byron's publisher. The letters had been 'selected with a thorough knowledge of Byron's life and feelings, and the whole of the books chosen with the minutest knowledge of his taste and peculiarities' (quoted in Ehrsam, p. 171).

Both Moxon and Murray returned their letters to William White. At the famous sale there had also been annotated books from Byron's library. Major Byron becomes a Collier at this point. The sale catalogue announced

Books from the Library of Lord Byron, Rendered Particularly Interesting in Consequence of their containing Unpublished Poems and Fugitive Pieces, in the Autograph of that Illustrious Poet.

(quoted in Ehrsam, pp. 82–3)

One of these new pieces was, ironically, a version of Ossian's 'Hymn to the Sun' from the minor poem *Carthon*. This poem found its way into most editions of Byron. Occasionally the

Major invented a poem (Ehrsam, p. 168) but he preferred to plagiarize contemporary poets or even the authors themselves.

So Major Byron's forgeries covered the gamut from counterfeiting to creative forgery, from interpolation to unauthorised publication. His ability to imitate the hand of the Romantic poets was something of a Midas touch, producing that 'magical value' of the presence of the author. The documents were purchased willingly by a growing market greedy for prestigious literary relics. It is interesting to speculate about the advent of photography at this time. Would a photographic reproduction of a manuscript fetch as high a price as the original, or be as highly regarded by dealers and scholars? The answer is obvious. Yet one would have access to the same words in the same form.

Some of the Major's forgeries found their way into the hands of Thomas James Wise, who exposed their falseness with great verve. That is a fitting final irony, for the extent to which Wise's fake first editions are false is a fascinating question.

Scientific Forgery: Thomas James Wise

There are moments in cultural history when it is difficult to distinguish between innovations in fact and fiction. Thomas James Wise began forging first editions of rare books in the late 1880s. The success of his enterprise relied on an expertise in bibliography, which is often described as the 'science of books'. Bibliography is at the opposite end of the literary spectrum from aesthetics. Bibliography deals with the physical properties and technical peculiarities of the book and (to a lesser extent) the manuscript. Bibliography treats literature as concrete artefact, and its methods can be applied to all and any works. The impetus behind the growth in bibliographical skills however has always been editing: of rare works from the past, and particularly literary works. Fired by the need to achieve and locate the authentic text, editors and scholars investigated those areas of the literary production process that had previously been the preserve of the printer and publisher. To a bibliographer a writer is Defoe's 'Operator with Pen and Ink'.

T.J. Wise's crime was wholly bibliographical. He tampered

with the book-making 'Operation'. Unlike the other forgers in this book he did not tamper with the text in any way. He made no intrusions into the imaginative content of the books he faked. For Wise's forgeries are essentially that: faked books. Wise was a professional, a master-forger. He applied the forger's knife with the delicacy and control of an expert. To smoke him therefore required at least the same level of bibliographical knowledge. A literary detective was needed to conduct a 'forensic' investigation. When such an enquiry eventually took place in the 1930s it was hailed as a revolutionary advance in bibliographical method. Wise's forgery classically gives a 'valuable impetus to further investigations' as René Wellek has said (*Wellek and Warren*, p. 67), though he qualifies the remark for Wise, as we shall see.

If Wise's forgery needed fifty years to produce the required advance, however, the expertise was already there in fiction. At almost exactly the same time as Wise began forging, Sherlock Holmes took up residence in 221b Baker Street.[3] Holmes's formidable range of skills included forensic bibliography. He had written monographs on the chemical dating of documents, and 'The Typewriter and its Relation to Crime'. By examination of type fount (of crucial significance in uncovering Wise's practice) Holmes dated the Baskerville manuscript to within twelve years of its true date. His knowledge of watermarks enabled him to identify native Indian paper ('A Sign of Four') and to trace one letter to a small German town near Carlsbad ('A Scandal in Bohemia'). The fictional analogy brings out strongly the extent to which bibliography is a form of detective work. In the cases we have looked at so far inconsistencies have been rife and circumstantial evidence problematical. It remains to see what conclusions were drawn from the Wise revelations, and whether a Holmesian certainty settled on the question of the authenticity of a text.

Wise was not, like Collier, an editor so much as a bibliophile and book collector. His forte was producing bibliographies of Victorian authors: authoritative lists of their publications. Wise's credentials were substantial if not impeccable: a member in his twenties of the Browning and Shelley Societies; a patron of the British Museum; President of the Bibliographical Society 1922–24; founder of the Ashley Library, a magnificent hoard of rare books which was bought by the British Museum after Wise's

death in 1937 for £250,000. Certainly by the early part of this century Wise was established as a literary authority. Whether his empire was founded on corruption is not our concern. His status made his unmasking all the more damaging. Wise was never brought to trial. Self-confessed motives are not available for our consideration.

There may be a number of reasons why in the late 1880s Wise began to fake first editions. The texts he chose to forge were literary curiosities. Many Victorian authors had single poems or short prose pieces privately printed in pamphlet form before publication. The print run would obviously be very low indeed, because the pamphlets were not properly books and were not commercially printed. Such a rare, limited and curious literary product is ideal collectors' material. Moreover the pamphlets were extremely intimate with their authors, almost having the status of a manuscript. As T.A.J. Burnett has said, 'printing was very cheap, and this procedure was analogous to having something typed up cleanly' (*Times Literary Supplement*, 16 March 1984, p. 286). Major Byron's forgeries exposed the passion in the auction rooms for autographs. This passion extended to the nearest printed equivalent: the first edition. 'Early' is most certainly better than 'late' for this market. Wise decided to make some of the pamphlets rarer and more valuable than they had been by pushing back their publication date, and effectively creating new first editions which had not been known about. It was not simply a case of changing the date on the title page. Wise had first to produce a text which was a replica of the genuine one. He needed an authentic printing method which would also enable him to invent pamphlets that never existed. Before he began to forge, Wise persuaded the Browning and Shelley Societies to print type-facsimiles or facsimile reprints of Browning's *Pauline* (1833) and Shelley's *Adonais*, *Hellas* and *Alastor*. According to Wilfred Partington 'it was the page-for-page imitating of the 1833 *Pauline* and of Shelley first editions that most probably started Wise on his series of typographical forgeries' (1946, p. 45).

The line between forgery and reproduction is a thin one. To perform this 'typographical mimicry' (Carter and Pollard, 1934, p. 119), Wise hired the printing firm Richard Clay and Sons. They were responsible for printing the pamphlets with the false

dates, and may have done so unwittingly. What is more important is that the text remained unchanged in every way. Those who bought a Wise pamphlet may have been deceived by its date of origin by a few years, but the text was the same as in the genuine first edition. The literary status of the text was not damaged or transformed. Unless, of course, the earlier text is more 'magical' as it is nearer the creator. Wise broke the rules of authentic book-making. He damaged the credit of the rare book-market rather than the authors concerned. Aesthetic considerations were never an issue. Market value mattered most, 'the literary importance of the pieces chosen was a secondary consideration' (Carter and Pollard, p. 113). The outrage and scandal, the alarm and recriminations, the fanfare that hailed Carter and Pollard's *Enquiry* in 1934—all was a response to the alteration of publication date on otherwise intact books. Wise indulged in other forms of Curllicism, but he is mainly remembered as a forger of the fake pamphlets. The extent to which they are inauthentic is very tenuous.

The fake pamphlets covered most major Victorian authors. The most famous pamphlet is Elizabeth Barrett Browning's *Sonnets from the Portuguese*. These poems first appeared in print in 1850 in a collected edition of her poems. Wise produced a pamphlet dated 'Reading: 1847'. The forgery had no original as such. The text was copied from the 1850 *Poems* unchanged; only the printed form had changed in accordance with that 'special magic which we regard to-day as inseparably connected with the firstness of a first edition' (Carter and Pollard, p. 100). There was little evidence to either refute or support the provenance of *Sonnets from the Portuguese* (1847). There were no textual flaws to seize on. The pamphlet had 'Not For Publication' on the title page, which pandered to the confidential and personal aura emanating, in theory, from the text. Carter and Pollard resorted to pure science to discredit the pamphlet. A chemical analysis of the paper and scrutiny of type fount (especially the broken-backed 'f' in the pamphlet text) traced the *Sonnets* to Richard Clay and Sons and the late 1880s. These were just two of the revolutionary investigative methods pioneered by Carter and Pollard. Such techniques are inadequate for assessing the cultural 'falseness' of Wise's pamphlets.

Cultural rather than bibliographical investigation therefore

leads us to the auction rooms and literary market. Carter and Pollard point out some of the criticisms that were levelled at the cult of the first edition at the end of the nineteenth century. William Roberts, for instance, in an article entitled 'The First Edition Mania' (*Fortnightly Review*, March 1894) observed that 'every little volume of drivelling verse becomes an object of more or less hazardous speculation, and the book market itself a stock exchange in miniature' (Carter and Pollard, p. 105). There are further scathing references to the 'rubbishy tracts by living authors' and 'flatulent little *biblia abibia*'. Artificially created market value is masquerading as aesthetic value. One wonders if Roberts would have been appeased by the sight of only worthwhile texts on the auctioneer's table. His conclusion, however, suggests the market is innately to do with false artistic merit:

> the history of book collecting has never offered such a fruitful source of ridicule as it does at present, because never before has the apotheosis of the infinitely little been so pronounced.

Roberts fails to see or refuses to elucidate why 'littleness' has become so marketable. The cult of the first edition is fired by the cult of the author. At this juncture bibliography ceases to be scientific. In the preface to the reprint of Browning's *Pauline*, Wise observed

> there is a sentiment attaching to the very form in which a book of this description first appeared which is entirely wanting if the same work is perused in another dress; and therefore, failing the original, we are only too glad of the opportunity of providing ourselves with a good likeness of it. It is in this sentiment that the true book lover finds his pleasure.
>
> (Partington, p. 46)

Wilfred Partington dismisses this view as an 'absurd craze for imitative reprints'. However, if we turn to one of the standard books on bibliography still used today—Ronald B. McKerrow's *An Introduction to Bibliography for Literary Students* (1928; repr. 1951)—we read: 'We may as a general rule assume that the handsomest edition of a book is the first' (p. 184) even though the text is not necessarily the most reliable.

McKerrow also has a section on 'Fakes and Facsimiles'. The

coupling is interesting in itself. McKerrow declares 'fakes are of many kinds' (p. 231) but the five different categories all involve copying, rearranging and combining—the range of typographical forgery which Wise was in fact perpetrating. The fake pamphlets are the most famous, but not the only forgeries Wise produced. The authority of many other texts was destroyed by his duplicitously mixing them with pages from other editions. It is now known that Wise stole from the North Library of the British Museum at least 206 leaves from seventeenth-century quarto plays. These leaves were then used to restore his own imperfect copies of the same plays. In other words he repaired his own texts by mutilating others. Wise has earned severe censure for this carnage. T.A.J. Burnett has stated of the act:

> to exploit the greed and gullibility of collectors was one thing. To display total contempt for the priceless texts which he pretended to revere was quite another.
>
> (*Times Literary Supplement*, 16 March 1984, p. 286)

Arthur Freeman, who recently discovered a hoard of unused 'wreckage', imagines Wise 'at his desk with piles of *disjecti membra*, patiently shuffling and sorting combinations until each finally, made-up copy of a quarto was the best he could manage' (*Times Literary Supplement*, 17 September, 1982, p. 990). The crime, according to Freeman, was that Wise

> destroyed evidence of original issue, integrity of issue and state, and old provenance, with a wanton and even vicious disregard for the physical book, the object to which he had ostensibly devoted his scholarly and collecting career.

It is difficult to see how the removal of a page or two from a text can totally destroy its 'integrity of issue and state', a sonorous idea Freeman does not explain further. One suspects Wise's 'vicious' Curllian 'disregard' for the purity of the book damns him sufficiently. Yet there is a thin line between restoration and forgery, as the case of Thomas Percy's *Reliques* showed. Many of Wise's 'sophisticated' or repaired books found their way back into the British Museum as part of the Ashley Library. Wise kept most of these corrupt texts for himself. He may have had a very

high regard for the physical book, so long as he could be its possessor.

Freeman dates this second wave of forging activity as around 1901–06. For most of his career Wise also produced 'suspicious' works, often with the help of another bibliophile Harry Buxton Forman. T.A.J. Burnett notes 'how hard it is to separate' these different false texts: 'forgeries, piracies, false limited editions, hybrid publications part genuine, part false' (p. 286). It should be clear by now how inadequate these categories are for determining the authentic text. All limited editions are artificially created (most printed products, we must remember, are 'copies' as soon as they appear), and all publications involve hybrid components. There is too much reliance on the term 'false'. Twenty-five years on from the *Enquiry* John Carter hoped that further study of Wise's hundred or so doubtful books would reveal 'the shading between forgery, piracy, and avowed but unauthorized private printings' (Todd 1959, p. 17). The revelation still has to be made.

Carter and Pollard's *Enquiry* appeared in 1934. Wise was implicated but not accused directly (he died unrepentant in 1937). The reaction of the literary establishment was shock followed by euphoria: shock at the crime and the blow to bibliography; euphoria at the self-redeeming nature of the *Enquiry*. Bibliography was drubbed and purged at the same time. In 1959 Carter recalled the 'shock administered to the solar plexus of the bookish world' (Todd, pp. 4–5), and showed mixed revulsion and admiration for Wise:

> The nineteenth-century pamphlet forgeries were ethically reprehensible, bibliographically scandalous, bibliophilically deplorable, and economically depressing. But their maker was an artist.
>
> (p. 19)

The importance of the *Enquiry* could not be underestimated by those anxious to restore bibliography's credibility. The *Times Literary Supplement* on 5 July 1934 believed the debt owed to Carter and Pollard by 'all concerned with the study, sale, or collecting of nineteenth-century literature is incalculable'. This view contradicts René Wellek's assertion that 'the forgeries of Wise, who never invented a text, concern rather the book

collector' (*Wellek and Warren*, p. 68). The *Publisher's Weekly* on 7 July 1934 announced with appropriate ballyhoo 'A Bibliographical Sensation'. The unknown faker was a 'genius', the *Enquiry* an 'amazing book'. Though 'the honourable science of bibliography' had been dealt a heavy blow, 'the repercussions of which will be long and widely felt', 'the answer to the more serious questions, that of the essential prestige of bibliography itself, is presented ... by the present monumental work itself' (*Publisher's Weekly*, 7 July, 1934, p. 54, p. 56). Perhaps the truly 'serious questions' have not been answered, because they may not have been raised. In 1965 F.B. Maggs noted ironically of Wise:

> it is rather curious to find that his bogus pamphlets are beginning to fetch more at the auctions than they did when they were believed to be above reproach.
>
> (Maggs, 1965, p. 7)

The marketing of forgeries is really just another way of absorbing their threat. The forgery has to be a false work before it can be pedalled as a curiosity. Still, Maggs' observation takes us nearer the cultural authentication of a text than do the raptures about Carter and Pollard's *Enquiry*. The authority of a text does not emanate from the words on the page, nor simply from the make-up of the book. An 'original' text can only be understood by a set of assumptions and judgements. Wise's pamphlets were both original and unoriginal: original in being his creation, having no 'original' in the sense of a text they were simply counterfeiting in every detail, and being the text of first or earliest printed editions; unoriginal in being the result of 'shuffling and sorting combinations' with no imaginative input at all—as Edward Young said of imitations, they are 'wrought up by those mechanics, art, and labour, out of pre-existent materials not their own' (Young 1759, p. 12). Arthur Freeman also uses an industrial image for Wise which brings back the original sense of forge: to make. Freeman describes Wise's study as 'a practical factory for reconstituting early dramatic quartos' (*Times Literary Supplement*, 17 September 1982, p. 990). Contrast Edmund Blunden's description of the *Enquiry* as 'the weeding of the bibliographical garden' (*Times Literary Supplement*, 28 September 1946, p. 472). Edward Young also used an organic

image to indicate originality: a 'vegetable nature'. T.J. Wise's forgery provoked both analogies.

Notes

1. A letter in the *Times Literary Supplement* (22 July 1983) accuses Collier of 'cavalier treatment of his sources' in the introduction to George Cruikshank's illustrations to *Punch and Judy* (1828): 'inventing ballads, poems and newspaper articles which he passed off as original sources'.

2. In a reply to Arthur Freeman's strictures of his book, Dewey Ganzel shifted blame for the pollutions of Collier's minor pieces on to earlier editors:

 > casual forgery was rife in the eighteenth century ... all the manuscript collections that were used at that time contain many potential forgeries. Since Collier was the first scholar systematically to print complete manuscript transcriptions, and since he was no better able to detect forgery than his contemporaries, it was inevitable that he would publish fabrications that earlier readers, for unknown reasons, had inserted in the Alleyn papers, the Bridgewater papers, the Stationer's Register, *et al.*
 >
 > (*Times Literary Supplement*, 20 May 1983, p. 516)

3. Sherlock Holmes first appeared in a short novel *A Study in Scarlet*, published in *Beeton's Christmas Annual* in 1887. The short stories began to appear in the *Strand Magazine* in 1891.

If we are convinced that evolution is the true method of creation and that man and anthropoid have been evolved from a common ancestry, what is more probable than that we should find early human forms in which anthropoid and human features are combined?

Sir Arthur Keith, *A New Theory of Human Evolution* (1948)

4

The Missing Link: Archaeological
Forgery and Fictions of the First Human

Archaeology is the study of remnants and artefacts of the past.
The discipline emerged in the eighteenth century as part of the
historiographical revolution seeking truly authentic modes of
access into history. The word 'monument' covered literary as well
as concrete relics: ancient manuscripts as well as time-encrusted
artefacts and human remains. Most of the literary forgers of the
eighteenth century were producers of historical fiction which
evolved from and satisfied many of the needs of contemporary
literary-historical inquiry. In doing so the forgeries laid bare the
processes of evaluation and judgement concerning 'genuine' art
that might not otherwise have been subjected to scrutiny.

Archaeological forgery is a tangible form of historical fiction.
There were no archaeological fakes in the eighteenth century
because the discipline had not become a central cultural activity.
This happened in the nineteenth century. There were major
discoveries, the most famous being Heinrich Schliemann's
supposed discovery of Homer's Troy in 1873. This incident is
particularly ironic for our purposes. Not only had Schliemann
not uncovered Priam's fabled city (but a much earlier one)—but
it has recently been revealed that Schliemann's discovery of the
fabulous treasure which became world famous was a hoax.

The complexion of this forgery is very interesting. Most of the
treasure was genuine in the sense of being genuinely old. The
relics were not modern fabrications. Some of them probably
came from the site of excavation, others were from other sites or
even bought from dealers. The treasure was a forgery because its
provenance was false. Schliemann even inserted the fictitious tale
of discovery into his own diary. This revelation opens up the

whole question of unreliable memoirs, and of the complicity of biographers who fail to check information in the proper way. Schliemann's treasure of Troy was not what it appeared to be. The parts were genuine but the whole was fictional. Schliemann forged authentication and invented a context. His activity shows how significant external factors are in producing the authenticity of a relic. One of these factors is of course the market. The value of relics like works of art is estimated in financial as well as cultural terms. Also a great deal of national prestige is attached to archaeological discoveries. Schliemann was lionised by the civilised world. He had abused his authority to achieve greater recognition. He made 'a dream discovery ... what every archaeologist wants to find' (David Trail speaking on 'Chronicle', BBC 2, 31 July 1984). That is the feeling behind the quest that occupied many nineteenth- and early twentieth-century archaeologists in a different area: the search for the first human being. People thought Schliemann had transformed Homer's fiction into fact. The same incarnation awaited our evolutionary parent—a figure who, ironically, had only recently been invented.

The archaeological equivalent of a Shakespeare manuscript in the nineteenth century was a fossilised relic of an early human. Advances in geology and zoology had produced the idea of evolution: natural and human life had begun in a simpler, common form, and had become gradually diversified and sophisticated over an immense amount of time. The theory was very controversial, contradicting orthodox religious accounts of creation. Moreover, evolutionary theory posited that humans were once a much more primitive form of animal, something resembling a modern primate such as an ape.

In 1856 in Germany a skull was discovered near the river Neander which had a human-like jaw and overhanging, simian brows. This 'Neanderthal Man' seemed to confirm the existence of an ape-like ancestor for humankind, living on the earth several hundred thousand years ago. In 1859 Charles Darwin finally published *The Origin of Species by Means of Natural Selection*. The book was the most authoritative statement so far of evolutionary change in history. Though Darwin did not include humanity in the picture until *The Descent of Man* (1871), he was popularly credited with the 'monkey theory' of

our ancestry. The primitive human, monkey-like or not, was a burning issue among scientists after *The Origin of Species*. There was a need to find very ancient human remains, particularly a skull or part of a skull. The intensity of this need can be judged by the appearance outside Britain of three forgeries all produced in the decade after the *Origin*. All three were fabricated remnants of a primeval human—in effect, historical fictions.

The first of these forgeries occurred at Moulin-Quignon, near Abbéville in France, in 1863. A site was being excavated by Boucher de Perthes, an archaeologist committed to the existence of fossilised human remains. He had previously unearthed flint tools in the same stratum of earth as the bones of extinct animals. This was evidence that humans had existed at this very ancient time, and that somewhere their bodies—not only accoutrements—must be buried. He turned his attention on Moulin-Quignon, and offered a reward of 200 francs for any labourer who found a human remain. In March 1863 a workman gave Boucher de Perthes a human tooth and the relevant authenticating assortment of flints and fossils. The spot where the discovery had been made was excavated exhaustively, and soon presented the lower half of a human jaw. Boucher de Perthes had found a prehistoric human. The discovery was hailed nationally and archaeologists and anthropologists flocked to the site. They were disappointed, but the Moulin-Quignon jaw was given a prestigious place in the Academy of Sciences.

Doubts as to the authenticity of the jaw were soon raised, particularly in England, and fierce nationalist bickering broke out. Some of the flints found alongside the jaw proved to be fakes. A black market of fake archaeological relics already existed, an automatic response to the high prices being offered by museums and collectors. Indeed it was in England at exactly this time that the most famous flint faker Edward 'Flint Jack' Simpson was at work. An untold number of his fakes permeated the market, and it was only because of his own confession that anyone ever found out. Flint Jack gave a public demonstration of his skill in 1862 which earned him sincere praise by Llewellyn Jewitt in the *Reliquary Quarterly Archaeological Journal and Review*:

antiquaries owe him a debt of gratitude for opening their eyes to deception, and for showing them how a lost art may be restored ... the man possesses more real practical antiquarian knowledge than many of the leading antiquarian writers of the day; and he is a good geologist and palaeontologist.

(quoted in Cole, 1955, p. 79)

The Moulin-Quignon fake was not seen so positively. A scientific analysis of the amount of organic matter in the jaw proved it to be modern. Hence the forgery had led to one of the first independent dating tests. The Anthropological Society of London was relieved. The magnitude of what was at stake was expressed by Sir John Evans (father of Sir Arthur Evans, the discoverer of Minoan Crete) in the *Athenaeum*. His fears are very reminiscent of Thomas Warton's grave prophecies about the wrong outcome of the Chatterton controversy:

> It may be asked why, when so many genuine flint implements had been found in the beds of Moulin Quignon ... it was worth taking so much trouble to prove that a certain small number of implements reputed to have been found there were false. To this I reply that trivial as the question may appear, the consequences of a wrong answer to it are most important. For if these implements, without a solitary sign of antiquity about them, had been determined to be undoubtedly genuine, we should then have had no characteristics left whereby to distinguish true from false, and should have been at the mercy of every flint knapper and gravel digger who thought fit to impose upon us.
>
> (*Athenaeum*, 6 June 1863; quoted in Cole, p. 125)

The issue is about true or false history. But Evans limits the matter to the question of the age of the relic. He does not consider the possibility of a genuinely old fossil being planted in a location, as Schliemann did with his treasure. The difficulty of defining this kind of 'falseness' may account for the prolonged controversy over Piltdown Man, as we shall see.

The main method of dating a relic involved the identification of the geological stratum the relic was found in, reinforced by adjacent existence of other fossils: context and contiguity. In 1866 in America another attempt to exploit this procedure took place. The New World wished to stake its own claim to our antiquity. In gravel deposits at Calaveras in the Table Mountains of California a gold miner claimed to have found a human skull deep inside a mine. That location could only mean it was very

old, but the bewildering question of how the skull found its way into the rock weighed against its authenticity. The issue was decided by the first fluorine dating test on human bone. Almost a hundred years passed before the test was revived to solve the riddle of Piltdown Man. Sir Arthur Keith, a biologist and staunch supporter of Piltdown, noted risibly of the Calaveras skull: 'the discovery of a modern aeroplane in a church crypt which had been bricked up since the days of Queen Elizabeth would form a parallel instance to finding a modern human skull in a Miocene formation' (1911, p. 143). Those words were written on the eve of the Piltdown revelation which was to show the unworkability of Keith's analogy. In Piltdown terms the 'modern aeroplane' becomes an Elizabethan relic.

The third archaeological forgery of the 1860s presents us with a picturesque sideshow. The New World is again the location. George Hull, a trickster, carved a giant statue of a man and buried it for a year on his brother's farm in the Oriondaga valley, south of Syracuse, in 1869. Once a patina had been acquired he dug it up. The giant was frozen in a grimace of extreme agony. Hull allowed the sensationalists to move in. The question was posed: was this an ancient statue or a fossilised giant man? Hull put his find to lucrative use, charging spectators an entrance fee to see the colossus. The famous impressario Phineas T. Barnum tried to buy Hull out. When Hull rejected him, Barnum had a replica of the giant made and took that on tour. By now no one believed the 'original' to be genuine, and the judge to whom Hull went for an injunction ruled that it could hardly be a crime to exhibit a 'fake fake' (Klein, 1956, p. 143). That ruling says much about the ethics of reproduction, something we shall be considering in the final chapter.

Another connection worth making is the support George Hull was given in literary fiction. In 1872 Jules Verne published *Journey to the Centre of the Earth*, a geological fantasy in which a group of explorers penetrates to the earth's core and travels back through evolutionary time as they do so. The climax of the journey is the discovery of a preserved antediluvian world in which life is gigantic, including a briefly-glimpsed prehistoric human:

There, indeed, less than a quarter of a mile away, leaning against the trunk of a giant kauri, was a human being, a Proteus of these underground

regions, a new son of Neptune, keeping watch over that innumerable herd of mastodons ... this was not a fossil man whose body we had lifted out of the ossuary, he was a giant able to command these monsters. He was over twelve feet tall: his head, as large as that of a buffalo, was partly concealed by the tangle of his matted hair: anyone would have thought he had a mane, like that of the primordial elephant. In his hand he wielded an enormous bough, a crook worthy of this antediluvian shepherd ... I would rather admit the existence of some animal whose structure resembles the human, some monkey-like being from the earliest geological period ... but the size of the one we had seen went beyond all palaeontological limits.

(Verne, pp. 194–5)

The 'monkey-like being' was to win the day, however. When Sherlock Holmes's creator, Sir Arthur Conan Doyle depicted his version of a prehistoric world preserved in the present in *The Lost World* (1912), he opted for the human-ape, and anticipated the unveiling to the world the same year of Piltdown Man.

The main reason the 'monkey-like being' rather than the colossus won through was the appearance in 1871 of Darwin's *The Descent of Man*. Here the question of our simian origins was addressed directly. Darwin states that 'man is the co-descendent with other species of some ancient, lower, and extinct form' (*Darwin*, 1874, pp. 2–3). He stresses this idea is not new, and ironically cites Boucher de Perthes as one of those who had consolidated the 'high antiquity of man' (p. 2). This 'common progenitor' (p. 152) was as much simian as human, an 'ape-like creature' (p. 43) or a binary 'semi-human' (p. 46). Our bodies were once covered with a 'uniform hairy coat' (p. 18) and our canine teeth were much more prominent:

He who rejects with scorn the belief that the shape of his own canines, and their occasional great development, in other men, are due to our early forefathers having been provided with these formidable weapons, will probably reveal, by sneering, the line of his descent.

(p. 41)

Yet Darwin comments shrewdly on the logic of evolution:

In a series of forms graduating insensibly from some ape-like creature to man as he now exists, it would be impossible to fix on any definite point when the term 'man' ought to be used.

(p. 180)

When was the modern human born? At what point did the ape become a recognisable human being? Some aspect of our morphology had to be chosen as uniquely *human*, such as a developed brain, an upright stance, a smooth brow. Yet by evolutionary theory such characteristics would be latent or present in a less developed form one stage lower down the ladder of creation, a few thousand years previously. Hence the attractiveness for believers in evolution of the idea of the 'missing link', a single anthropoid bridge between the lower and upper forms, human and ape. In 1863 the scientist, philosopher and evolutionary convert T.H. Huxley had asked

> Where, then, must we look for primaeval Man? Was the oldest *Homo sapiens* pliocene or miocene, or yet more ancient? In still older strata do the fossilized bones of an Ape more anthropoid, or a Man more pithecoid, than any yet known await the researchers of some unborn palaeontologist…? Time will show.
>
> (Huxley, p. 159)

Darwin was more positive:

> those regions which are the most likely to afford remains connecting man with some extinct ape-like creature, have not as yet been searched by geologists.
>
> (Darwin, 1874, p. 157)

Piltdown Man was a fictional solution to this dilemma. Before that 'discovery' in 1912 the ranks of Ancient Men had swollen: Java Man, found by Eugene Dubois in 1891–92; Heidelberg Man, 1907. In 1911, on the eve of Piltdown Man's birth, these two latest candidates for the 'missing link' were assessed by Arthur Keith. He concluded that neither were sufficiently simian. Dubois named his find *pithecanthropus erectus* ('upright ape')

> as a link which bridged the gulf between man and anthropoids. In a zoological sense the name is justified, but so many are the human characters and so strong is the suggestion that in the discovery of Dubois we have a representation of an actual stage in the evolution of man, that it seems more expedient to simply give the name of *Homo javenesis*, or the fossil man of Java.
>
> (*Keith*, 1911, p. 133)

Heidelberg Man was a little more tricky. The jaw of this

ancient ancestor was massive, an ape-like mandible in 'a condition intermediate to the anthropoid and the modern human form' (p. 83). However, Heidelberg's canines were retrogressed, placing it a couple of stages too far along the evolutionary production line. This early human may have been 'brutish, perhaps, in appearance' but was for Keith 'in every sense of the biologist—a man' (p. 93). How fortunate for Piltdown Man, therefore, that he (or she) possessed those tell-tale prominent canines.

Piltdown Man 1912–53

In the last chapter we saw how Sherlock Holmes's amazing bibliographical skills came to prominence at precisely the time Thomas James Wise's fake first editions began to roll from the presses. Sir Arthur Conan Doyle seems to have had an uncanny knack of fictionally paralleling major forgeries. In 1912 his science fiction novel *The Lost World* was serialised in *Strand Magazine*. The story is really the converse of Verne's *Journey to the Centre of the Earth*. This time the intrepid explorers venture up on to a hidden plateau rather than down into the bowels of the earth to discover the prehistoric world evolution has passed by. As in the earlier story, there are ancient humans as well as dinosaurs. Conan Doyle's early human, however, is very much Darwin's simian progenitor. The first encounter with one occurs at the top of a tree the narrator has climbed to try to get a clear view of the Amazonian tableland. Modern and ancient human meet face to face:

> It was a human face—or at least it was far more human than any monkey's that I have ever seen. It was long, whitish, and blotched with pimples, the nose flattened, and the lower jaw projecting, with a bristle of coarse whiskers round the chin. The eyes, which were under thick and heavy brows, were bestial and ferocious, and as it opened its mouth to snarl what sounded like a curse at me I observed that it had curved, sharp canine teeth.
>
> (Conan Doyle, p. 198)

This description would fit perfectly John Cooke's famous reconstruction of Piltdown Man. Professor Challenger, the comically bumptious leader of the expedition, ponders on the *tête à tête*:

'the question which we have to face is whether [it] approaches more closely to the ape or the man. In the latter case, he may well approximate to what the vulgar have called the "missing link"'.

(p. 203)

The question remains academic for, as so often happens in science fiction, the newly encountered alien soon becomes a menace. The novelist has much greater freedom than the archaeological forger who cannot animate his fiction. Conan Doyle's ape-humans are brutal and savage, and there is soon open warfare between the two extremes of the human evolutionary scale. '"Apemen—that's what they are—Missin' Links, and I wish they had stayed missin'"' (p. 231) exclaims one of the beleaguered crew. Developed canines are no match for rifles, however, and the semi-human progenitors are soon conquered in a familiar imperialist scenario.

On their return to civilisation Challenger's party are only too aware that the public and particularly the scientific community will scoff at their experiences. Even photographs are not sufficient, for they can be faked. Incontrovertible authentic evidence is needed. Challenger calls a public meeting, and in a sensational *coup de grâce* produces a live pterodactyl which had been captured on the plateau. Needless to say, the creature is frightened by a member of the audience and flies out of an open window. The living evidence of the lost world and its 'missing link' was lost, at least until another expedition could be mounted. But the loss was being more than compensated for in real life. On 18 December 1912, a matter of weeks after Professor Challenger's revelation, Charles Dawson and Arthur Smith Woodward unveiled to a packed meeting of the Geological Society in London a reconstructed skull of a human-ape whose brain-case and jaw they claimed to have discovered. The cranium was human; the mandible simian. Surely, then, here at last was the long-awaited 'missing link'. It took almost half a century to decide the matter.

Charles Dawson was a lawyer and respected amateur archaeologist. His story of how he discovered Piltdown Man appeared in the *Quarterly Journal of the Geological Society* in March 1913. Some time in 1909 Dawson was out walking near his home at Piltdown, near Fletching, in Sussex, when he noticed

that ancient flint tools had been used to repair a road surface. Dawson asked the workman digging in gravel nearby to be on the alert for any similar artefacts. Like Boucher de Perthes he was extraordinarily lucky, and was soon presented with the partial brain-case of a human skull. The layer of gravel the fragment came from made it very old indeed. Dawson set to work excavating the gravel beds himself. He enlisted the aid of his friend Arthur Smith Woodward, anthropologist and Keeper of the Geology Department at the Natural History Museum, and later (from 1913) a Jesuit priest Father Teilhard de Chardin. More pieces of skull were found in this site which, in archaeological terms, was fast becoming a treasure trove. Then in 1912 came the really sensational find: the ape-like mandible. According to Smith Woodward's posthumously published memoirs this jaw was very appropriately a joint discovery: 'We both saw half of the human lower jaw fly out in front of the pick-shaped end of the hammer' (*Smith Woodward*, 1948, p. 11). In fact there was nothing human about the jaw at all except in its physical proximity to the remains of the human cranium. By standard archaeological logic however, there could be only one reasonable explanation for this remarkable occurrence: the two portions of the skull had originally been halves of the same structure. Here was a literal human-ape, a binary creature whose different halves were so obviously antagonistic. All Dawson and Woodward had to do was to glue the halves together. It was this reconstruction which was exhibited at the end of 1912. Smith Woodward awarded Dawson the highest accolade by naming the missing link after him: *Eanthropus Dawsoni*. Arthur Keith, one of the first and most loyal converts to Piltdown Man recalled in 1915:

> It was quite plain to all assembled that the skull thus reconstructed by Dr Smith Woodward was a strange blend of man and ape. At last, it seemed, the missing form—the link which early followers of Darwin had searched for—had really been discovered.
>
> (*Keith*, 1915, p. 306)

Piltdown Man was, from a historical point of view, 'the most important and instructive of all ancient human documents yet discovered in Europe' (p. 293). The half-million year-old ancestor was 'the earliest specimen of true humanity yet

discovered' (p. 316). The *Manchester Guardian*, with a licence to exaggerate granted to journalistic ballyhoo, captured this feeling of euphoria: 'A Skull Millions of Years Old' proclaimed its headline on 21 November 1912 (news of the find leaked out before the public unveiling). There were of course dissenting and incredulous voices. Even Arthur Keith expressed an initial anxiety that there were no large canine teeth actually in the jaw. The canines may have retrogressed, which would make Piltdown's claim to be the missing link really no more credible than Neanderthal Man. Dawson's band returned to the gravel pits, and soon produced a large canine tooth from the appropriate adjacent piece of earth. 'Dawn Man', as he was nicknamed, was complete, and took his place on the frontier of our antiquity. Charles Dawson was still not satisfied. In 1915 he shifted to a new site a couple of miles away and came up with another composite human-ape. Like the second manuscript Chatterton sent to Horace Walpole, this duplication could have been a disaster. But so perfectly did Piltdown Man satisfy archaeological and cultural needs that the second discovery did not destroy the authenticity of the whole. One could call Dawson a liar and contest the provenance of the relics, but that still left the relics themselves. It was, after all, impossible to refute Dawson's story other than by evidence from the 'text'—the fossil bones. There was no other way of countering Dawson's testimony. In any case he died in 1916, leaving those opposed to Piltdown with no possibility of cross-examining him. The manner in which the two halves of the Piltdown skull were linked was scientifically respectable. They had been found literally cheek-by-jowl. They had the same iron staining from the gravel. To Arthur Keith Conan Doyle's fiction had been realised in fact:

> there was revealed, for the first time, a human race in which the canine teeth were pointed, projecting, and shaped as in anthropoid apes. That we should discover such a race, sooner or later, has been an article of faith in the anthropologist's creed ever since Darwin's time.
>
> (*Keith*, 1915, p. 447)

Piltdown Man's modern home became the British Museum. There, with Smith Woodward's help, the Dawn Man was protected from troublesome and inquisitive investigators. The

perfect residence for what the *Manchester Guardian* called 'the first Englishman' (quoted in Reith, 1970, p. 41) had been found. This is not to say that the Piltdown fraud was perpetrated by the inner coterie of the British Museum. But there is a strong possibility of a certain amount of complicity in not wishing this national treasure to be pried into too closely. The pressure for a fresh analysis grew as more Ancient Men were found around the world. Australopithecus, discovered in South Africa, showed reverse characteristics from Piltdown. The jaw had become human-like before the upper skull: canines retrogressed before the brow-line. Nevertheless it was not until 1949 that permission was granted to carry out scientific tests on the Piltdown skull. The same pattern of events that occurred with T.J. Wise's forgery was about to take place. A forgery was to advance a specialist field of knowledge by its destruction.

During the Second World War K.P. Oakley, a junior geologist and anthropologist at the British Museum, came across the long-forgotten fluorine dating test that had been used on the Calaveras skull. The older bones are the more fluorine they absorb from the earth. Oakley asked to apply the test to Piltdown. His request for a sample was grudgingly granted. He was only allowed to drill away a tiny amount of bone from the cranium, too little for a conclusive result, but sufficient to reduce the antiquity of Piltdown Man from 500,000 to 50,000 years old. Oakley picked up a scent. With the help of J.S. Weiner and other scientists concerted pressure was put on the British Museum for a larger test sample to be made available. The Museum succumbed, and the full might of modern science was unleashed against our increasingly fragile ancestor. J.S. Weiner recalled the 'whole battery of chemical and physical tests' employed and the use of 'anatomical, radiological, and chemical' analyses (*Weiner*, 1955, p. 34). So in 1953 Piltdown Man received its death-blow, its human and simian halves torn apart. The most startling results related to the jaw. Whereas the skull was really thousands of years old, the jaw was that of a modern orang-outang. All the various parts of the composite head had been given an artificial iron stain. The molar teeth had been filed flat to give them the human quality of being worn by mastication. The bone of the jaw was so fresh it burnt when drilled. The revelation was quickly parodied. In a cartoon in *Punch*, for example, an ape sits terrified

in a dentist's chair. The dentist is saying 'It will probably hurt, but I'm afraid I've got to extract the whole lower jaw' (Reith, 1970, p. 46). J.S. Weiner reckoned that most of the pieces of the Piltdown jigsaw, like some of Schliemann's treasure, could have been picked up on market stalls. The newspapers were characteristically quick to find victims and scapegoats for the hoax. 'The Missing Link Hoax: Experts Spoofed by Monkey's Jaw', 'A Lawyer made a Monkey out of Scientists' read some of the headlines (quoted in Cole, 1955, p. 158). Away from the glare of stagelights a more interesting reaction is that of A. T. Marston, a London dentist and amateur archaeologist who had discovered the Swanscombe skull in 1935. He had apparently been telling Oakley for years to apply modern science to Piltdown. The British Museum had stood in the way:

> Those who besmirch the memory of Mr. Dawson are hiding their own sycophantic servility to the traditions of the British Museum. It is the British Museum who for years have been playing a hoax on the public by presenting the Piltdown skull, the so-called 'missing link', as something authentic. Now they have knocked the guts out of their own argument.
>
> (Cole, pp. 159–60)

The value of a cultural object is determined externally. J.S. Weiner expressed relief: 'the end of Piltdown man is the end of the most troubled chapter in human palaeontology' (*Weiner*, p. 204). From that point independent and reliable dating methods existed. But Weiner could not predict an end to archaeological forgery. He might have asked a more pertinent question: what is the complexion of 'genuineness'? So long as there is more to authenticity than we are led to believe, forgery will continue to be both a meaningful concept and a threat.

A forgery, even the best can hardly be said to exist on the same plane as a genuine work of art

George Savage, *Forgeries, Fakes and Reproductions* 1976

At the present time there is no good reason for thinking that forgeries are intrinsically aesthetically wrong, and the claim that they are is ruled out by the most acceptable theories of the aesthetic available

Michael Wreen in *The Forger's Art*, ed. Dutton (1983)

The objects on display range from straightforward 'modern' copies of sixteenth-century pieces, acquired by the Museum purposely as copies, and examples that were deliberately made to deceive and evidently did so. Between these two extremes lie works that were produced as modern pastiches of earlier styles— some of which were sold by later owners as authentic examples—and objects that are in part of early date but which have been adapted, redecorated or otherwise 'improved'.

Wall display in the 'Fakes and Forgeries' room of the Victoria and Albert Museum, London, 1984

5

Crusaders against the Art Market:
Hans van Meegeren and Tom Keating

The two most famous and interesting cases of forgery in the visual arts both belong to the twentieth century. The fake Vermeers of Hans van Meegeren were exposed at the end of the Second World War; Tom Keating's Samuel Palmers in 1976. The story of both forgers is well documented, and the similarities are revealing. In both cases the authenticity of their paintings eventually confronted the authority of the law courts. On trial however was more than two elderly painters. The whole question of the *value* of a work of art in the art world was subjected to rigorous scrutiny. The means by which such value is determined emerged considerably tarnished.

Since the boom in art collecting in the nineteenth century there has been a tendency to equate the financial value of a work of art with its aesthetic value. The art market has become a place for lucrative investment. Yet the artist whose name is often so crucial in commanding a high price is at the bottom of the money-making chain. Dealers, auctioneers, collectors—the equivalent of publishers in the literary world—have the most to lose in the promotion of 'great' art. A safe way to ensure good returns is to further the cult of the original artist, to convince the buyer of the sheer worth of a unique, original production of a famous mind. A few scribbles by a master will almost certainly fetch a higher price on the market than a first-class picture by an unknown artist. To a bemused public who see astronomical sums of money exchanged in the auction room, it seems the focus is on the artist's signature rather than the work as a whole. These points may all seem obvious, but they need to be stressed because forgeries expose the power and expediency of the trading

system. Van Meegeren and Keating are not the only forgers to claim the target of their forgeries was not merely sham critics but the corruption of the art market. Middlemen have been accused of complicity, of trafficking in fake provenances and signatures. Dealers have even been presented as the forgers: taking works given to them as pastiches and passing them off as original. The famous 'confidentiality' with which dealers and auctioneers protect their clients has often been called into doubt.

Two conclusions are to be drawn from the success of a forgery. First, the pundits who serve the market by issuing certificates of authentication and aesthetic judgements have had their critical authority cast into doubt. Second, the possible covering-up by dealers with a vested interest in the sale of a picture becomes a mooted issue. The first consequence is the easier drubbing for the market to bear. Critics can be cashiered and scapegoated. The more serious questions about attribution may be left untouched. The large amounts of capital involved in the art trade make the need to define *bona fide* original works of art even more urgent and powerful than in the literary world. Yet Boswell's comment that the '*Filiation*' of a work is 'difficult of proof' is applicable here too.

The problems for attribution begin with the 'birth' (as Boswell put it) of the work. We have seen the difficulties for aesthetic theory created by collaborative authorship. The image of a workshop of artistic production is nearly always denigrating. Such a mechanistic view of the creative process is in opposition to the Platonic mysteries of the individual artist. Arthur Freeman imagined T.J. Wise's workroom as a 'factory' of forgery (ironically reviving the root meaning of the word). Forgery, as an example of bad art, becomes an unoriginal act, more akin to Edward Young's idea of imitation. Yet for some of the Renaissance masters such an image was a reality. Rembrandt, Rubens and others had schools of painting. Apprentices would do much of the essential brushwork. The master acted as manager, guiding and polishing. Rubens's works have been categorised into six grades: pictures entirely by Rubens; works which Rubens sketched for his assistants, supervised and later touched up; works in which a formal division of labour took place; workshop pictures painted in the spirit of Rubens by his followers, in which his personal share was small; school copies

without Rubens's personal participation; copies executed by other schools, sometimes to order (Arnau, 1961, p. 72). Only the first of these formulas follows the strict rules of authenticity. The others, like the Apocrypha, have a highly ambiguous status. Frank Arnau has asked, 'What is a genuine van Dyck? What percentage of personal intervention by Rembrandt is required to make a painting a "genuine" work by that master?' (Arnau, p. 14). Today, it seems, nothing less than total intervention is required. In late 1982 it was revealed that two Rembrandts in the National Gallery in London 'could no longer be accepted as genuine products of the Dutch master's brush' (*Guardian* October 23, 1982, p. 24). 'Tobit and Anna' and 'A Man Reading in a Lofty Room' were reattributed to 'Rembrandt's pupils or imitators between 1625 and 1631'. Their financial value plummeted. Had these pictures now become contemporaneous forgeries? David Piper, director of the Ashmolean Museum in Oxford, felt that a stigma had been imposed on the paintings. He defended their aesthetic value:

> What it all comes down to in the end is that however often the labels change, the quality of the picture remains the same ... the Chinese have no such concept of originality. They see things in terms of the quality and how it's done.

Piper attacks the basic assumptions about art in the West. He is unhappy with the idea that 'because a picture is not by so-and-so, it is somehow evil'. In these radical comments authenticity is subordinated to beauty. Looking elsewhere, it is known that the painter Boucher was one of probably many masters who put his signature to his pupil's works (Tietze, 1948, p. 13). Does this constitute forgery? Only of course if culture requires it to be so. The existence of 'school' paintings implies that the rules of authentic creation were more relaxed. We cannot however totally excuse the masters on the grounds that they had no concept of forgery. For example, take one of the greatest of all masters, Michelangelo.

Vasari in his *Lives of the Most Excellent Painters, Sculptors, and Architects* (1550), tells how the young Michelangelo was encouraged by a Milanese dealer to give a false patina to a statue of a sleeping Cupid. The statue was then sold to Cardinal San

Giorgio for two hundred ducats as a genuine antique. Later the Cardinal discovered the truth and demanded his money back. The interesting part of this account is Vasari's defence of Michelangelo's indulgence in forgery. Vasari's comments are very similar to David Piper's defence of school Rembrandts:

> Cardinal San Giorgio cannot escape censure for what happened, since he failed to recognize the obvious perfect quality of Michelangelo's work. The fact is that, other things being equal, modern works of art are just as fine as antiques; and there is no greater vanity than to value things for what they are called rather than for what they are. However, every age produces the kind of man who pays more attention to appearances than to facts.
>
> (Vasari, 1979, p. 238)

Ironically, Vasari's words could have more to do with his awe of Michelangelo than an ahistorical, non-individualist view of art. The sleeping Cupid forgery has been lost. Needless to say, if it was discovered today it would be priceless.

There is a story that in 1603 Rubens was sent by Gonzaga, Duke of Mantua, to deliver to the Spanish court facsimile copies of paintings and mosaics by Pietro Facchetti in the Chigi Chapel of Santa Maria del Popolo. The copies were damaged en route. Rubens restored them, adding two new pictures which he allowed to be accepted as legitimate copies by the King (Mendax, 1955, pp. 149–51). When Sir Dudley Carlton requested genuine Rubens pictures in 1618, Rubens actually supplied him with school works 'retouched so skilfully by my own hand that they can hardly be distinguished from the originals' (Wraight, 1974, p. 106). Restorations, imitations, reproductions: all can become species of forgery. At a recent multi-disciplinary symposium on problems of authenticity in the visual arts, J. Bruyn confessed his inability to 'draw the dividing-line between school-pieces and forgeries' ('The Concept of School', in *Jaffe*, 1977, p. 24). Such shadowy works are particularly subversive. As potential contemporaneous forgeries, they cannot be attacked by dating techniques. Nor can stylistic considerations necessarily segregate them from the master's originals. A chronological gap does not enforce the difference between the original work and its imitation, as is the case with many forgeries. Reliance may have to be made on the absence in the school work of the true touch of genius that identifies the master's hand. The school piece can

then be called an imitation. But as Frank Arnau points out, 'the truly great names in painting were constantly producing imitations' (Arnau, p. 47). Arnau couples together several examples of pictures whose similarities must border on visual plagiarism: Rubens's and Jan Scorel's portraits of Paracelsus; a Rembrandt figure of Christ and the equivalent in Dürer's 'Christ Scourging the Money Changers'; Raphael's 'Holy Marriage' and Penigno's 'Wedding of a Virgin'; Rubens's and Titian's 'Adoration of Venus'. Arnau concludes 'the boundaries between permissible and impermissible, imitation, stylistic plagiarism, copy, replica and forgery remain nebulous' (Arnau, p. 45). We realise that works of art are a collaboration between artists alive and dead, between styles of the past and present, between those who make the pictures and those who distribute and display them. It is the interpretation put on these procedures by culture that is so revealing.

If the Renaissance art world, like eighteenth-century literary England, is a hotchpotch of contradictory assumptions and practices, by the nineteenth century the centrality of the cult of the original artist had been established and the great age of acquisition begun. Major forgeries also began to appear. We can only deal with the most notable cases.[1]

Giovanni Bastianini (1830–68) was an Italian sculptor, whose brilliance at working in the Renaissance style was soon spotted by a Florentine art dealer. A series of pastiches followed which entered major European collections. It is uncertain whether Bastianini knew of the fate of his works. It is certain that the dealer Antonio Freppa made large profits. The most famous sculpture, a terracotta bust of the Florentine philosopher Benivieni (1453–1542) made in 1864, was sold to the Louvre in 1866 for 13,250 francs. Other 'cinquecento' sculptures went to the Victoria and Albert Museum in London and the Jacquemart-André Museum ('La Chartreuse Florentine'). The whistle was eventually blown by Freppa himself, who claimed he had been double-crossed by other dealers. The Louvre refused to accept their statue was a fake. Either they genuinely believed this, or they were protecting their reputation.[2] Either reaction involved serious repercussions for the art world. An extraordinary inversion had taken place. Bastianini was denied ownership or 'filiation' over his own creation. Those mystical ties linking the

work and its maker had been severed. Bastianini had to prove his work's authenticity: its genuineness as a fake. He had to fight the cultural authorities for the authority of his work. His opponents let the case rest on the notion that a great original work is inimitable. A reward of 15,000 francs was offered to anyone who could match the bust of Benivieni. Bastianini's response was published in a newspaper:

> Deposit your 15,000 francs in safe hands. We will then choose between us a jury, not composed entirely of Frenchmen, and I will for my part guarantee to make a bust, for 3,000 francs, as good as the *Benivieni*.
>
> (Jeppson, 1970, p. 22)

Unfortunately Bastianini died before the trial could occur. The exposure of cultural litigation was left to later forgers. His works were demoted. The Victoria and Albert Museum continued to exhibit them as neo-Renaissance pastiches, and they are now in the 'Fakes and Forgeries' gallery.[3]

The Louvre was at the centre of another storm which broke near the end of the century. In Odessa in 1895 a Russian goldsmith and engraver named Israel Rouchomowsky was hired by a bogus dealer to produce a gold tiara in ancient Greek style. Rouchomowsky came up with the 'Tiara of Saitaphernes' (a barbarian king who sacked the city of Olbia). Rouchomowsky was paid 2,000 roubles. Via several other dealers the tiara was bought by the Louvre for 200,000 roubles. The relic was first displayed, with an unconscious sense of irony, on 1 April 1896. Initial doubts about its authenticity only added to its glamorous appeal. Various claims to its authorship were made. Rouchomowsky decided to stake his own claim. His confession appeared on the front page of *Le Figaro*, 25 March 1903 (Tom Keating was to make the front page of *The Times*, as we shall see). Once again the Louvre remained implacable. Rouchomowsky came to Paris in a wave of publicity. He had acquired a heroic Chattertonian aura of the rebel snubbed by authority. Ironically, copies of the tiara were selling in great numbers (Jeppson, p. 29). At the official inquiry Rouchomowsky won his case by making a new tiara in front of all those present. No one could disbelieve their own eyes. Rouchomowsky had proved he was not a fake faker. More importantly, he had undermined the closely-guarded

secrecy of the act of composition. He gave a public 'birth', a rare event. His victory was, however, a Pyrrhic one. He returned to Odessa disillusioned and embittered. To vent his spleen he made 'Saitaphernes of 1895' and 'Saitaphernes of 1903'.

The extraordinary achievements of Rouchomowsky's twentieth-century counterpart Alceo Dossena earned him the soubriquet 'aristocrat of forgery'. Shortly after the First World War he was hired by unscrupulous dealers to produce Renaissance-style sculptures. Again his forgeries only came to light because Dossena himself confessed in 1927. He claimed he had sold his works as pastiches, not originals. He transferred the transgression on to the dealers. His confession was in outrage at discovering his works had permeated most major Western art collections at an estimated value of $2,175,000 (Jeppson, p. 57). Here again was a forger seeking revenge on the art market's corrupt merchants. Examples of the success of Dossena's forgeries were his 'Mutilated Athena', bought by the Paris dealer Jakob Hirsch for 30,000,000 lire, and a wooden sculpture after Giovanni Pisano (c. 1249–1314) which went to the Cleveland Museum of Art for $18,000 (the 'Athena' subsequently went there in 1927 for $120,000). Dossena's confession was eventually accepted. Though he died penniless in 1937, he became a cult figure among art historians. He left an indelible mark on many minds high up in the art world. The Boston Museum of Fine Arts, for instance, had purchased a Dossena sarcophagus in 1924 for $100,000. When the revelation burst in 1927, the sarcophagus went to the basement. In 1935 the new director George Harold Edgell requested it be re-exhibited. The Museum's managing committee agreed, on condition that there be an inquiry into its authenticity. The findings of this inquiry were that Dossena had modified a genuinely old tomb, adding, for instance, a spurious coat-of-arms. Edgell was free to exhibit the work along with the inquiry's findings. He also added a note of his own:

> The director would like to emphasize ... that the tomb is put on exhibition because it is a beautiful object. The public is entitled to the opinion of the Museum as to its condition and authenticity, which the Museum hereby announces. Nobody ... would deny the beauty of the tomb and therefore the propriety of its exhibition.
>
> (Jeppson, p. 66)

111

The propriety of aesthetics could not rule for long. The tomb went back to its own tomb in 1954, presumably only to be resurrected for an exhibition of fakes and curiosities.

Another mandarin in awe of Dossena's abilities was Dr. Hans Curlis, Director of the Institute for Cultural Research in Berlin. Before Dossena died Curlis made a film of him at work entitled 'The Creative Hand'. Curlis wrote and narrated the commentary. The conclusions Curlis draws from the experience are very radical:

> We had witnessed the reincarnation of a Renaissance master and an Attic sculptor. To an art historian, at least, but also to me, this is at once an alarming and enthralling thought. One of the fundamental laws governing our attitude to all art seems to have lost its meaning, the law according to which a work of art can only originate once, at the point where certain temporally determinate causes intersect. It is as though causality has been suspended and its dogmas cut adrift from the safe anchorage of experience.
>
> (Arnau, p. 224)

Dossena had liberated authority from authenticity and ended the monopoly of 'uniqueness'. Frank Arnau is reluctant to agree with Curlis's view, stating that even a 'creative' copy such as Dossena's is separated from the original by 'an unbridgeable chasm of spiritual and temporal incompatibility' (Arnau, p. 194). But a few pages later he admits that Dossena's work 'seemed, in a fundamental sense, empirically genuine' (Arnau, p. 221). Aware of the incompatibility of his own views, Arnau can only find one way out: 'there are no absolute rules or norms in the domain of art' (Arnau, p. 222).

Before Dossena died, forgery had hit the headlines again. In 1932 the trial began of a Berlin gallery owner named Otto Wacker. He was convicted of displaying fake van Goghs and sentenced to one year in prison. Wacker's source has never been located. It has always been assumed Wacker himself painted the pictures. The discrediting of the Wacker van Goghs had not proved an easy task. Wacker had begun to display them in the late 1920s. He obtained certificates of authentication from experts, including Julius Meier-Graefe, art reviewer for the highly respected *Frankfurter Zeitung*. Thirty Wacker van Goghs were canonized in J. Baart de la Faille's *L'Oeuvre de Vincent Van Gogh: Catalogue Raisonné* (1928). When suspicions about the

pictures were traced to Wacker, it took four years for police and art experts to assemble their case. Wacker was convicted mainly on circumstantial evidence. The pictures remained an irritation. Meier-Graefe testified that

> some of Wacker's van Goghs were of such high quality that, if proved false, no expert in future would ever be able to distinguish between true and fake van Goghs with any certainty.
>
> (Jeppson, p. 84)

The words were prophetic. Of the thirty Wacker van Goghs originally authenticated by de la Faille and subsequently rejected, six were reclaimed. One of the thirty, a self-portrait, was hanging in the National Gallery in Washington in 1970 (when Jeppson's book was published).

Van Gogh's nephew Vincent Wilhelm, who gave evidence at Wacker's trial, had a rather different view of the same problem. He had devoted his life to establishing the true canon of his uncle's work. This required the elimination of fakes. The major obstacle was not aesthetic inability to distinguish the true from the fake picture, but rather the corruption of art dealers. Wilhelm saw them as 'impregnable defences erected by rich and powerful persons in whose interest it was that certain secrets should not be revealed' (Jeppson, p. 86).

Hans van Meegeren

The case of the Dutch forger Hans van Meegeren is perhaps the most spectacular instance of a clash between aesthetics and authority. This conflict incarnated itself in a Dutch court room in 1947. Van Meegeren stood accused of treachery. The charge was that during the war he had sold a painting by the seventeenth-century Dutch master Vermeer to Nazi leader Hermann Goering for £165,000. If found guilty of such collusion with the enemy van Meegeren would be executed. He came up with a remarkable defence. He claimed that the Vermeer sold to Goering was a fake painted by himself. Hence he had duped rather than co-operated with the Nazis. Van Meegeren needed his charge to be commuted to an offence against culture rather

than the state. His confession fell on deaf ears. So, like Bastianini and Rouchomowsky before him, van Meegeren had to prove his artistic guilt: the genuineness of his fakes. This involved laying claim to other works by Vermeer and his contemporaries which had found their way into major collections before and during the war. Van Meegeren had to paint a 'new' Vermeer in front of the authorities before they would commission a scientific investigation of the suspected works. He eventually won his case and was branded forger rather than traitor: artistic not political offender. The strain of the trial took his life before he could serve his year's prison sentence. Never has the question of the criminality of the forger been so intensely at issue. George Savage has stated recently: 'There is no reason why art-forgery should not be punished as severely as cheque-forgery, larceny, counterfeiting, or fraud, since there is no moral difference between any of them' (Savage, 1976, p. xi). For van Meegeren the 'difference' between a crime against art and a crime against the state was a matter of life and death. Let us look at how this remarkable situation arose.

Before he turned to forgery in the 1930s van Meegeren was a respected if not famous artist. While studying architecture at the Delft Institute of Technology in 1912–13 he won first prize in a painting competition organised by the General Sciences Section. He switched to studying art and gained his degree at the Hague in 1914. He had two successful exhibitions there in 1916 and 1922. He made a comfortable living giving lessons and painting portraits. His drawing 'Queen Juliana's Deer' was his most famous pre-forgery work, finding its way on to calendars and greeting cards. He was a member of the prestigious Haagsche Kunstring, whose chairmanship he failed to win in 1932. This snub provoked his resignation. He retired to the côte d'Azur to begin forging. Over a period of many years he perfected techniques used by the masters and ways of artificially giving the appearance of age to his works. In 1937 he posed as the owner of a newly discovered Vermeer 'Disciples at Emmaus'. The authentication of the work went to one of the greatest scholars of Dutch seventeenth-century art, Abraham Bredius. Though in his eighties and defective in his sight (Dutton, 1983, p. 30), Bredius authenticated 'Disciples at Emmaus' in two days. His fulsome praise for the lost masterpiece appeared in *Burlington Magazine*

in September 1937 under the heading 'A New Vermeer':

> It is a wonderful moment in the life of a lover of art when he finds himself suddenly confronted with a hitherto unknown painting by a great master, untouched, on the original canvas, and without any restoration, just as it left the painter's studio ... in no other picture by the great Master of Delft do we find such sentiment, such a profound understanding of the Bible story—a sentiment so nobly human expressed through the medium of the highest art.
>
> (quoted in Dutton, pp. 30–1)

The 'new' work was bought by a conglomeration of dealers, collectors and pundits for 520,000 guilders (about £1 m by 1983 standards), by any standards a staggering amount. According to Hope B. Werness, van Meegeren's share was two thirds, sufficient to make him wealthy for life (Dutton, p. 37). This did not mean his career as forger was at an end. A stream of forgeries flowed from his brush unhindered by the Nazi occupation of the Netherlands. They allowed the art trade to continue. Van Meegeren's fakes went to private collectors and the Dutch state. The canon of his forgeries (itself an ironical undertaking) has not yet been fixed. The most recent summation by Hope B. Werness credits van Meegeren with eleven Vermeers (including 'Christ Teaching in the Temple', painted in prison), two de Hooghs, two Terborchs, three Halses and a Baburen. Though this output falls well short of Tom Keating's estimates for his own career (see below), van Meegeren's penetration of the art market was considerable.

The problems began after the war. A Vermeer ('Christ and the Adulteress') was found in the private collection of leading Nazi Hermann Goering and traced to van Meegeren, its supposed owner. He was arrested by the Netherlands Field Security Service in May 1945 and charged with collaboration. The course of events described earlier then occurred. Van Meegeren confessed to forgery. He tried to prove the 'filiation' of his work by painting a Vermeer in front of witnesses. Clearly the 'self-evidencing light' of his works had not revealed their creator. The Dutch authorities, considerably perplexed and embarrassed, had no choice but to defer to cultural 'forensics' and appoint a commission of inquiry. Its head was P.B. Coremans, director of the Central Laboratory of Belgian Museums. He assembled a

formidable team. Their job was not only to date the Vermeers van Meegeren had claimed, but to rule on the possibility that he could have painted them, if they turned out to be modern. Hence the team sworn in on 1 June 1946 comprised three technicians and two aestheticians. The scientists were Coremans, W. Froentjes (advisor on chemistry to the Dutch Minister of Justice), and A.M. de Wild (picture expert at the Hague). Their findings were checked by Professor H.J. Plenderleith (Head of the British Museum Research Laboratory) and F.I.G. Rawlins (Head of the National Gallery Research Laboratory, London). The art experts were J.Q. van Regteren Altena (professor at the University of Amsterdam) and Dr. H. Schneider (ex-director of the State Office for the History of Art Records at the Hague). Coremans also consulted many other experts (see P.B. Coremans, 1949, pp. vii-viii). The inquiry's report took nine months to complete. After extensive scientific tests the paintings were declared modern. Stylistic comparisons with van Meegeren's acknowledged work showed that he could have been the artist. But now that he had been accepted as a forger, van Meegeren still posed a problem for the legal authorities. What should he be charged with? He was eventually prosecuted for defrauding one of his customers, the same charge to be brought against Tom Keating—that is, an economic offence. The aesthetic and cultural consequences of his forgeries did not have to be faced inside the courtroom.

But the reverberations spread beyond the trial. Van Meegeren is reported to have said his motives were to expose the ignorance and petulance of the critics who, like Bredius, support the art market.[4] These 'self-appointed judges' as Lord Kilbracken calls them in his biography of van Meegeren (Godley, 1951, p. 13) issue warrants of originality, the basic requirement of meaningful or valuable art, as well as deciding on whether a work is good or bad. Van Meegeren believed that in his early career he had been 'systematically and maliciously damaged by the critics, who don't know the first thing about painting' (Dutton, p. 48) and it became his duty 'to prove, once and for all, their utter incompetence, their shocking lack of knowledge and understanding' (Klein, 1970, p. 106). He can be seen to have had some success. The art world was brought into disrepute. For instance, Dr. Hannema, director of the Boymans Museum in Rotterdam,

admitted at the trial that business rather than aesthetic sense influenced his decision to buy 'The Washing of Christ's Feet' for well over £100,000, noting that 'Vermeers are scarce' (Godley, p. 217). Lord Kilbracken has championed what he believes was van Meegeren's mission:

> van Meegeren felt that the standards of artistic recognition were hopelessly astray; that judgements were made falsely and that the value of a picture was related to no intrinsic merit, but to the extent to which the painter was well-known and in fashion. Not only (he believed) were these self-appointed judges unable to distinguish between the false and the true; but having decided, perhaps wrongly, who had painted a picture, they valued it simply by the reputation of the name. He hoped to expose them once and for all, to place their incompetence beyond a shadow of a doubt.
>
> (Godley, p. 13)

Kilbracken ends his biography with a series of questions about van Meegeren that are not answered. Should we consider

> that he was a charlatan—or genius? That he had perpetrated a series of disgraceful frauds, to benefit himself—or that he had planned simply to discredit a corrupt and incompetent system? That the forging of a series of 'Vermeers' was nothing to prove his artistic talent—or that he had shown himself the master of a new and original art, requiring its own particular genius and in which he had never been surpassed?
>
> (Godley, pp. 208–09)

Much will have to change before forgery can be seen as a 'new and original art'. Kilbracken leaves forgery suspended between the acceptable and the unacceptable, a position it often occupies. Forgery is particularly productive of dichotomies. As Godley says: '"Is this a good picture?" or "Is this a Vermeer?"—which question, in the end, does the collector ask himself?' (Godley, p. 171). The question can only be answered if those laws governing our attitude to art are spelt out. There is nothing innately wrong with treating a work of art like any other piece of merchandise as long as such an approach is not hidden behind bogus aesthetic claims. Van Meegeren had a limited victory in exposing some of this sham.[5] Thirty years later Tom Keating administered another painful emetic to the art world.

Tom Keating: *Art Trading and Faking*

In July 1976, *The Times* exposed several fake works supposedly by Samuel Palmer, the early nineteenth-century British artist. The drawings were all pastiches of Palmer's 'Shoreham' period (1825–35). Some of them were owned by Leger galleries in London. In a now familiar reaction, Leger were initially incredulous; at least that was the public face they wore. They had sold one 'Palmer', 'The Horse Chestnut Tree', at Christie's for £15,000, and another for £5,000 at Philips' in 1975 ('Shoreham Moonlight'). Both these works had been canonized in James Sellar's *Samuel Palmer* (1974). But scientific analysis of 'Shoreham Moonlight' by Julius Grant (the forensic paper expert who examined the Hitler diaries in 1983) found the work to be modern. The author of *The Times* revelation was the sales room correspondent, Geraldine Norman. She ended the piece with a sly request: 'Somewhere there is a talented painter at work, and I would love to meet him (*The Times*, 16 July, p. 12). Norman thereafter managed to steer a course between openly advocating forgery and openly rejecting it. She tracked down the forger, Tom Keating, and many of his works, but championed his cause of exposing the market psychology of the art world. She brought Keating's forgeries on to the front page of *The Times* and also helped to shadow-write his autobiography. Her investigative journalism won her the News Reporter of the Year award. Keating subsequently went to court on fraud charges. The outcome of his trial was as interesting as van Meegeren's, as we shall see. Before his death in 1984, Keating became an institutionalised rebel: the reformed rogue, no longer a threat. Forgery still has a way to go before it is absorbed into mainstream culture.

A few weeks after *The Times* scoop, Norman had interviewed Tom Keating. She described him as 'a talented artist and picture restorer' who bore a grudge against 'the art establishment' (*The Times*, 10 August). A few biographical details were given. They showed Keating to be an underprivileged working-class radical more in the Chatterton than Dossena vein. After failing his art diploma at Goldsmiths College in London—'scoring high points for painterly technique but falling down on original composition' (10 August, p. 1)—he struggled to make a living as a restorer.

His forgeries began when dealers sold his restorations as originals. Ten days later Keating confessed openly in a letter to *The Times*. His self-denigrating ironies are reminiscent of W.H. Ireland. He claims he was amazed his 'crude daubs' could be taken seriously, and of his Palmers he says no one 'with a true love of this kindly, generous and devout artist' would have been taken in:

> I flooded the market with the 'work' of Palmer and many others, not for gain (I hope I am no materialist) but simply as a protest against merchants who make capital out of those I am proud to call my brother artists, both living and dead.
>
> *(The Times, 20 August, p. 13)*

Keating's forgery binds him closer to other artists, while critics and 'merchants' are shouldered out of the way. Keating also claimed his forgeries were a way of studying the craft of his fellow workers:

> I was openly working on a series of paintings depicting 'the masters at work' (Constable, Degas, etc.) which I hoped to finish by the end of the year, and then disclose the ruse.

This scheme eventually saw fruition in a television series and linked exhibition 'Tom Keating on Painters'. One can imagine the irritation and hostility festering in the bosoms of critics and dealers reading Keating's confession. So much critical endeavour is expended deciding what gives an artist his or her distinctive style. Keating suggests that not only has such labour proved inadequate in detecting his bogus Palmers; the forger is much more intimate with the master than the critic or pundit can ever be. The attempt to prove uniqueness often avoids the imitation or imitative content present in most works. As Geraldine Norman said in Keating's 'autobiography' *The Fake's Progress*:

> Some people might argue that to work in another artist's style automatically precludes originality or 'inspiration'. But they do so at their peril, for the history of art is a history of borrowings and adaptations. All artists lean on the experience and achievement of others and the work of different artists is often hard to tell apart, even when there has been no conscious attempt to deceive.
>
> (Keating, *et al.* 1977, p. 200)

While the full extent of Keating's *oeuvre* was being investigated by Norman, Keating's confession turned the correspondence columns of *The Times* into a hotbed of debate about the conflicting material and aesthetic facets of the art world. The radicals were the first to find voice. The conventions under which the art world operates were heavily attacked. One correspondent noted:

> The art world seems as bad at defining philosophical issues as it is at recognizing Tom Keating's paintings. Either art critics, dealers and people wanting to buy artefacts should assess and value a work of art according to aesthetic criteria—about which there would and should be argument; or they should be priced according to demand and rarity value. Under the first system *there would be no concept of forgery*. A painting would be bought because it was liked and considered good. Under the second, a man might as well make a collage out of a krugerand. The values that prevail in the art world at the moment say more about capitalism than they do about artistic merit.
>
> (*The Times*, 24 August 1976, p. 11; emphasis added)

This book has shown that the existence of art in society has never been purely aesthetic. The disappearance of forgery posited in the above passage does not demand an extinction of the art market altogether—only a revision of its values. A second letter was more forthright in denouncing the debasement of aesthetic merit by merchandising works of art:

> If anyone enriches the world by giving us a work as good as the originals we should be grateful. That they have to sign the work by a false name is *our* fault. It reflects the artificial values created and fostered by the dealer/collector relationship. They are sellers and buyers of signatures and even the most trivial and worthless scribble can change hands for thousands of pounds if it can be authenticated as a genuine Guardi or Leonardo etc. If finding some old documents in a back street in Delft were to prove the Rembrandts in the National Gallery false it would not reduce their real value at all. They would still be the masterpieces they were last week—except of course to the dealers.*

The defenders of individualistic originality were prompt to reply. Alan Jacobs, a gallery owner and one who had much to lose if his

*See above, p. 107; the words were prophetic.

values were shown to be 'artificial', payed homage to the original artist:

> If a work of art is to be appreciated fully, not partially, it is important to know, if possible, exactly who the artist was. It gives more aesthetic meaning to relate each work to a documented artist's life and development than merely to let it 'speak for itself' without any such reference. The concept of forgery is an attempt to deceive and it makes nonsense of art history to take seriously the suggestions made by some of your correspondents that it would not affect the value, in aesthetic terms, if we did not take the name of the artist into account.
>
> (*The Times*, 25 August, p. 13)

Forgery may well make nonsense of art history, as Thomas Warton noted in relation to Chatterton's forgeries. Forgery runs counter to the principles upon which most art and literary history is still established: one original artist is replaced by another, the passage of time or merely their separate existence stamping on their works individual uniqueness. Jacobs' letter actually avoids the central point of the earlier attacks: the turning of art into investment merchandise. No defences of this position were forthcoming. Instead the cult of originality was worshipped. Another correspondent stated:

> The difference between original and fake is the difference between art and artefact. Surely it is Palmer's original Shoreham period vision which makes these works valuable, rather than their technical ability which Mr Keating seems able to match?
>
> (*The Times*, 27 August, p. 13)

This inspirational view of art, that an artist's 'vision' which informs the works is a once-and-only-once event not reproducible, was reiterated a few days later: 'An artist's idea of the world can only reside in the works he leaves behind him ... to fake is to grasp the mannerism, not the idea' (30 August, p. 7). By this criterion forgery is prohibited from possessing any of that mysterious 'idea' or 'vision'-producing faculty we would call creativity. But as Alfred Lessing has pointed out, mere technical copying does not constitute forgery:

> Forgery is a concept that can be made meaningful only by reference to the concept of originality, and hence only to art viewed as a *creative*, not as a

reproductive or technical, activity. Technique is, as it were, public.

(Dutton, p. 68)

Most of the forgeries looked at in this book have been 'new', creative works rather than copies. Hence their subversiveness. Lessing's words come from his famous essay 'What is Wrong With a Forgery?' written in 1964. The essay denounces the linking of authenticity with superior merit as having 'little or nothing to do with aesthetic judgement or criteria. It is rather a piece of snobbery' (Dutton, p. 58). So Lessing eschews notions of authenticity and declares that a van Meegeren Vermeer can be more beautiful than a true Vermeer. But the forgery is still flawed somewhere. Lessing locates the flaw, somewhat ironically, in art history. Assuming that most forgeries are historical, Lessing points to the 'disparity or gap between its stylistically appropriate features and its actual date of production' (Dutton, p. 73). So he actually falls back on the idea of historically generated authenticity; of a painter's style being unable to transcend its time. Lessing's theory would have problems with contemporaneous forgery. A shrewd *Times* correspondent told of the existence of a nineteenth-century Palmer faker named William Henry Brooke. The pertinent question was put: 'What was *his* motivation?' (31 August, p. 11). Presumably even a contemporary forgery can be declared to have no spiritual bond with the original. At his trial Keating is reported to have said he was inspired by the masters whose spirits 'came down and took over his work when he was painting in their style' (*Daily Telegraph*, 2 February 1979, p. 19). There is probably some bravado in the claim, which can never be validated. But the aesthetics of forgery oppose what Hans Tietze describes as the 'mysterious cell of individuality' which creates a work of art's 'essential uniqueness' (Tietze, p. 44). We remember Hans Curlis's belief that Alceo Dossena's forgeries liberated art from 'the point where temporally determinate causes intersect'.

Another pro-Keating correspondent to *The Times* pointed out a different 'disparity' to the one mulled over by Lessing and Curlis: 'the logical gulf between aesthetic and saleable value' (1 September, p. 13). Questions of merit 'begin and end with the paint on canvas'. The idea that in the work we possess the artist is a 'tenuous historical assertion'. But the art world had much to

lose if this 'assertion' were abolished. Keating's forgeries began flushing skeletons out of the varnished woodwork of galleries and auction rooms.

The purge began when Leger galleries struck a confidential deal with the buyer of 'Shoreham: Moonlight'. Leger agreed to take the work back. They did not refund the original price. They gave instead an undisclosed number of 'objéts d'art' in return for an assurance from their client that he

> would make no statement about whether the painting was authentic, that he would bring no legal proceedings against the galleries, and that he would not discuss with any expert the authenticity of the work, and that he would not speak to the press about the matter.
>
> (*The Times*, 14 August 1976, p. 2)

Putting such a muzzle on their client was guaranteed to raise suspicions that Leger were covering up. The sanctioning of this covert wheeling and dealing by the British Antique Dealers' Association (it supported Leger as acting with 'the utmost propriety'; 14 August, p. 2) only tainted its image. BADA (to use the acronym) announced it was setting up an inquiry into the Keating affair. The chairman was to be Sir Anthony Lousada, former chairman of the Trustees of the Tate Gallery. The panel would be 'responsible art historians, conservationists, technicians and painters' (*The Times*, 26 August, p. 13). The conduct and outcome of this inquiry were less than satisfactory. Its job was only to decide on the authenticity of thirteen Palmers, for which the expert, Julius Grant, was again called in. The larger questions, particularly the questionable practices of the art market itself, were not to be raised. Hugh Leggatt, himself a dealer, believed Keating 'pulled the art world's leg mercilessly because he feels the art world runs down artists. One has to admit that certain dealers do' (*The Times*, 21 August, p. 1). Leggatt wanted the true villains exposed: those dealers who manufactured and falsified provenances. He insisted Keating name names. Keating always prevaricated on this score. Partly perhaps he was protecting his friend Jane Kelly, who had once acted as his agent, claiming the Palmers were being imported from Ceylon where a descendant of one of Palmer's friends had taken them. Partly, though, Keating was leaving the art world to sort out the legalities of provenance itself. The notorious 'confidentiality' which surrounds

the owner-dealer-auctioneer-collector connection came under heavy fire. Keating was not asked to testify at the BADA inquiry. The implication was that he knew too much. He certainly tantalised the art establishment with talk of a certain 'Jim the Penman' who was said to add fake signatures to genuine pastiches (*The Times*, 28 August, p. 1). Keating's remiss attitude to his forgeries was also a source of great embarrassment. His prodigious output over many years was calculated at some 2,000 fakes ranging over a galaxy of famous artists. Again Keating left the job of sorting out the mess to the art world's expertise. Keating did exert his authority randomly, just to inject doses of humiliation into the situation. For instance, a few days before the BADA inquiry wound up, Keating claimed five Constables which were catalogued in Harold Day's *Constable Drawings* (1975). Such was the furore created by these constant revelations that in the House of Lords on 2 October 1976 Lord Chelwood asked if there could not be a Department of Trade investigation of the whole matter to vindicate the reputation of the British art world, a major economic asset. It was not to be. The clearly inadequate BADA inquiry had to suffice. Its results were announced on 29 October. Seven of the thirteen Palmers were declared to be of a later date than the Shoreham period (1825–35) but four of the seven fell within Palmer's lifetime.

The inconclusiveness of these findings 'amazed the world' as Geraldine Norman recalled (Keating *et al.*, p. 233). BADA had failed miserably to tackle the gravity of the problem. The possibility of a cover-up was again strong. The narrowness of the inquiry had been criticised from the beginning by the Society of London Art Dealers. Another august relative of BADA, the London and Provincial Antique Dealers Association, said the affair would have been better referred to the police (to whom it now went), and concluded 'the reputation of the British art market has been damaged' (*The Times*, 4 November, p. 17). So Keating's 'crusade against the art market, and their prostitution of art' as Geraldine Norman described Keating's mission (*The Times*, 27 August 1976, p. 1) seems to have had even more success than van Meegeren's earlier sortie. One of BADA's panel of experts had resigned in early September claiming there was 'too much hesitation, and too much secrecy' (*The Times*, 10 September, p. 2). The art expert Brian Sewell summed up in a

letter to *The Times* on 8 November:

> A benevolent onlooker might describe the art trade as the blind leading the
> blind; a less kindly observer would note its kinship to the back-street motor
> trade.

<div align="right">(p. 13)</div>

Nor was this the end of the indictment. As the affair moved
into 1977 and the police assembled a case against Keating, his
autobiography *The Fake's Progress* appeared. Though written in
the first person, the story was actually ghost-written by Frank
Norman based on lengthy interviews in which his wife claimed
she 'learnt more about the art world than in seven years as *The
Times* sales room correspondent' (*The Times*, 27 August 1976,
p. 1). The irony of a forger's life story being 'written by someone
else' was noted by one wily reviewer (*The Times*, 30 June 1977,
p. 14). The story contained no new revelations. The meat of the
book was Geraldine Norman's essay 'Art Trading and Art
Faking' which occupied the final third of *Fake's Progress*. The
piece contains many swingeing attacks on the corruption of the
art market. Dealers and auctioneers will not always guarantee a
sale against forgery, while putting into circulation many doubtful
attributions as well as 'genuine out-and-out fakes' (p. 203). If a
fake is discovered, the dealer can fall back on the inscrutable
façade of confidentiality to protect that all-important reputation.
The authority of the dealer stems from what Alfred Lessing
termed 'snobbery'. Norman calls it 'the aura of respectability
which now surrounds the upper echelons of the art trade' (p.
252). That 'aura' must be protected at all costs. Hence the appeal
for Norman of Keating's romantic working-class-radical image,
his 'old-fashioned socialism, a determination to fight for worker's
rights, for the exploited' (*The Times*, 27 August 1976, p. 8). The
thrust of 'Art Trading and Art Faking' was not however toward
aesthetic revaluation. The companion volume to *Fake's Progress*
was a catalogue of some 200 of Keating's fakes, identified with a
reasonable degree of certainty. Keating was a faker first, a radical
second.

Keating's case eventually came to court in early 1979. He was
charged with criminal deception to the value of several thousand
pounds. The paintings in question had been sold in the early
1960s. More dirty laundry from the art world appeared. David

Posnet, director of Leger gallery, admitted selling a Keating-Palmer for £9,400 even though its authenticity had been challenged by Sir Carl Parker, a Palmer expert. Keating's trial was not as spectacular as van Meegeren's. But the initial charges were again scaled down. The prickliness of forgery, the inability of the system to deal with its ambiguities satisfactorily, was again demonstrated. When Keating fell ill during the trial, the case against him was dropped.

Keating did not, like some of his predecessors, paint a new work by a master in front of the authorities. This was to be done in a much more institutionalised fashion. The plans Keating had for a series of studies of the masters achieved fruition in a TV series 'Tom Keating on Painters' originally broadcast in 1982. In each of the programmes Keating would elucidate the techniques and style of the master by painting a forgery and explaining each stage in the process. The old audacity was present as 'new' Titians, Rembrandts or Degases appeared on canvas. Some of these pictures were reverse views of famous works, such as 'The Fighting Temeraire' and 'The Haywain'. Keating exploded the notion that art had to be created in a mythical secreted chamber, the 'locked upstairs room' he was supposed to have used himself (*Daily Telegraph*, 20 January 1979, p. 3). He restored the place of imitation to its role of complementing, comprehending and embellishing another artist or work. Another forger from earlier in the century, Iclio Joni, believed critics should be apprenticed in such knowledge:

> It is my sure belief, that modern critics ought to have a thorough experience of painting, both in oil and tempera, and not only of the actual technique, but also, above all, of the fundamental methods of preparation, if they are to avoid talking the nonsense they often do talk.
>
> (Joni, 1936, p. 324)

Keating said in *Fake's Progress* (or rather Frank Norman/Keating said) of his 'Sexton Blakes' (his cockney rhyming slang for fakes—note the suggestion of a detective-hunt):

> I didn't look upon them as a way of making money. I did them as a way of studying a painter that I admired at close quarters. When I make a Sexton Blake of another artist's work I have to study their technique far more

conscientiously than I would if I was merely making a copy out of idle curiosity.

(p. 82)

Shortly before his death Keating sold some of his 'genuine' fakes at Christie's for £72,000.

Much has still to change if the concept of forgery is to disappear. Van Meegeren's and Keating's forgeries certainly challenged prevailing aesthetic assumptions. But the more direct challenge was to the art market which relies on and fosters those assumptions. Peter Nahum of Sotheby's Belgravia summed up in early 1979:

> It was not Tom Keating who was on trial, but the whole of the art trade. Throughout, the trade has [looked] after its own interests rather than those of the public.
>
> (*Daily Telegraph*, 28 February 1979, p. 10)

Nahum declared forty per cent of all goods on the market to be 'wrong in some sense'. This paints the art market as a black market with a glossy mask of snobbery and prestige. Lord Dacre, we recall, said there was a 'grey' market of historical relics like the Hitler diaries. Sir Frederick Corfield of the London and Provincial Antique Dealers Association saw a need for the appointment of a watchdog body to monitor the market's practices (*Daily Telegraph*, 28 February 1979, p. 10). But the suggestion was thrown out by BADA. Disputed pictures would never get sold.

Notes

1. Brief mention can be made here of some of the forgers who have not been included in this chapter (this list is not meant to be exhaustive):

 The *Riccardi brothers* were the ringleaders of a gang faking Etruscan relics in the 1930s. Three large figures were sold to the Metropolitan Museum in New York in 1937. Their authenticity was not disproved until 1961 (Jeppson, Ch. 10).

 Francis 'Flag' Lagrange managed to copy a triplicate by Fra Filippo Lippi in the cathedral of Notre Dame in Rheims in 1926. The original was stolen and the copy put in its place. The original went to a Californian collector for 4m francs. When he went bankrupt in 1929 the

work was put on the market and the forgery discovered. Flag was already under arrest for currency counterfeiting—one of the few art forgers to cross the divide. He received a ten year sentence for the artistic crime, but life (commuted to fifteen years) for the economic crime. Jeppson reckons ironically that the Lippi Flag copied may itself not have been original. When the cathedral's treasures were transferred to the Musée des Beaux Arts after the War the Lippi was not displayed (Jeppson, Ch. 7; Francis Lagrange, 1963).

John Charles Millet learnt to forge the signature of his grandfather the painter Jean François Millet. He could then 'authenticate' new Millets painted by his friend Paul Cazot. Also, under French law, an artist's next of kin become the official authenticators of the *oeuvre*. This left Millet uniquely placed to do a flourishing trade. He claimed that about 4,000 of his and Cazot's forgeries entered the market (Jeppson, Ch. 6).

Dietrich Fey and *Lothar Malskat*, while supposedly restoring, actually forged murals in the Marienkirche in Luebeck shortly after the Second World War. They were jailed for eighteen months in 1954. It is also believed they forged frescoes in St. Peter's cathedral, Schleswig, in 1937 (Jeppson, Ch. 8; Cole, Ch. 7; Reith, pp. 169–80).

Jean Pierre Schecroun forged many paintings in the 1950s and 1960s. He served ten months in jail and was lionised briefly for saying 'My trial will be that of the picture dealers' (Jeppson, p. 184).

Elmyr de Hory's story is, ironically, chronicled by Clifford Irving, the forger of the Howard Hughes autobiography. If we can trust this source, de Hory did lucrative trade in fakes of modern painters in America in the 1950s and 1960s. When some of these were discovered de Hory was safely beyond extradition in Europe. Irving claims a major scandal was avoided because de Hory's testimony 'would be a 1929 crash for the art world' (Irving, p. 228). Irving's book brought about a libel lawsuit by Fernand Legros, de Hory's partner, and *Fake!* was withdrawn by its publishers, Heinemann, soon after publication.

David Stein posed as a playboy art dealer in America in the 1960s selling his own forgeries. He was arrested on a charge of larceny in 1967 and, like van Meegeren, painted a forgery in front of the courts to have his sentence commuted. A media star, he was given his own exhibition in London after his release from jail.

The *Sunday Times Magazine* (25 March 1984) exposed the private collection of the late Marshal Tito of Yugoslavia as a huge parcel of forgeries. As 'genuine' items they had been valued at about £4 bn.

2. Christopher Wright's recent investigations into faked masters have produced similar stonewalling. In *The Art of the Forger* (1984) he produces compelling evidence based on stylistic analysis and anachronisms for casting doubt on the authenticity of works by Georges de La Tour (particularly 'The Fortune Teller' in the New York Metropolitan Museum) and a range of others including 'St Ivo' by Rogier van der Weyden (in the National Gallery, London). It is not surprising that the owners of these paintings defend their authenticity. Together they cost about £1½ m, and are worth more. The *Observer* reported in August 1984

that Lorne Campbell, the leading Rogier expert, rejected Wright's claim that 'St Ivo' was a modern fake but cashiered the work to a studio painting. If this is accepted, the value of 'St Ivo' would plummet from £5 m to about £500,000.

3. On a visit I made to the Victoria and Albert Museum in 1984 there were three Bastianinis on display: 'Girolamo Savanarola' (a pigmented terracotta acquired in 1896 as a fake); 'Lucrezia Donati' (a marble exposed as a fake in 1868); 'Marsilio Ficino' (a terracotta exposed as a forgery in 1867).

4. One of the most famous of all 'self-appointed judges' was Bernard Berenson. His partnership with the art dealer Lord Duveen is notorious. Berenson's lists of authentic works by masters have only recently come under scrutiny. Berenson was part scholar, part 'intuitive' critic. A recent biography by Meryle Secrest offers circumstantial evidence that Berenson gave many 'optimistic' pedigrees for works Duveen sold. See Secrest 1979, pp. 248–74, 399–407.

5. The final word on Vermeer could rest with *Times* columnist Bernard Levin. In a revealing article written in 1983 Levin pondered: 'if we stood in front of van Meegeren's Vermeer and felt profoundly affected by the majesty and power of the scene, just why would we stop feeling such things if a newsboy rushed into the gallery shouting that it had just been proved a fake?'

If there is no change in feeling certain conclusions follow:

1. 'the identity of the artist is not important'

2. 'questions of legal liability plainly have nothing to do with artistic validity'

3. 'The honest truth seems to be that our response to art rests on a foundation much less secure than we like to think ... it begins when we learn about art ... in terms of hierarchies of eminence ... many visitors to an art gallery look first for the label'.

(*The Times*, 24 November 1983, p. 12)

The author is a modern figure, a product of our society insofar as, emerging from the Middle Ages with English empiricism, French rationalism and the personal faith of the Reformation, it discovered the prestige of the individual, of, as it is more nobly put, the 'human person.' It is thus logical that in literature it should be this positivism, the epitome and culmination of capitalist ideology, which has attached the greater importance to the 'person' of the author. The *author* still reigns in histories of literature, biographies of writers, interviews, magazines, as in the very consciousness of men of letters anxious to unite their person and their work through diaries and memoirs. The image of literature to be found in ordinary culture is tyrannically centred on the author, his person, his life, his tastes, his passions....

Roland Barthes, 'The Death of the Author' (1968)

I wrote it. That is to say, I collaborated in writing it. No book is produced individually, as you know

O'Brien, in George Orwell's *Nineteen Eighty Four* (1948)

The Booksellers are the Master Manufacturers or Employers. The several Writers, Authors, Copyers, Sub-writers, and all other Operators with pen and Ink are the workmen employed by the said Master Manufacturers

Daniel Defoe (1725)

6

Literary Forgery in the Modern Age

The twentieth century is not rich in literary forgery. There is nothing resembling the spectacular and ambitious fabrications of Macpherson, Chatterton, Ireland, Collier and Wise. It seems therefore that the cultural custodians of authenticity have triumphed, deterring the would-be forger with sophisticated bibliographical policing methods. At best the forger has been cashiered to a plagiarist. Most modern literary scandals involve a crime against copyright. Such infringements may not seem the most exciting topic to pursue in this final chapter, until we remember that copyright is underwritten by those crucial concepts of authorial originality and authenticity. Those same technical advances which prevent another Chatterton appearing are actually putting the traditional notions of authorship under an intolerable strain—doing the job, ironically, of literary forgery. We shall be following the demise of the author in some detail and attempting to look ahead to a situation where 'originality' has become extinct. First, however, we must look at several interesting forgeries that do not involve straightforward plagiarism.

Fictions of the Self

We begin with two venerable modern authors in the twilight of their careers: Thomas Hardy and George Bernard Shaw. It is common for a writer to authorise an 'official' biography before his or her death. Many writers also produce autobiographies, but a biography has the edge of being an objective and balanced

131

account. Hardy and Shaw, however, decided that not even an authorised biographer could be trusted to get it right. So possessive were they of their literary identities that they wrote large sections of their own biographies. This collaboration was of course secret, an inversion of Pope's Homer. The aim was to produce textual authority by surrendering authenticity. Hardy's is the most interesting case.

The Early Life of Thomas Hardy 1840–91 and *The Later Years of Thomas Hardy* appeared in 1928 (the year of Hardy's death) and 1930 under the authorship of his wife Florence Emily Hardy. No one could possibly know Hardy better than her. That was the intention. But the whole thing was a huge deception:

> Florence Hardy's *Life* is one of the more curious literary deceptions of modern literary history since Hardy himself wrote, in the third person, all but the last two chapters, leaving instructions for the work to be completed and published after his death. Great pains were taken to conceal his authorship and for many years the work was accepted as genuinely having being written by his widow ... the situation is odd. It is common enough for an inexpert writer's autobiography to be 'ghosted' but Hardy is unique among major literary figures in reversing this process; he is, in effect, 'ghost writer' of his own biography.
>
> (R. H. Taylor, 1978, p. 189)

Hardy's typescript was destroyed as soon as possible and any corrections he made were in a disguised hand. This almost comic megalomaniac cloak-and-dagger manoeuvring is not actually 'unique' to Hardy. George Bernard Shaw, who died aged 94 in 1950, collaborated on three biographies by Hesketh Pearson, Frank Harris and Archibald Henderson. All evidence of Shaw's work with Harris was destroyed, and the revisions to Henderson's *Playboy and Prophet* were not acknowledged. In a recent bibliography of Shaw these biographies appear euphemistically under 'Works edited by Shaw' (see Lawrence, 1983). On the sliding scale of literary deception Hardy and Shaw's forgeries may not register highly. But they show that authority and authenticity are no more firmly rooted in the twentieth century than in the heady days of Edmund Curll.

The most famous fake autobiography of this century remained in manuscript form and never actually became a book. The work caused much public mischief and attracted tidal waves of publicity while remaining locked in its invisible form. This fate

was quite appropriate, for the work in question was an autobiography of the secreted millionaire Howard Hughes, 'ghosted' by the American expatriate Clifford Irving. The ironies multiply. Irving was already known as the author of *Fake!* the story of art forger Elmyr de Hory. So Irving had expertise in tracking down elusive figures. The fact that *Fake!* was withdrawn soon after publication was a minor worry compared with the multi-million-dollar potential of the Hughes story. In early 1971 Irving saw a facsimile of a sample of Hughes's handwriting in *Life* magazine. Fake lives of Hughes had appeared before, but Irving and fellow Ibizan Richard Suskind decided they could succeed where other forgers had failed and supply the world with its most media-hunted quarry. With the aid of fake letters from Hughes, Irving persuaded his publishers, the giant McGraw-Hill company, that Hughes was favourable to a series of interviews leading to a possible autobiography. Like Gerd Heidemann of Hitler diaries fame Irving went straight to his senior management who could hardly believe their luck. The handwriting in the letters was identified as genuine. McGraw-Hill winced a little at the fee—$750,000 to be paid via Irving —but they looked ahead eagerly to the $2,000,000 or so they would reap in various publishing deals. Irving was in a strong position. His contact with Hughes was of course totally secret. Hughes' known eccentricity gave Irving a free hand in inventing exotic and bizarre locations for the all-important interviews (including blindfold journeys and car lots). All the time Irving was actually researching material on Hughes. Finally, and most importantly, the ghosted text that Irving produced was entertaining and interesting, full of humour and catchy anecdotes. McGraw-Hill's greatest fear had been that Hughes would be a rambling bore. Factual inaccuracies could not in themselves threaten the authenticity of the account. Hughes' memory could be faulty, or he might be deliberately romanticising or falsifying. Irving did indulge in some pure fiction. But the bulk of his account was based on the known sources and one very important unpublished and little-known source, a manuscript by Jim Phelan. The Phelan material was pure gold and was largely responsible for giving Irving's Hughes the authentic human touch. As we shall see, it also led to the story's downfall.

Irving had taken a calculated risk that Hughes would prefer to remain in exile rather than step into the limelight to refute the work. When the unthinkable happened, the results were not as devastating as one might think. Hughes' semi-fictional state worked in Irving's favour. In January 1972 Hughes broke his silence and said he had never heard of Clifford Irving. Unfortunately for Hughes his authority was questionable. He had extinguished his identity. Before anyone could begin to take his statement seriously he had to prove his own identity, to authenticate himself. A bizarre radio interview took place between a ghostly, disembodied Hughes and seven journalists who were his inquisition. This was 'McLuhanism gone mad' as one observer has noted wryly. Hughes failed to answer many of the questions put to him correctly, and was more interested in types of aircraft wing than in people. He came across as rather pathetic. Though the journalists voted in favour of his authenticity his success in destroying his own credibility was such that Irving dismissed Hughes' statement as last-minute cold feet.

Irving had enough to worry about from the authorities. Investigations had revealed that the 'H.R. Hughes' to whom fat cheques had been made payable was an alias for his wife Edith. She had already withdrawn all the money from the Swiss bank account it had been deposited in. Irving was charged with fraud, and confessed soon after. He did not implicate the autobiography, however. Its 'self-evidencing light' shone bright and clear. McGraw-Hill went ahead with plans for publication. At this eleventh hour yet another ghost entered the plot seeking revenge. This was journalist Jim Phelan. Some years earlier he had been hired to ghost-write the memoirs of Noah Dietrich, one of Hughes' ex-colleagues. The work went well and he had produced a substantial script, when he was unexpectedly sacked. This was at the instigation of Stanley Meyer, one of Dietrich's advisors and a double agent for Irving. Meyer had realised Phelan's racy literary skills would be the ideal pep-me-up for Irving's work. Somehow Meyer had to ensure Dietrich's memoirs did not get into print first and he had to get a copy of Phelan's manuscript to Irving. Both these ends were secured by persuading Dietrich that Phelan's work was poor and having his contract cancelled. Irving then plagiarized Phelan's work. It was only very late in the day that Phelan recognised his own words in

some of the extracts from Irving's work that appeared in the press. Phelan went to McGraw-Hill and convinced them of a large number of borrowings, including some facts Hughes could not possibly have known. In February 1972 these revelations about Jim Phelan's manuscript were published in *Time* magazine. McGraw-Hill had no choice but to abort publication. The clash of two capitalist empires was over. Irving confessed that he had never met Hughes.

Irving served seventeen months in jail from a sentence of two and a half years for defrauding McGraw-Hill of about £300,000 (one wonders what his sentence would have been had he stolen this money directly from a bank). He is now a modestly successful producer of legitimate fiction. For a final view of the ironies of this story we can turn to the *Sunday Times* reporters whose book has been the source of my account:

> If [Irving and Suskind] could manufacture a pseudo-Hughes and set him in opposition to the real Hughes, there was a strong likelihood that people might accept the pseudo-version. After all, the real Hughes, eternally locked in his air-conditioned nightmare, was already totally incredible. Reconstituting the old man would be almost a service to reality.
>
> (Fay *et al.*, p. 63)

Plagiarism

It is not the intention to repeat here what was said in Chapter 2. Plagiarism is the unacknowledged and therefore dishonest borrowing from another text which has copyright protection. The point at which literary influence (under its trendy modern title 'intertextuality') becomes a criminal activity is difficult to determine. Would we want to censure Wordsworth for the following unacknowledged appropriation of Milton? In Wordsworth's autobiographical epic *The Prelude* (1805) a revelation about his imagination is described in terms of Adam who after the Fall saw

> Darkness ere day's mid course, and morning light
> More orient in the western cloud, that drew
> O'er the blue firmament a radiant white,
> Descending slow with something heavenly fraught.
>
> (Book VIII, ll. 661–4)

This is not the Biblical Adam but the considerably enlarged version of him in *Paradise Lost*:

> Darkness ere day's mid-course, and morning light
> More orient in yon western cloud that draws
> O'er the blue firmament a radiant white,
> And slow descends, with something heavenly fraught.
>
> (Book XI, ll. 203–6)

There is no possibility with such an extended borrowing that Wordsworth is unintentionally quoting Milton. Had Milton been alive he could have brought a suit against Wordsworth. In a technical, external sense plagiarism becomes a crime once a legal objection is raised. On an internal aesthetic level another writer's authority is hijacked or 'prejudiced' and unoriginality masquerades as originality. A double standard operates in much literary scholarship. This discovery of a verbal echo or parallel enriches a text while the stigma of being 'derivative' is always ready to pounce. Borrowing is likely to be severely chastised in poor literature, or indeed be seen as a precondition of lack of aesthetic merit. Imitation is acceptable and even rewarding in skilful hands.

In early 1982 a row erupted about the last section of D.M. Thomas's novel *The White Hotel*. The story's central character Lisa gets caught up in a Nazi massacre of Jews at Babi Yar, a real incident. On the copyright page Thomas acknowledged he had used as a source Anatoli Kuznetsov's *Babi Yar*. But the scale of the borrowing was extensive and often verbatim. When an antiques dealer named David Kenrick pointed this out in a letter to the *Times Literary Supplement* Thomas was quick to reply. He said his artistic purpose was to have Lisa's story become the words of the survivor of Babi Yar (Dina Pronicheva) as fiction becomes fact and she is consumed by history, and that he, Thomas, had broken no law. This did not satisfy Geoffrey Grigson, who called Thomas's copyright reference 'plagiarism admitted in advance' (*Times Literary Supplement*, 16 April 1982, p. 439). Grigson's revulsion at Thomas's opportunistic use of harrowing and shocking material was sufficient for Grigson to upend the copyright process. To add to the case against Thomas, Kuznetsov's widow revealed that Thomas had never sought permission to use her husband's work and had therefore made

only an 'inspirational' acknowledgement. Thomas was hauled over the coals again for his next novel *Ararat*. The massacre he chose to depict this time was that of the Armenians by the Turks in the First World War. Rather more conspicuously this time, Thomas referred in an 'Author's Note' to his principal source: a book published in 1980 by Christopher J. Walker. The sop was not taken. Walker revealed many passages borrowed verbatim and observed:

> Historians expect their books to be used and quoted from. I'm not so sure they expect their words to end up almost verbatim in the mouth of another author's fictional character.
>
> (letter to the *London Review of Books*, Vol. VI, 4, p. 4)

Walker's letter began 'Is this plagiarism?' In order to offer a range of answers to the issues raised by the *White Hotel* fiasco the *Times Literary Supplement* published a symposium on plagiarism in April 1982. The spread of views of the contributors is fascinating. Harold Bloom regards all texts as 'webs of allusion' and concludes that 'no writer can ever be certain when he is quoting.' The distinction between originality and imitation is blurred, and plagiarism is 'a legal rather than a literary matter'. Literary texts can and should be available to all writers. In this demand, Bloom ignores capitalist modes of production. Not so Wilfred Mellers, who notes 'in a producer-consumer society, the producer must protect his rights, and calls on moral rights in doing so'. This legal hold over originality is at odds with much modern practice:

> Pound's pillage of the past, Joyce's multi-layered cultural and social strata, Brecht's identification of poet and people, Burrough's exploitation of the collage and cut-out.

The most interesting and provoking comments come from John Sutherland, author of *Fiction and the Fiction Industry* (1978), who is always eloquent on the subject of copyright. Sutherland also goes to the commercial basis of art. In bestsellerism 'me-tooism' is encouraged to generate imitators. A wry perspective opens up on literary history:

> Burrough's volumes on the sources of Shakespeare's plays would doubtless furnish a modern copyright lawyer with any number of actions.

Sutherland also considers the factuality of literature—'fact' is often drawn from printed sources. The nineteenth-century novelist Charles Reade prepared his 'matter-of-fact' novels by assembling newspaper cuttings. There has been controversy about several modern novels which have become entangled in what John Sutherland describes as 'alleged over-reliance on source books': Norman Mailer's *Marilyn*, Alex Haley's *Roots*, Ken Follett's *The Key to Rebecca*, and Stephen Sheppard's *The Four Hundred*. Plagiarism, which is a complex legal ruling and not an aesthetic judgement, has not been proved in these cases so far as I am aware. Nor has it been proved in the controversies involving Martin Amis (who claimed his *The Rachel Papers* had been plagiarized in Jacob Epstein's *Wild Oats*), Mikhail Sholokhov (his authorship of the Nobel Prize-winning *Quiet Flows the Don* has always been suspect) and Jerzy Kosinski. He has been accused of being another Alexander Pope in putting his name to novels written by his proof-readers. Kosinski has denied all charges but expressed dismay that his texts are not self-evidencing:

> how can you prove that you've written something? I look at my books and I think, how do I show the hours I've spent on them, how do I take these hours into a court—in a suitcase? What is evidence? Basically it's a matter of belief.

> (*Sunday Times*, 27 March 1983)

Raymond Chandler noted wearily of imitators of his novels 'if another writer can really steal your style, it can't be very important' but sympathised with aspiring writers: 'Everybody imitates in the beginning' (MacShane, 1981, p. 125).

Copying

In their interesting book *Copyright. Intellectual Property in the Information Age* (1980) Edward Plowman and L. Clark Hamilton note that 'what remains of the author's so-called natural right to maintain the integrity and content after publication has never been clearly resolved in Anglo-American jurisprudence' (p. 14).

Copyright began as a protective act for publishers and has

remained so. A text which is owned by a publisher is essentially de-authored. The words on the page bear no relation to an originating mind. Forgeries have often exposed the tenuousness of this link. Twentieth-century technology has taken over the task. The concept of authorship and therefore the traditional authentic text is being broken down:

> some countries have chosen to view the production of broadcasting and sound recording equipment as authorship and have incorporated such works within the copyright law. Other countries, while recognizing that the production of such material requires skill, have not viewed the broadcaster or record manufacturer as being the equivalent of an author.
>
> (Plowman and Hamilton, p. 32)

We live in an age of multi-personal 'equivalent' authorship moulded by legal statute. The 1956 Copyright Act abolished any 'moral' claim of an author to a text in Britain. France apparently hung on to the old ways in its copyright laws:

> the author of an intellectual work shall, by the mere fact of its creation, enjoy an incorporeal property right in the work, effective against all persons.
>
> (p. 92)

But elsewhere new media were effecting radical changes:

> New technologies make possible new ways of producing works so that neither 'work' nor 'author' has more than a vague resemblance to the classical definitions and situations. An extreme example is the case of works which have been produced, edited or given their final form through the use of electronic equipment.
>
> (p. 35)

Plowman and Hamilton are also alive to the aesthetic consequences of these changes. For insight here they use the Marxist critic John Berger's book *Ways of Seeing* (1972):

> There are more subtle effects of new media on our attitudes towards art and artistic creation. The art critic John Berger, in an analysis of the effects of the camera on our perception of visual arts, states that 'the uniqueness of an original painting now lies in its being the original of a reproduction ... its first meaning is no longer found in what it says but in what it is ...' (Berger, p. 21). He goes on to make the point that in an age of reproduction the meaning of paintings is no longer attached to them, but becomes

transmittable and thus a sort of information which can be put to many uses:
'The art of the past no longer exists as it once did. Its authority is lost. In
its place there is a language of images. What matters now is who uses
this language and for what purposes. This touches upon questions of
copyright for reproduction, the ownership of art presses and publishers,
the total policy of public art galleries and museums. As usually presented
these are narrow, professional matters ... what really is at stake is much
larger'. (*ibid.*, p. 32)

The age of reproduction has thus had the effect of destroying uniqueness.

(p. 186)

Marxist critics have long held the view that 'the proposition that
the writer or artist is a creator belongs to a humanist ideology'
(Macherey, 1978, p. 66). Berger was heavily influenced by the
German critic of the 1930s, Walter Benjamin. In a famous essay
'The Work of Art in the Age of Mechanical Reproduction' he
observed 'that which withers in the age of mechanical
reproduction is the aura of the work of art'. By 'aura' Benjamin
denotes the uniqueness or cult value of a work of art, its 'basis in
ritual' which 'revolutionary means of production' such as cinema
have shattered: 'they brush aside a number of outmoded
concepts, such as creativity and genius, eternal value and
mystery' (1977, p. 220). The single art object has become a
plurality of images:

> To an ever greater degree the work of art reproduced becomes the work of
> art designed for reproducibility. From a photographic negative, for
> example, one can make any number of prints; to ask for the 'authentic'
> print makes no sense. But the instant the criterion of authenticity ceases to
> be applicable to artistic production, the total function of art is reversed.
> Instead of being based on ritual, it begins to be based on politics.
>
> (p. 226)

Benjamin has praise for the potentially democratising techniques
of montage in Brechtian theatre, Dadaism and cinema. The
text—visual or literary—becomes a dynamic synthesis or
fabrication of languages and images: the 'height of artifice' (p.
235). Roland Barthes, the French structuralist critic, summed up
the position for literature in an essay written in 1968 (he uses the
male pronoun throughout):

> The Author is thought to nourish the book, which is to say that he exists
> before it, thinks, suffers, lives for it, is in the same relation of antecedence to
> his work as a father to his child. In complete contrast, the modern scriptor

is born simultaneously with the text, is in no way equipped with a being preceding or exceeding the writing, is not the subject with the book as predicate. Here is no other time than that of the enunciation and every text is eternally written here and now.

('The Death of the Author'; Barthes, 1977, p. 145)

Books are no longer children of the mind. Text and authorship coalesce in 'a multidimensional space in which a variety of writings, none of them original, blend and clash' (p. 146). If there is no originality there can certainly be no forgery. The future for the writer looks increasingly technologised and mechanised. The writer may become openly what he or she has always been: a wordsmith. Whether the de-authored text is put to socialist or capitalist use is of course dependent on political developments. John Sutherland prophesies a 'new monasticism where authors will benignly disintegrate into the communism of pure writing function' (review of Plowman and Hamilton's book, *London Review of Books*, 2–16 October 1980, p. 10). Perhaps human creativity will be replaced altogether by an Orwellian or Swiftian versificator or fiction machine.

For the moment however the establishment continues to pedal the 'outmoded' concepts while in reality dismantling them. Only offences against copyright force the issue of authenticity out into the open.

We can end by looking at two recent discussions of copyright. In 1982 the publishing world was outraged by the news that Cambridge University Press had renewed copyright on the novels of D.H. Lawrence. Lawrence died in 1930. His novels should therefore have entered the public domain in 1980. CUP however argued that their ongoing authoritative Lawrence editions constituted new texts which they could re-copyright. Their editions are based on Lawrence's early drafts. But in practice the 'new' texts sometime entail only changes of punctuation (*Economist* 10 April 1982, p. 33). So close is the resemblance to earlier texts that anyone quoting Lawrence may well have to ask CUP for permission. This precedent means that authors can be 'protected' (ie. monopolised) for up to 100 years after death in Britain, and 150 in America. John Sutherland has expressed fears that CUP may also be trying to monopolise their collection of Lawrence manuscripts. 'Lawrence hated the whole

business of turning art into property', says Sutherland. 'He wanted to be read, not owned' (quoted in Michael Holroyd and Sandra Jobson, 'Copyrights and Wrongs: D.H. Lawrence', *Times Literary Supplement*, 3 September 1982, pp. 943–4).

Surely if the modern author must disintegrate it should be into public ownership. Ironically the pirating of printed and visual material can be seen as a way of navigating around monopolies and making art and knowledge cheaply and more readily available. In a paper given to the 1984 Congress of the International Publishers Association, David Ladd, the United States Registrar of Copyright, declared that 'marvellous new machines' now enabled 'the broad-based dissemination and simultaneous reception by huge audiences of almost unimaginable quantities of creative works' (*The Bookseller*, 9 June 1984, p. 2337). Ladd is afraid that 'brilliant technologies will overwhelm authorship and copyright' as pirates in the Far East respond to the demands of 'consumer politics'. It is difficult not to see cultural imperialism here:

> we must never abandon the idea of the author's right. For countries standing in the European tradition ... the defence will be the easier. In these countries, the philosophical basis of copyright is rooted in the idea that an author's work is the extension of his personality; the foundation of the author's right as a natural right dominates the jurisprudence.
>
> (p. 2340)

In fact the capitalist pedalling of the myth of 'natural right' is only too apparent. Not to say that Third World countries benefit in the long run from cheap reprints of the OED or the West's leading authors. The novelist Salman Rushdie has praised piracy in India and Pakistan for spreading radical ideas but regrets that government-backed piracy only prolongs cultural and economic dependence on the West ('Shame about the pirates', *The Times*, 24 November 1984, p. 8).

According to John Sutherland, Brecht was startled when he was told that the *Threepenny Opera* was not his to adapt for film: 'He was the author but not the owner' (*Times Literary Supplement* 9 April 1982, p. 415). The authenticity and authority of a text are created not by an author's distinct set of words but

by the decisions of anonymous capitalist institutions. Perhaps such a fabrication should be labelled a modern forgery. At least that would bring the concept up to date.

Bibliography

Place of publication is London, unless otherwise stated.

Adams, Percy G. (1962) *Travelers and Travel Liars 1660–1800.* Berkeley and Los Angeles: Univ. of California Press.
Aldington, Richard (1957) *Frauds.* Heinemann.
Arnau, Frank (1961) *Three Thousand Years of Deception in Art and Antiques.* Jonathan Cape.

Barthes, Roland (1977) *Image Music Text.* ed. Stephen Heath. Fontana.
Benjamin, Walter (1977) *Illuminations.* Fontana.
Bentley, Richard (1967) *A Dissertation on the Epistles of Phalaris.*
—— (1701) *A Short Review of the Controversy between Mr Boyle and Dr Bentley.*
—— (1732) *Milton's Paradise Lost. A New Edition.*
Bilbo, Jack (1948) *An Autobiography.* The Modern Art Gallery Ltd.
Blackwell, Thomas (1735) *An Enquiry into the Life and Writings of Homer.*
Blair, Hugh (1763) *A Dissertation on Ossian.*
——*Lectures on Rhetoric and Belles Lettres.* 2 vols.
Boswell, James (1970) *Life of Johnson.* ed. R.W. Chapman. Oxford: Oxford Univ. Press.
—— (1974) *Boswell's London Journal 1762–63.* ed. Frederick. A. Pottle. Book Club Associates.
—— (1963) *Boswell's Journal of a Tour to the Hebrides.* ed. Frederick A. Pottle and Charles H. Bennett. Heinemann/Yale Univ. Press.
—— (1924) *The Journal of a Tour to the Hebrides,* ed. R.W. Chapman repr. Oxford: Oxford Univ. Press, 1979.
Bratchell, D.F. (1981) *The Impact of Darwinism.* Amersham: Avebury.
Broad, William and Wade, Nicholas (1983) *Betrayers of the Truth.* Century Publishing.

Brownell, Morris (1978) *Alexander Pope and the Arts of Georgian England*. Oxford: Clarendon Press.

Bryant, Jacob (1781) *Observations upon the Poems of Rowley*.

Burrow, J.A. (1982) *Medieval Writers and their Work*. Oxford: Oxford Univ. Press.

Carter, John and Pollard, Graham (1934) *An Enquiry into the Nature of Certain Nineteenth Century Pamphlets*. Constable.

Catholic Dictionary (1957) Routledge & Kegan Paul.

Cecsinsky, Herbert (1931) *The Gentle Art of Faking Furniture*. Chapman and Hall.

Chambers's Encyclopaedia (1970) New Revised Edition. International Learning Systems Corporation Limited. 13 vols.

Charles, R.H. (1913) *Apocrypha and Pseudographia of the Old Testament in English*; repr. Oxford: Oxford Univ. Press, 1978. 2 vols.

Chatterton, Thomas (1971) *The Complete Works of Thomas Chatterton*. ed. Donald S. Taylor. 2 vols. Oxford: Oxford Univ. Press.

Cole, Sonia (1955) *Counterfeit*. John Murray.

Conan Doyle, Arthur (1912) *The Lost World*. Hodder and Stoughton.

Coremans, P.B. (1949) *Van Meegeren's Faked Vermeers and De Hooghs*. Amsterdam: J.M. Meulenhoff.

Cross, F.L. (ed). (1974) *The Oxford Dictionary of the Christian Church*. Oxford: Oxford Univ. Press

Darwin, Charles (1984) *The Origin of Species by Means of Natural Selection*. Penguin.

—— (1874) *The Descent of Man*.

Davis, Lennard J. (1983) *Factual Fictions. The Origins of the Early Novel*. New York: Columbia Univ. Press.

Defoe, Daniel (1927) *Memoirs of a Cavalier*. Oxford: Basil Blackwell.

—— (1965) *Robinson Crusoe*. Penguin.

—— (1971) *Moll Flanders*. Oxford: Oxford Univ. Press.

—— (1972) *A Journal of the Plague Year*. Penguin.

—— (1976) *Roxana*. Oxford: Oxford Univ. Press.

Dictionary of National Biography. (1885) ed. Leslie Stephen. Smith, Elder & Co. Vol. IV.

Douglas, William (1751) *Milton vindicated from the charge of plagiarism*.

—— (1756) *Milton no plagiary*.

Dutton, Denis (ed.) (1983) *The Forger's art: forgery and the philosophy of art*. Berkeley; London: Univ. of California Press.

Ehrsam, T.G. (1951) *Major Byron. The Incredible Career of a Literary Forger*. John Murray.

Encyclopaedia Britannica (1969) Fourteenth Edition. William Benton. 30 vols.

Fairclough, Peter (ed.) (1972) *Three Gothic Novels*. Penguin.

Farrer, J.A. (1907) *Literary Forgeries*. Longman, Green.

Fay, Stephen *et al.* (1972) *Hoax. The Inside Story of the Howard Hughes-Clifford Irving Affair*. Andre Deutsch.

Fielding, Henry (1975) *Tom Jones*. Penguin.

Fleming, Stuart James (1975) *Authenticity in Art: the scientific detection of forgery*. Oxford: Institute of Physics.

Ford, Boris (ed.) (1982) *From Dryden to Johnson*. Penguin, 1982.

Ganzel, Dewey (1982) *Fortune and Men's Eyes*. Oxford: Oxford Univ. Press.

Gibbon, Edward (1776) *The Decline and Fall of the Roman Empire*. Vol. I.

Godley, John (Lord Kilbracken) (1951) *The Master Forger. The Story of Han van Meegeren*. Home and van Thal.

Goodspeed, Edgar J. (1939) *The Story of the Apocrypha*. Chicago: Univ. of Chicago Press.

Gray, Thomas (1935) *Correspondence of Thomas Gray*. ed. Paget Toynbee and Leonard Whibley. Oxford: At the Clarendon Press. 2 Vols.

Grove, Philip Babcock (1961) *The Imaginary Voyage in Prose Fiction*. The Holland Press.

Harris, Robert (1986) *Selling Hitler. The Story of the Hitler Diaries*. Faber and Faber.

Hearnshaw, L.S. (1979) *Cyril Burt Psychologist*. Hodder and Stoughton.

Home, Henry (Lord Kames) (1763) *Sketches of the History of Man*. 2 vols.

Hurd, Bishop (1751) *A Discourse on Poetical Imitation*.

Huxley, T.H. (1863) *Evidence as to Man's Place in Nature*.

Innes, Thomas (1729) *A Critical Essay on the Ancient Inhabitants of the Northern Parts of Britain, or Scotland*.

Ireland, William Henry (1796) *Miscellaneous Papers and Legal Instruments*.

—— (1799). *Vortigern*.

—— (1805) *The Confessions of William Henry Ireland*.

Irving, Clifford (1970) *Fake! The Story of Elmyr de Hory*. Heinemann.

Jaffe, H.L. *et al.* (1979) *Authentication in the Visual Arts. A Multidisciplinary Symposium*. B.M. Israel. B.V. -Amsterdam.

James, M.R. (1953) *The Apocryphal New Testament*. Oxford: Oxford Univ. Press.

Jeppson, Lawrence (1970) *Fabulous Frauds*. Arlington Books.

—— (1924) *A Journey to the Western Islands*. ed. R.W. Chapman; repr. Oxford: Oxford Univ. Press, 1979.

—— (1975) *Lives of the English Poets*. Everyman.

Johnson, Samuel (1976) *Rasselas*. Penguin.

Joni, Iclio (1936) *Affairs of a Painter*. Faber and Faber.

Keating, Geoffrey (1723) *The General History of Ireland*. 2 vols.

Keating, Tom, Norman, Frank and Norman, Geraldine (1977) *The Fake's Progress*. Hutchinson.

Keith, Arthur (1911) *Ancient Types of Man*. Harper and Brothers.

—— (1915) *The Antiquity of Man*. Williams and Norgate.

—— (1948) *A New Theory of Human Evolution*. Watts and Co.

Klein, Alexander (1970) *Grand Deception*. Faber and Faber.

Lagrange, Francis (1963) *Flag on Devil's Island*. Peter Davies.

Laing, Malcolm (1800) *The History of Scotland*.

—— (1805) *The Poems of Ossian*. 2 vols.

Larkin, Philip (1983) *Required Writing*. Faber and Faber.

Lauder, William (1750) *An Essay on Milton's Use and Imitation of the Moderns*.

Lawrence, Dan (1983) *Bernard Shaw: A Bibliography*. Oxford: Clarendon. 2 vols.

Lewis, Aneirin (ed.) (1957) *The Correspondence of Thomas Percy and Evan Evans*. Baton Rouge: Louisiana State Univ. Press.

Locke, John (1968) *An Essay Concerning Human Understanding*. Fontana.

Macherey, Pierre (1978) *A Theory of Literary Production*. trans. Geoffrey Wall. Routledge & Kegan Paul.

Macpherson, James (1760) *Fragments of Ancient Poetry*.

—— (1762) *Fingal*.

—— (1763) *Temora*.

MacShane, Frank (1981) *The Selected Letters of Raymond Chandler*. Macmillan.

Maggs, F.B. (1965) *The Delinquent Bibliophile*. Radlett Literary Society.

Mair, John (1938) *The Fourth Forger*. Cobden-Sanderson.

McKerrow, Ronald B. (1928) *An Introduction to Bibliography for Literary Students*. repr. Oxford: Clarendon Press, 1951.

McKillop, A.D. (1956) *The Early Masters of English Fiction*. Lawrence: Kansas Univ. Press.

Mendax, Fritz (1955) *Art Fakes and Forgeries*. Werner Laurie.

Milles, Jeremiah (1782) *An Examination of the Poems attributed to Rowley and Canynge.*

Mills, John Fitzmaurice (1972) *How to detect fake antiques*. Arlington Books.

Milton, John (1971) *Paradise Lost*. ed. Alastair Fowler. Longman.

Moss, Norman (1977) *The Pleasures of Deception*. Chatto and Windus.

Munro, Robert (1905) *Archaeology and False Antiquities*. Methuen.

Nobili, Riccardo (1922) *The Gentle Art of Faking Furniture*. Seeley Service and Co.

Partington, Wilfred (1946) *Thomas J. Wise in the Original Cloth*. Robert Hale.

Peardon, T.P. (1933) *The Transition in English Historical Writing 1760–1830*. Columbia: Columbia Univ. Press.

Percy, Thomas (1765) *Reliques of Ancient English Poetry*. 3 vols.

—— (1794) *Reliques of Ancient English Poetry*. 3 vols. Pinkerton, John (1781) *Scottish Tragic Ballads.*

—— (1783) *Select Scottish Ballads*. 2 vols.

Plowman, Edward and Clark Hamilton, L. (1980) *Copyright. Intellectual Property in the Information Age*. Routledge & Kegan Paul.

Pope, Alexander (1967) *The Iliad* and *The Odyssey*. Vol VII of the Twickenham Pope. ed. Maynard Mack. Methuen.

—— (1975) *The Poems of Alexander Pope*. ed. John Butt. Methuen.

Porter, Roy (1982) *English Society in the Eighteenth Century*. Penguin.

Psalmanazar, George (1704) *An Historical and Geographical Description of Formosa.*

—— (1764) *Memoirs.*

Reichenbach, Harry (1932) *Phantom Fame*. Noel Douglas.

Reith, Adolf (1970) *Archaeological Fakes*. Barrie and Jenkins.

Reynolds, L.D. and Wilson, N.G. (1974) *Scribes and Scholars*. Oxford: Clarendon Press.

Richetti, John (1969) *Popular Fiction Before Richardson*. Oxford: Oxford Univ. Press.

Ritson, Joseph (1794) *Scottish Songs*. 2 vols.

—— (1792) *Ancient Songs.*

—— (1802) *Ancient English Metrical Romances*. 3 vols.

Robertson, William (1759) *The History of Scotland*. 2 vols.

Rogers, Pat (1978) *The Eighteenth Century*. Methuen.

Salway, Lance (1979) *Forgers*. Kestrel Books.

Savage, George (1976) *Forgeries, Fakes and Reproductions.* White Lion Publishing.

Savage, Richard (1729) *An Author to Lett.*

Sayers, Dorothy L. (ed.) (1981) *The Divine Comedy.* 3 vols. Penguin.

Scott, Walter (1834–71) *The Miscellaneous Prose Works* Vol. 17 Edinburgh: Robert Cadell.

Secrest, Meryle (1979) *Being Bernard Berenson.* Weidenfeld and Nicolson.

Sherburn, George (1934) *The Early Career of Alexander Pope.* Oxford: Oxford Univ. Press.

Smith, Adam (1963) *Lectures on Rhetoric and Belles Lettres.* Thomas Nelson and Sons Ltd.

Smith Woodward, Arthur (1948) *The Earliest Englishman.* Watts and Co.

Spearing, A.C. (1982) Introduction to *The Franklin's Prologue and Tale.* Cambridge Univ. Press.

St. John, Henry (Viscount Bolingbroke) (1752) *Letters on the Study and Use of History.*

Straus, Ralph (1927) *The Unspeakable Curll.* Chapman and Hall.

Sutherland, James (1963) *A Preface to Eighteenth Century Poetry.* Oxford: Oxford Univ. Press.

Swanberg, W.A. (1961) *Citizen Hearst.* Longman.

Swift, Jonathan (1975) *A Tale of a Tub and Other Satires.* Everyman.

—— (1967) *Poetical Works.* ed. Herbert Davis. Oxford Univ. Press.

Syme, Ronald (1968) *Ammanius and the Historia Augusta.* Oxford: Clarendon Press.

Taylor, Donald S. (1978) *Thomas Chatterton's Art. Experiments in Imagined History.* Princeton: Princeton Univ. Press.

Taylor, Richard H. (ed.) (1978) *The Personal Notebooks of Thomas Hardy.* Macmillan.

Theobald, Lewis (1728) *Double Falshood.*

Tietze, Hans (1948) *Genuine and False.* Max Parrish.

Todd, William B. (ed.) (1959) *Thomas J. Wise. Centenary Studies.* Austin: Univ. of Texas Press.

Toland, John (1740) *A Critical History of the Celtic Religion and Learning.*

Vasari, Giorgio (1979) *Artists of the Renaissance: an illustrated selection.* trans. George Bull. Penguin.

Verne, Jules (1965) *Journey to the Centre of the Earth.* Arco.

Walpole, Horace (1764) *The Castle of Otranto.* See Fairclough.

Warburton, William (1727) *A Critical and Philosophical Enquiry into the Causes of Prodigies and Miracles as related by Historians.*

Warton, Thomas (1774–81) *The History of English Poetry.* 4 vols.

—— (1782) *An Enquiry into the Authenticity of the Poems attributed to Thomas Rowley.*

Watt, Ian (1982) 'Defoe as Novelist', in *From Dryden to Johnson.* ed Boris Ford. Penguin.

Weiner, J.S. (1955) *Piltdown Forgery.* Oxford: Oxford Univ. Press.

Wellek, René and Warren, Austin (1963) *Theory of Literature.* Penguin.

Whitehead, John (1973) *This Solemn Mockery.* Arlington Books.

Wordsworth, William (1976) *The Prelude.* ed. J.C. Maxwell. Penguin.

Wraight, Robert (1974) *The Art Game Again!* Leslie Freuin.

Wright, Christopher (1984) *The Art of the Forger.* Gordon Fraser.

Young, Edward (1759) *Conjectures on Original Composition.*

Index

Index